MONDRIAN ‖ NICHOLSON

IN PARALLEL

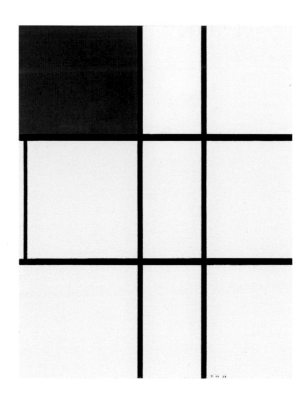

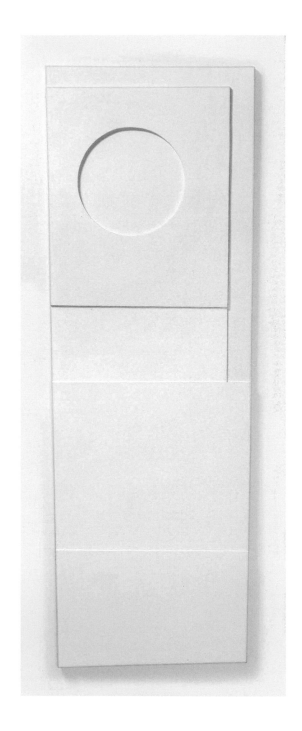

Piet Mondrian
Composition B/(No. II), with Red,
1935, cat. 6

Ben Nicholson
1936 (white relief),
cat. 11

MONDRIAN || NICHOLSON
IN PARALLEL

EDITED BY

Christopher Green
Barnaby Wright

ESSAYS BY

Christopher Green
Sophie Bowness
Lee Beard

CATALOGUE BY

Christopher Green
Barnaby Wright

THE COURTAULD GALLERY
IN ASSOCIATION WITH
PAUL HOLBERTON PUBLISHING

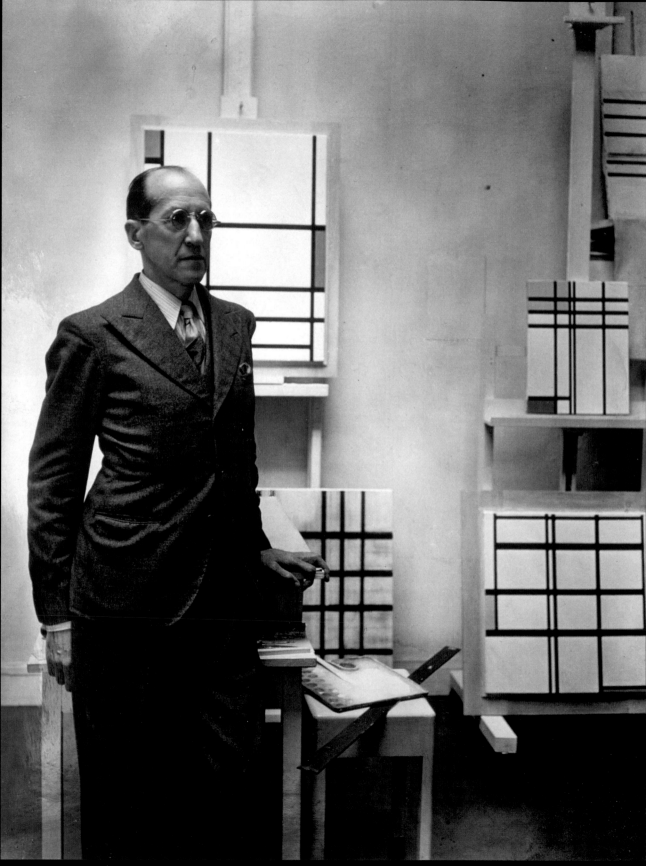

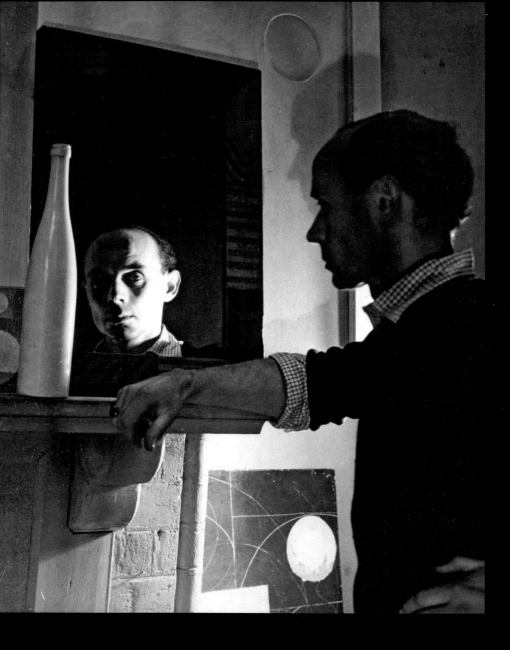

First published 2012 to accompany the exhibition

MONDRIAN ‖ NICHOLSON
IN PARALLEL

The Courtauld Gallery, London
16 February – 20 May 2012

The Courtauld Gallery is supported by
the Higher Education Funding Council
for England (HEFCE)

HIGHER EDUCATION *hefce*
FUNDING COUNCIL FOR ENGLAND

ISBN 978 1 907372 32 2

British Library Cataloguing in Publication Data
A catalogue record for this book is available from
the British Library

Produced by Paul Holberton publishing,
89 Borough High Street, London SE1 1NL
www.paul-holberton.net

Designed by Philip Lewis

Origination and printing by E-graphic, Verona, Italy

Contents

Foreword

In recent years The Courtauld Gallery has built a reputation for its engaging programme of focused exhibitions. Often springing from works in our own permanent collection, these exhibitions invite viewers to look in detail at particular episodes in the history of art. They are intended to promote and share new research and as such are a central part of our public benefit and purpose as a leading university art museum. In its clarity of focus and in the attention it draws to a remarkable but largely untold story, *Mondrian ‖ Nicholson: In Parallel* exemplifies the virtues of this approach.

This exhibition was first proposed to the Gallery by The Courtauld's own Professor Christopher Green. The fact that all three other intellectual partners in this endeavour were once Chris's students speaks eloquently of his influence as a scholar and teacher. Working alongside Chris, his co-curator Barnaby Wright, Sophie Bowness and Lee Beard constituted an enviably collegial and expert group. I want to thank them most warmly for the commitment, sensitivity and enthusiasm with which they undertook the many aspects of this project, including especially the original research that underpins it.

The integrity of this exhibition depended on very carefully selected individual loans, each of which is of direct historical relevance to its central theme. On behalf of The Courtauld I want to extend my warm thanks to the public and private lenders who so generously entrusted us with works from their collections. The Courtauld was equally fortunate to have been able to rely on such an enlightened group of sponsors and benefactors. Each of them played a part in enabling us to organise this exhibition and I am profoundly grateful for their support in these challenging times. Special mention must be made of the Embassy of the Kingdom of the Netherlands as an important early advocate, and I want to extend my personal thanks to Jan van Weijen and Daphne Thissen.

The Courtauld is especially grateful to ING, whom we are proud to have as our lead sponsor. ING's support came at a decisive moment in the planning of the exhibition and gave us the confidence to develop the project at the highest level of quality. It is a privilege for The Courtauld Gallery to be able to present the creative relationship between Ben Nicholson and Piet Mondrian, and we are deeply indebted to ING for making this possible.

ERNST VEGELIN VAN CLAERBERGEN
Head of The Courtauld Gallery

Lead Sponsor's Foreword

We are delighted to be supporting the exhibition *Mondrian ‖ Nicholson: In Parallel* at The Courtauld Gallery in 2012. A study of the cooperation between these artists, one Dutch, one British, is an obvious fit for ING's operations in London.

Art is an essential part of ING's corporate identity. In the Netherlands, ING is one of the largest collectors of modern Dutch art. Drawing on our British heritage, the collection we inherited from our predecessor business, Barings, is one of the finest corporate collections in the UK. These collections act as a catalyst for interaction with our communities, fostering closer links with clients, employees and the general public, and acting as a backdrop to educational projects with schools and interested groups. Our involvement with this initiative by The Courtauld Gallery is a natural extension to this activity.

We hope that all visitors enjoy what we are sure will be a highly popular and successful exhibition.

Exhibition Supporters

LEAD SPONSOR

MAJOR SPONSORS

Abellio Group

Embassy of the Kingdom
of the Netherlands, London

The Friends of the Courtauld

NautaDutilh

FURTHER SUPPORT PROVIDED BY

Crane Kalman

Hester Diamond

Richard Green

Hazlitt Holland-Hibbert

The Headley Trust

Bernard Jacobson Gallery

The Courtauld would also like to
extend its great thanks to Daniel Katz
for supporting the post of the
exhibition's co-curator, Barnaby
Wright, Daniel Katz Curator of
20th Century Art.

Acknowledgements

We are indebted to the institutions and
individuals who have lent works to the exhibition
and we would like to offer our sincere thanks,
on behalf of The Courtauld, to the following:
Fondation Beyeler, Riehen, Basel; The Hepworth
Estate; National Museum, Cardiff; Museum
Kunstpalast, Düsseldorf; The Peggy Guggenheim
Collection, Venice (The Solomon R. Guggenheim
Foundation, New York); Bernard Jacobson
Gallery, London; Kröller-Müller Museum, Otterlo;
San Francisco Museum of Modern Art; Scottish
National Gallery of Modern Art, Edinburgh;
Philadelphia Museum of Art; Musée national
d'art moderne, Centre Georges Pompidou, Paris;
Tate, London; Tate Archive, London; and those
private owners who prefer to remain anonymous.

It has been a great pleasure and a privilege to
work closely with Sophie Bowness and Lee Beard
on this exhibition. We would like to thank Sophie
most warmly for her excellent essay for this
publication and also for her unstinting support,
generosity and unrivalled knowledge, which has
been indispensable in bringing this project to
fruition. Lee's contribution to this publication
shares some of the fruits of his work on
Nicholson over many years and his contribution
to the exhibition as a whole has been invaluable.
We are extremely grateful to him.

Sir Alan Bowness has been extremely generous
in his support of this exhibition and publication in
a variety of ways and he has greatly enriched the
new research that is presented here. We would
like to extend our sincere thanks to him.

We owe a significant debt of gratitude to
Angela Verren Taunt and Liz Taunt who have been
exceptionally generous in their support of this
publication.

This exhibition would not have been possible
without the generosity and support of a large
number of people who have helped to realise
the exhibition and its catalogue. In particular
the curators and authors would like to thank:
Rafael Appleby, Graeme Barraclough, Janet Bishop,
Julia Blanks, Sue Bond, Stephanie Buck, Philippe
Büttner, Caroline Campbell, Mary Ellen Cetra,
Charles Darwent, Kate Edmonson, Patrick Elliott,
Jessica Fertig, Matthew Gale, Adrian Glew, Simon
Grant, Sophy Gray, Jonathan Hepworth, Henrietta
Hine, Paul Holberton, Jack Kettlewell, Karin Kyburz,
Philip Lewis, Brigitte Léal, Chloe Le Tissier, Andrew
Nicholson, David Nicholson, Esther Nicholson,
Jovan Nicholson, Shirley Nicholson, Laura Parker,
David Pilling, Anne Puetz, Hannah Talbot, Michael
Taylor, Ben Read, Hilary Richardson, Lynn Scrivener,
Chris Stephens, Ernst Vegelin van Claerbergen,
and Joff Whitten.

CHRISTOPHER GREEN
AND BARNABY WRIGHT

Samuel Courtauld Society Members

Piet Mondrian, *Composition No. 1, with Red*, 1939, cat. 16

Ben Nicholson, *1938 (white relief)*, cat. 17

CHRISTOPHER GREEN

Mondrian || Nicholson
Nicholson || Mondrian
IN PARALLEL

"The most one can say for the purpose of painting and sculpture is that there is a continuous progress and decline between parallel lines – not a catastrophic perfection not yet reached or understood."
MYFANWY EVANS, 1935[1]

Putting Mondrian and Nicholson together

Just after Christmas 1935, Ben Nicholson wrote to Barbara Hepworth of a visit he had made to their friend Piet Mondrian, mentioning "shows brewing", in particular "one this spring in America". He added: "Mondrian … said and seemed to assume I'd be hearing about it".[2] The show in question was Alfred H. Barr Jr.'s history–making–and–shaping 'Cubism and Abstract Art', which opened in New York in March 1936 (fig. 1).[3] Barr did indeed include Nicholson, and he brought him together with Mondrian as representative of "the geometrical" "pole" of "the contemporary abstract movement" in the two paragraphs that concluded his accompanying book.[4] The opposite pole, represented by Henry Moore, he called "biomorphic". Barr saw biomorphic abstraction as the modernist future. Mondrian and Nicholson were paired as the survivors of a movement in decline. The two friends were quick to read Barr's verdict and to agree to ignore it. For Mondrian, writing to Nicholson a month or two after the book appeared, their "geom. abstr." was "always in the ascendant".[5] Barr, however, did do a service for Mondrian and Nicholson: he embedded them as a pair in any history of modernism to be written that includes his category, geometric abstraction.

By 1936, their relationship was close and mutually reinforcing, as Sophie Bowness's contribution to this catalogue makes clear. Already, the year before, their names were being routinely paired in London, and when, in 1937, Nicholson himself came to edit the painting section of *Circle: International Survey of Constructive Art* (fig. 2) – a publication designed to stand for abstract artists in alliance with architects and scientists – he insisted on the pairing.[6] He opened the block of illustrations dedicated to painting with a Malevich drawing and then four Mondrians of 1934–36, including *Composition with White and Red: B* (cat. 10), followed by four of his own white reliefs of 1935–36, including *1936 (white relief)* (cat. 9; figs. 3–5). Seen together in successive greyish black-and-white sequences, their spare geometries can seem to a skimming eye simply to be variations on a single geometric theme. *Circle*, as a publication, with its accompanying exhibition, was put together by Nicholson, the Russian Constructivist Naum Gabo and the young architect Leslie Martin to combat the disruptive impact of the

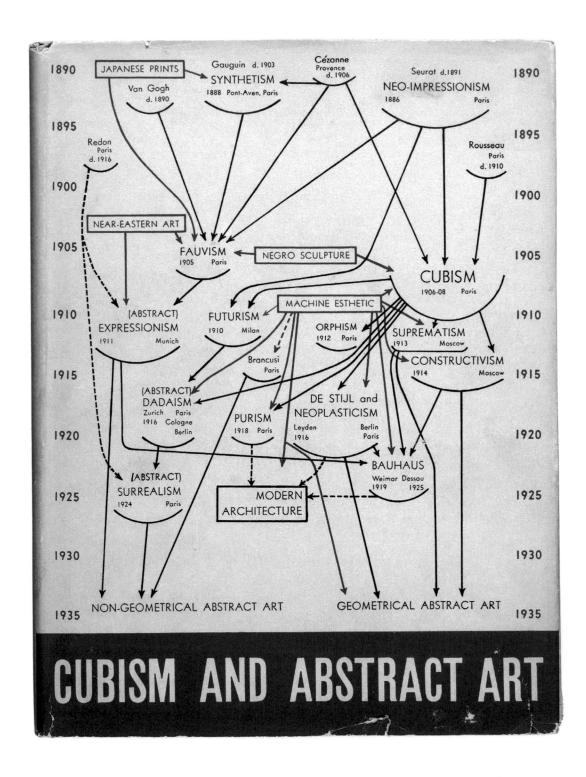

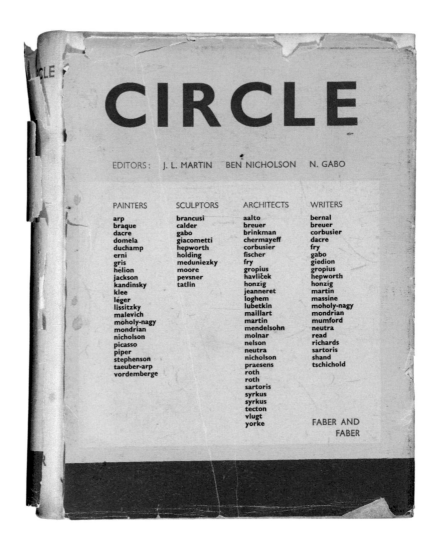

International Surrealist exhibition held in London the year before.[7] Like its rival, it insisted on its "International" status.

Mondrian's international role was not then and has not since been in doubt. He had made a major formative contribution to the movement whose name was taken from the periodical *De Stijl*, which had been driven by the irrepressible energy of the artist/theorist Theo van Doesburg whose wander-lust took him from Amsterdam to Berlin and Weimar, then Paris and Strasbourg.[8] After disagreement with Van Doesburg, from 1924 Mondrian had exhibited and sold his work in Germany, Switzerland and America and had published his writings in a widening range of periodicals aiming at international readerships. By the time his relationship with Nicholson had begun to develop in 1934, he counted him, with his first wife Winifred and his future wife Hepworth, as among a network of artist allies from France, the Netherlands, Germany, Hungary, Russia, Switzerland and the United States.[9]

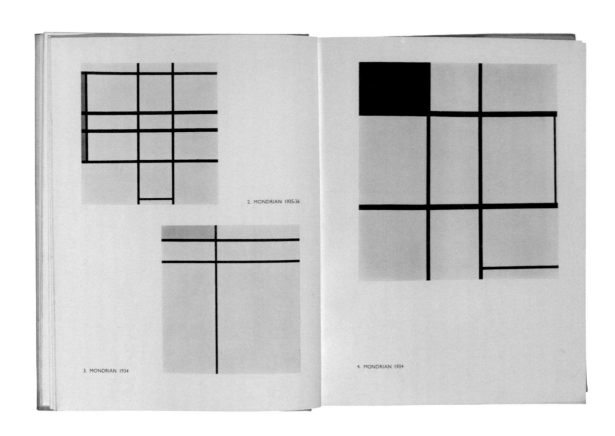

2. MONDRIAN 1935-36

3. MONDRIAN 1934

4. MONDRIAN 1934

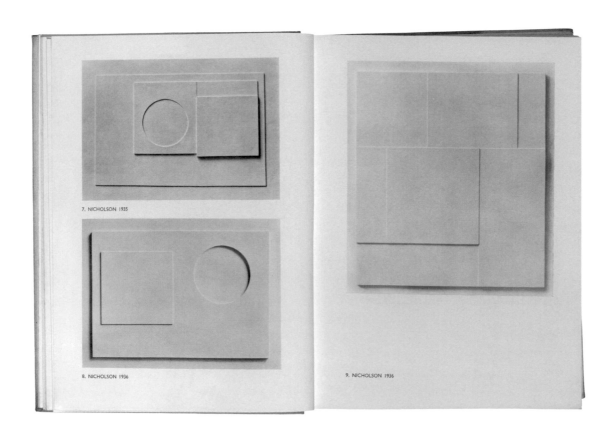

7. NICHOLSON 1935

8. NICHOLSON 1936

9. NICHOLSON 1936

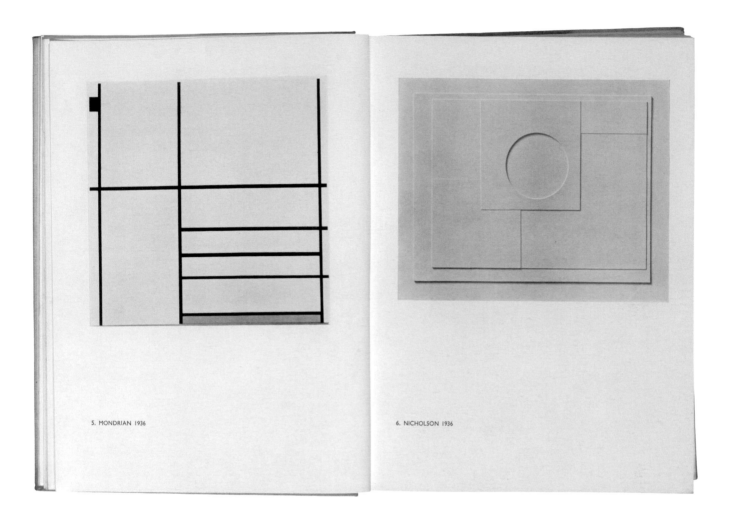

5. MONDRIAN 1936

6. NICHOLSON 1936

FIGS. 3–5
Opening sequence of double-page spreads
from J.L. Martin, Ben Nicholson and
N. Gabo (eds.), *Circle: International Survey
of Constructive Art*, Faber and Faber, London,
1937, courtesy Bowness, showing (plates 2–5)
Mondrian's *Composition White and Red: B*,
1936, here cat. 10; *Composition A, with Double
Line and Yellow*, 1935, B253; *Composition
(White and Red)*, 1936, B245; *Composition
in White, Black and Red*, 1936, B269; and
(plates 6–9) Nicholson's *1936 (white relief)*;
1935 (white relief); *1936 (white relief)*, here
cat. 9, and *1936 (white relief)*

A glance at the other artists illustrated in *Circle* in 1937 confirms how easy it was by the year after Barr's book was published to fit Nicholson too into an equally international network of artists, from a London as well as a New York vantage point.[10] Assessments of his importance as an historical figure (grudging as well as celebratory) have revolved around the legitimacy of his international status.[11] It can seem, however, that the individualism made so much of by John Summerson in the first Nicholson monograph actually sets him against the collectivist thrust of the internationalism associated with Mondrian, De Stijl and International Style Architecture.[12] More positively, the hand-crafted tactile surfaces brought out by the side-lit photographs used for the white reliefs illustrated in *Circle* have identified him with ingrained English Arts and Crafts 'truth to material' values and revealed a fondness for the rough rusticity of the 'domestic vernacular', of the whitewashed walls of Cumbrian and Cornish cottages.[13]

Both his individualism and his commitment to the hand-crafted do not, however, in my assessment, so identify him with the English and the insular as to diminish his internationalism. The fact that his white reliefs could fit well in the "domestic vernacular" whitewashed rooms of Winifred Nicholson's farmhouse in Cumberland (see figs. 18 and 43) should be balanced against the fact that they fitted equally well in Ben's friend Adrian Stokes's *pied à terre* in the uncompromisingly machine-age Lawn Road flats (see fig. 36). Ben wrote to Winifred in the summer of 1934 of the pleasure he took in seeing "my small reliefs" in Stokes's "clean, fresh and clear" living space. He and Hepworth lived nearby and, when he felt low, he added (for a moment a fervent lover, like Le Corbusier, of engineering on a monumental scale), he would visit the flats "all lit up at dusk and feel … as if a huge and lovely Atlantic liner had sailed up to the top of Hampstead."[14] Nicholson could be both English and international. He could also be both committed to the collective solidarity of *Circle* and an out-and-out individualist.

Le Corbusier's rhetoric can seem to shift the emphasis overwhelmingly away from the individual.[15] Modern Movement architects, however, never resolved the tension between impersonal reason and the wit of the individual designer, and, as Lucy Inglis has demonstrated, not only in

London but across the Channel in Paris the collective international aspirations of the artists who banded together under the banner of 'non-objective' or 'abstract art' were increasingly coupled with the aspiration to diversity, to art as individual "creation", not mechanized "production". The Paris-based association Abstraction-Création, whose *cahiers* and exhibitions were launched in 1932 and 1933 respectively, used a hyphen to tie abstraction and creation indissolubly together. Mondrian was a founder member, and both Nicholson and Hepworth were members in 1933 and 1934. Myfanwy Evans's English modernist periodical *Axis* followed suit from the start, championing the tight precision of Mondrian and Nicholson alongside the relative looseness of Kandinsky and Klee. Inglis is right to identify "a determined avoidance of any one theoretical stance coupled with a delight in individual creativity" as a defining characteristic of Evans's editorial style.[16]

There is a political dimension to this aspiration to diversity which repeatedly surfaces in *Axis* and which, as Popular Front resistance to Fascism from the Left was overtaken by the war effort in 1939–40, was given absolutely explicit expression by both Mondrian and Nicholson. Caught up in the Popular Front alliance between democratic Socialists and the Communist Party, Nicholson and Hepworth exhibited with the anti-Fascist Artists' International Association (AIA) and showed support for the Republicans in the Spanish Civil War.[17] There was no question, however, of their submitting as artists to any collective political agenda. In 1937, Herbert Read, their companionable neighbour in Hampstead and an eloquent defender of both international abstraction and international Surrealism, published *Art and Society*, arguing that art could only come of intense individual aesthetic experience and so should always stand aside from the propaganda demands of political struggle.[18] What, for artists, was most passionately to be resisted was the suppression of the individual in both the Fascist and the Soviet autocracies; a similar position was taken up by Barr in the book that accompanied *Cubism and Abstract Art*. This is, of course, an anticipation of the Cold War cultural freedom defence of liberal democracy. There is a strong echo of both Read and Barr in the opening of Nicholson's 'Notes on Abstraction', published in the periodical *Horizon* in 1941. He presents abstract art as "the liberation of form and

colour", adding that it is "linked to all the other liberations one hears about".[19] His position was precisely that taken up by Mondrian as war finally forced him from London to New York in 1940.

Left behind in London by Nicholson and Hepworth's decision to stay in Cornwall after the summer of 1939, Mondrian wrote to them both in February 1940 that he had begun "a new composition (small) and also an article in relation to the world situation".[20] A draft of that article was complete before he made the frightening journey across the Atlantic in September; it was titled 'Art Shows the Evil of Nazi and Soviet Oppressive Tendencies'. From his first publications in 1917, promoting what he called "Neo-Plasticism", Mondrian's theory of art was integrated into a totalizing philosophy that took in modernity in its fullest sense. Between 1926 and the early 1930s, when he met Nicholson, his writings show him steadily expanding the reach of his theory to detail its implications not only for the shaping of the environment and social life but also politics and international relations.[21] His draft of 1940 develops that thinking further.[22] As I shall show more fully later, Mondrian's theory of art gave to all its constituent elements absolute equivalence – each one (colour plane, non-colour plane, vertical and horizontal line) a separate entity or force – and described Neo-Plastic art as a process directed towards bringing them into what he termed "dynamic equilibrium". Where one force was allowed to dominate over another, equilibrium, "tragically", could not be achieved. For Mondrian, individuals, like classes or nations, had first to be thought of as separate, and not equal, but "mutually equivalent"; only then could their relationships be thought capable of working together towards equilibrium. The freedom of the individual from oppression was a fundamental principle for him, and his painting, he believed (like Nicholson), said so. "Plastic art," he writes, "shows that real freedom is not mutual equality but mutual equivalence. In art, forms and colours have different dimension and position, but are equal in value."[23] A theory of the freedom of the individual is mapped on to a theory of art.

Mondrian's theory of individual freedom seems directly to have shaped his attitude to friendship, in a way that has direct bearing on his relationship with Nicholson. From 1929, he started work on his most ambitious attempt to expand his ideas from art into life. This text, which

was not published until long after his death, is known from a draft dated December 1932, before he met the Englishman, but his correspondence shows that he went back to it in Paris in 1938 and then again in London in 1940, when he was keen to hear what Ben and Barbara thought of it.[24] One loss he confesses that the new way of thinking and living he advocates will bring is the loss of "the charm of traditional friendship and love". He wants, not the merging of one personality into another, but "mutual equivalence" between individuals who remain separate and independent, whose differences are the key to their relationship. Individual and social liberty was dependent, he wrote, on "the mutual separation of individuals", who then can "compose themselves in equivalent relationships".[25]

Mondrian was sixty in 1932, Nicholson was forty in 1934; Mondrian had become an abstract painter by 1917, Nicholson made his move to become what he called a "full time" abstract painter in 1933. He carved and painted his first white reliefs very early in 1934, before he had his revelatory experience in Mondrian's studio, but it has always been easy to slip into the master/follower discourse where their relationship is concerned.[26] Even Herbert Read, who might have known better, can write in 1948 that many Nicholsons "conform to the strict canons of neo-plasticism."[27]

Nicholson's relationship with Mondrian was certainly that of an unreserved admirer; but Mondrian equally was an admirer of Nicholson's work. Writing to Hepworth in May 1935, Nicholson reports that Mondrian has asked him for "a photo of a relief to pin on his wall", and follows up: "Could you possibly get me a small enlargement of the long relief". He includes a sketch of the large white relief carved in mahogany in the Tate collection (cat. 8).[28] Again writing to Hepworth after a visit to the Paris studio at the very end of 1935, Nicholson reports developments in Mondrian's work with an attentive enthusiast's eye, drawing a diamond canvas that is well underway – "a v. good project" – (see fig. 8), but also takes pleasure in finding differences between his work and Mondrian's. Ironically, given the tendency to stress Nicholson's liking for hand-craft finishes, he remarks (probably reacting to work on the go in the studio still at a relatively early stage [see, for example, fig. 6]): "I was surprised that technically some of his work looks positively

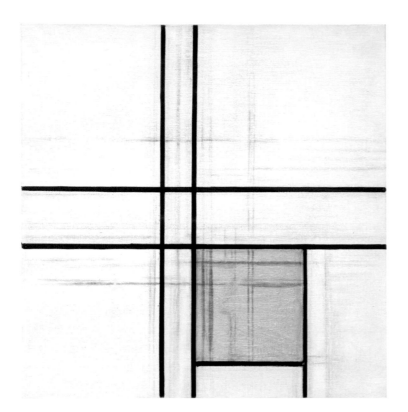

hand-done compared to my last lot."[29] Mondrian obviously liked such declarations of independence. Writing to Nicholson late in 1939, he reports receiving a review from a friend in New York: "They say about you: a painting by the Englishman Ben Nicholson whose abstract productions have a character of their own That will do you pleasure."[30]

Mondrian and Nicholson were close enough between 1934 and 1940 to be called friends, despite Mondrian's reluctance to give friendship a place in his world view. His letter writing is much warmer and more open than his tightly controlled, over-wrought theoretical texts. Writing to his youngest brother Carel just after his arrival in London in autumn 1938, he calls Ben and Barbara his "best friends."[31] Yet Mondrian's aspiration in his relations with others to "mutual equivalence" rather than friendship offers a viable way in to an exploration of the relationship between his and Nicholson's work. Their respect for each other as artists was built on the preservation of their independence, as it was in Mondrian's relations with all the artists he most deeply respected, including Winifred Nicholson and Hepworth.[32]

Following Mondrian's lead, this exhibition brings Nicholson and Mondrian's work of the 1930s together more to explore differences than similarities, to treat their work not as a single linear development within Barr's category "geometric abstraction" but as two distinct trajectories in parallel. Much difference is contained within the apparent homogeneity

of Barr's category. The reason for limiting the exhibition to the
Nicholson/Mondrian relationship, when Winifred or Hepworth or even
Naum Gabo could have been brought in (besides limitations of space) is
precisely that their work comes most obviously close while sustaining
profound difference; and the selection has focused on Nicholson at
his closest to Mondrian. One important difference between them, not
explored here, lies in the plurality of Nicholson's work as against the
singleness of Mondrian's purpose. Even in the mid to late 1930s, Nicholson
returned to the scraped, scratched and roughened still lives that had
been a major interest before 1933 (see, for example, fig. 7). But he did
so now with a strengthened conviction, in line with Mondrian, that
painting was a flat art to be encountered frontally. How then to
approach the difference between Nicholson and Mondrian when
they are at their closest?

Together and Apart

It is easy enough to make a checklist of the qualities or 'issues' that
might have attracted these two to each other. Nelly van Doesburg, wife
of Theo, recalls feeling that Mondrian's friendship with Theo was based
on "the so-called law that opposites attract".[33] A good case could be made
for explaining his friendship with Nicholson this way. Like Van Doesburg,

23

Nicholson was a networker and an activist; Mondrian was a loner. Nicholson was demanding and provocative; Mondrian was a model of diplomatic courtesy. Nicholson was impatient; Mondrian was infinitely patient. As usual with easy generalisations about character and behaviour, there is some truth in all these antitheses, but also more than a hint of myth-making, especially where Mondrian is concerned. A diligent correspondent, Mondrian was well networked into his international art world. According to Nelly van Doesburg, he could be caustic about people he took against.[34] There were similarities too that might have drawn the two together. Both felt viscerally a deep connection between bodily movement and art: Mondrian loved dancing and insisted that the rhythms of modern dance and modern art were akin; Nicholson disliked dancing, but he was a sporting 'natural' and insisted that his art engaged the eye and hand in ways akin to the mastery of movement in space shown by Wimbledon winners or Arsenal full-backs.[35]

Most relevant, however, to any exploration of their work together are two ways in which they were deeply in sympathy with each other as individuals and artists. First, they both believed that art was most profoundly concerned with timeless universals which could ultimately lift it above the contingent transience of everyday life, and which brought religion and art together. As Mondrian put it in his earliest writings on Neo-Plasticism, art is "an end in itself, like religion … the means through which we can know the universal and contemplate it in plastic form."[36] Mondrian remained, as Carel Blotkamp has emphasised, a thinker imbued with the pan-religious zeal of the Theosophical movement to which he became attached in 1909.[37] The possible conjunction between art and religious experience is a feature both of Nicholson's *Unit One* statement, written in December 1933 just as he was beginning to take Mondrian seriously, and his *Circle* statement of 1937. In *Circle* Nicholson focuses on art and religion to make one of his most quoted statements: "'Painting' and 'religious experience' are the same thing. It is a question of the perpetual motion of a right idea."[38] Nicholson's need to bring religion and art together had a different foundation from Mondrian's – not Theosophy but Christian Science, something of which Mondrian was well aware, apparently sympathetically.[39]

That phrase of Nicholson's from *Circle* – "the perpetual motion of a right idea" – is revealing. It is in this notion of the painting as an "idea" in movement given concrete presence that Mondrian's lingering sense of connection with Theosophy and Nicholson's active involvement with Christian Science come together, and are relevant to their actual work. Early on Mondrian coined the term "abstract-real" to convey his wish to realise the abstract in the concrete.[40] He writes in his piece for *Circle* of art being produced by a particular kind of intelligence, which "intuition enlightens".[41] The second area of sympathy between Nicholson and Mondrian directly relevant to their work emerges here: both saw intuition as essential to the concrete realisation of ideas.

In his *Unit One* statement, Nicholson combined a passage of expository prose with an opening passage which Hepworth called "poetry".[42] It is an evocation of the experience of making a Nicholson relief. He minimizes punctuation to convey the unstoppable urgency of a process without direction that comes to an end only when the work is "all the form and depth and colour that pleases you most". Then you have, he adds, "a living thing as nice as a poodle with 2 shining black eyes".[43] Mondrian would have been puzzled by the poodle, but he would have gone right along with the open spontaneity of the experience Nicholson evokes. He might have closed down the pictorial range of elements he worked with as a painter, but it has long been established that right through his Neo-Plastic phase he continued the open-ended approach to picture-making that had been his way as a Cubist. What counted for him were infinitesimal changes in the positioning and blackness of lines and the weighting of colour accents.[44] Nicholson's sketch of the diamond composition he saw already well advanced in the studio at the end of 1935 shows that between then and when it was finished three years later crucial changes were made (figs. 8 and 9). Mondrian, indeed, saw the very essence of Neo-Plasticism as the bringing together of the universal (in the purity of the oppositions achieved between lines and planes as an objective fact) and the individual (in the dynamic subjective process that generated it).[45]

If there was so much to encourage Mondrian's and Nicholson's close-ness as artists, where in their work is there difference? Few have looked

FIG. 8
Letter from Ben Nicholson to Barbara
Hepworth, 29 December 1935 with
a sketch of Mondrian's *Lozenge
Composition with Eight Lines and
Red/Picture* (fig. 9), Hepworth Archive

MONDRIAN ‖ NICHOLSON
IN PARALLEL

closely at what happened in Mondrian's painting between 1923 and his
New York period, 1940–44. The most thoroughgoing exploration so far
published is Yve-Alain Bois's compellingly argued extended essay written
for the major retrospective of 1995–96. It develops a highly effective
reading of Mondrian's theory and work together, and it includes a close
analysis of the work of 1932–39, when his trajectory ran parallel with
Nicholson's.[46] I shall take Bois's analysis as my way into the Mondrian
side of the duo. There is no obvious fully theorized way into the
Nicholson side. After all, Nicholson himself refused to theorize. Peter
Khoroche is certainly correct when he writes, "One should not expect
from Nicholson a rigorous philosophical statement".[47] Nicholson made
a public point of not being interested in Mondrian the theorist. "I could
not be bothered to read Mondrian's theories," he told interviewers in
1963. "What I got from him – and it was a great deal – I got direct from
the experience of his painting."[48] There is a lot of evidence that suggests
Nicholson did, in fact, read Mondrian, but there is a crude kind of truth
in Nicholson's claim: the theory did not matter to him alongside the
painting.[49] If the question is, however, where are the differences between
them there is one candidate who might give Nicholson side of the
contrast theoretical anchoring – Nicholson's tennis-playing friend, the
writer later to become a painter, Adrian Stokes.

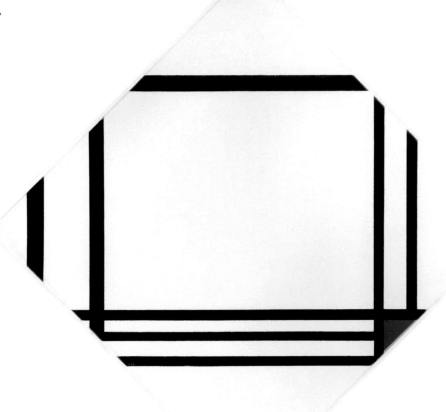

There are good historical reasons for using Stokes's writings of the 1930s in this way, despite the fact that Stokes himself stressed Nicholson's dislike of theory.[50] What matters here is the fact that their friendship became warm and close in the immediate aftermath of Nicholson's and Hepworth's joint exhibition at the Lefevre Gallery in October–November 1933, just anticipating the initial development of an interest in Mondrian on Nicholson's part;[51] that it was deepened by Stokes's probing reviews of each of their contributions to the exhibition, in which their work was in different ways seen to confirm his strongest convictions concerning the past and future of art as they were expressed in a book then very close to publication, *Stones of Rimini*;[52] that the instant mutual reciprocity of his and Nicholson's relationship was marked by his commissioning Nicholson to design the cover of *Stones of Rimini*, which appeared early in 1934 (fig. 10); that Nicholson's move in 1936–37, alongside the continued

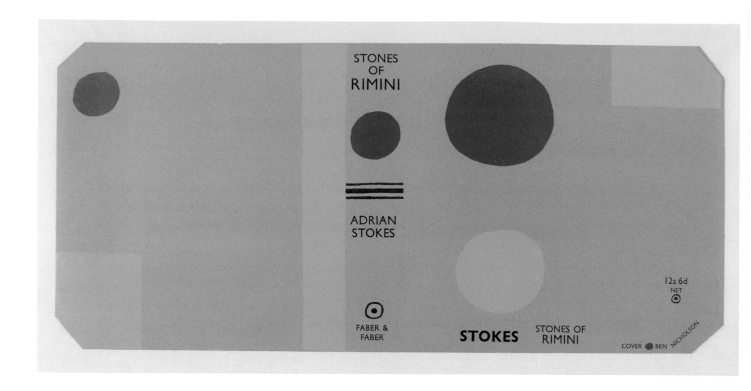

STONES
OF
RIMINI

ADRIAN
STOKES

FABER &
FABER

STOKES STONES OF
 RIMINI

12s 6d
NET

COVER ● BEN NICHOLSON

FIG. 10
Cover designed by Ben Nicholson
of Adrian Stokes, *Stones of Rimini*,
Faber & Faber, London, 1934,
Victoria and Albert Museum, London

making of white reliefs, into a stronger use of colour in paintings (see
for example cat.13–15) came as Stokes worked towards publication in
1937 of *Colour and Form*, his sequel to *Stones*, and that Stokes's review
of Nicholson's exhibition at the Lefevre that year, which included
some of the new paintings, responds to the move into stronger colour
as another confirmation of his ideas.[53]

Late in 1933, when Lázlo Moholy-Nagy sparked Nicholson's interest
in Mondrian, he was, it can seem, a very different artist from the maker of
the white reliefs who was in full flow by February 1934.[54] *1933 (six circles)*
(cat.1) is the most ambitious of his first carved reliefs, made at the very
end of the year. Its quirky poise is manifestly won by deft wit against the
resistance of uninviting materials. Wavering lines and wonky circles have
been cut impulsively into cheap board, enhanced by coarsely worked
dun brown and cream (it is very much the partner of Nicholson's cover for
Stones of Rimini). Nicholson was on the brink of something utterly new
for him, which would come straight out of the direct, physical character
of *six circles*. Mondrian, by contrast, had just made a move into a kind
of work that was a new departure for him. 1932 had seen the end of ten
years of commitment to a kind of pictorial composing which, Yve-Alain
Bois has argued, reached its apogee in a series of eight paintings
completed between 1929 and 1932; he has dubbed it the "classic" series.
One of the last of the series is *Composition with Yellow and Blue* (cat. 2).

These paintings almost exactly repeat the same linear division of the picture surface and on this virtually identical armature hang different weights and intensities of colour to bring about a tense equilibrium.

If the precariousness of the balance in Nicholson's *Six Circles* sums up his brinkmanship as an artist, Mondrian's "classic" series sums up the consistency and decisiveness of his Neo-Plastic composing between 1921 and 1932. What happened from 1932 was that Mondrian increased the precariousness of the equilibrium achieved in his work. The term "rhythm" now came to greater prominence in his writing, as the rhythms set going in his painting became more insistent, especially the pulsing of black lines across the white picture surface.[55] The little painting that Winifred Nicholson bought in 1935, *Composition with Yellow and Double Line* (cat. 4; see also fig. 43) was one of two finished in 1932 that started him moving in this direction.[56] It introduced the double line, which activated the white gaps between Mondrian's lines in an entirely new way, producing a rhythmic relationship between the beat of lines and intervals that he exploited with evident relish in such paintings as *Composition White and Red: B* of 1936 (cat. 10), *Composition No.1* of 1938–39 (cat. 16) and *Composition in White, Red and Blue,* 1936 (fig. 11). Instead of simply "equilibrium", he now favoured the term "dynamic equilibrium".[57]

Bois is right to emphasise the shift that occurred in Mondrian's work from 1932, but he is also right to assert, looking across all of Mondrian's Neo-Plastic work pre- and post-1932, that what mattered was the "implacable logic" of his entire "pictorial project".[58] That "implacable logic", however, as he also stresses, was unfolded in time; it never arrived at definitive conclusions.

The basics of Mondrian's Neo-Plastic theory of painting were repeated with only minimal variation all the way from 1917 to the end of the 1930s. The Hegelian logic of his thinking placed the emphasis not on the stability of particular forms in balanced relations but on the dynamics of movement and change; and this was so both before and after 1932. At all costs, stasis was to be avoided. Line, when single as well as double, was never to combine to define or enclose forms: geometric figures (squares or rectangles) were to be the result of linear intersections and so never to

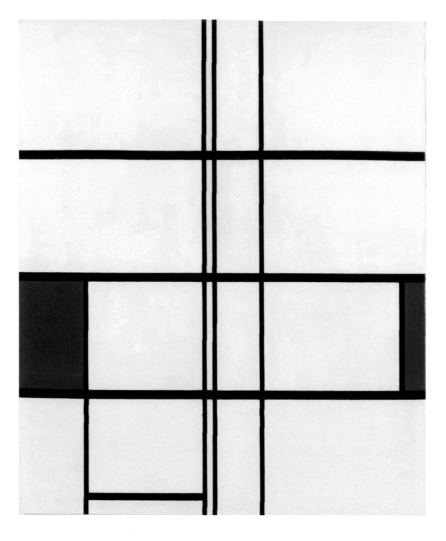

be self-contained and separate as "particular forms", and the crossing
of horizontals and verticals was to be handled in such a way as to avoid
their freezing into the fixed symbol of the cross. Colour was to be
reduced to the three primaries at their most saturated to minimize its
capacity to relate to the particular nuances of colour found in nature. By
limiting line to the vertical and horizontal, and colour to the primaries,
and by setting the stark black of his lines and the intense radiance of
his colours against non-colour (almost always white by 1932) Mondrian
turned painting into a field of force. Within that field, oppositions
worked dialectically with unmodulated power, each negating the other, at
least temporarily, until "mutual equivalence" had been reached between
their unequal elements (for example, the tiny area of red bottom right
in *Composition No.1*, 1939 (cat. 17), is judged intense enough to reach
"equivalence" with the wide expanses of white that threaten complete
domination). Universal "truth" lay, for Mondrian, not in a unity so

resolved that life (and painting) stopped, but in the *dynamic* logic
of the dialectical "law" governing the unstoppable movement of life.
Equilibrium was always precarious in a Mondrian. Every compositional
conclusion, however apparently resolved (as in the "classic" series) is
actually, as Bois puts it, on the point of being "undone".[59]

Finally, essential to the capacity of painting to give pictorial opposi-
tions maximum force was, for Mondrian, the refusal of any figure/ground
illusion of depth. The dynamism of line, colour and non-colour in
opposition was most irresistibly materialized flat on the picture surface.
One function of line, indeed, was to tie colour to the surface and so to
minimize each colour's capacity to advance or recede in relation to others.
The flatness and opacity of his white was an overriding preoccupation
for Mondrian through the 1930s. As Gabo put it, recalling the time he
took adding coat after coat of white: "He was against space".[60] He wanted
a dynamic equilibrium experienced through rhythm, the pulse of
movement experienced not in space but in time.

The most obvious difference between Nicholson's and Mondrian's
work is signalled by Nicholson's readiness to compose with "particular
forms" – circles, squares or near squares and rectangles – and to fix
attention on space as both expanse and depth – the relative depths of
his raised or cut-out or coloured "forms". This gets to the nub of Stokes's
reading of all art that most intensely moved him, and his attraction first
to Nicholson's reliefs and then to his paintings, which deploy saturated
and neutral colour. For Stokes (who makes no mention of Mondrian in
his reviews of Nicholson's exhibited work), art has the most force when
it denies "rhythm" and exploits space in three as well as two dimensions.
It stands for completeness, and its impact is instantaneous.

Stokes starts, however, by giving priority to the surface of relief or
painting as a presence that excites touch as well as the eye, and by
preferring hand-work to manufacture. In *Stones of Rimini* he holds up as
model the Quattrocento sculptor Agostino di Duccio in order to make
a fundamental distinction between what he calls "carving conception"
and "plastic" or "modelling conception." In *Colour and Form*, replacing
as model Agostino by Piero della Francesca and Cézanne, he develops the
distinction as one that applies to painting as well as relief sculpture. In

Stones the distinction is made thus: "Fine carving" is achieved when form is felt to bring the material it is carved out of to life; "plastic conception is uppermost" when the material is no more than the stuff out of which form is created.[61]

Nicholson's white reliefs are carved out of wood, which for Stokes was a technique whose quick directness invited a "plastic" approach, where form-invention takes precedence. But he also recognised that "carving" and "plastic" conception usually combined, even where one took precedence, and he treated the Nicholsons exhibited at the Lefevre in 1933 – paintings, not carved reliefs – as essentially carving. Especially in bas-relief, what counts for him in stone carving is surface, the bringing to life, as he puts it, of the stone's even luminosity by the loving attention of the carver. Nicholson, he claims, uses his grounds, often built up in plaster, as a starting point, so that "every canvas or panel" is "a different elucidation of the surface". For him, even Nicholson's collages are carved, because they fix attention on "the juxtaposition and close inter-relationship of surfaces," which is "the essence of carving".[62] Looking back at this review, Nicholson himself later acknowledged that Stokes anticipated his move into carved reliefs, the white reliefs as well as *six circles*.[63] In the white reliefs, the even coat of white still betrays the textures and grain of the wood, and surfaces slide into each other, closely interrelated, however deeply he cuts to form his geometric figures. When Stokes adapted his idea of "carving conception" to painting proper in *Colour and Form*, it was surfaces – the faces of form – that he stressed.[64] Cézanne was, for him, the crucial modern precedent, because he treated the entire expanse of the picture surface with "equal intensity"; he never allowed colour modulation to draw attention away from the surface.

Thus far, Stokes's thinking keeps Nicholson and Mondrian close: both concretise the abstract, as we have seen, by fixing attention on the picture surface. But where for Mondrian this ensures that the "universal" logic of relationships in life is transmuted into a subjective experience of forces as a succession of impacts across the canvas, by contrast, for Stokes Nicholson's, Piero's and Cézanne's insistence on surface does something very different: it gives the work objective distance from both the artist and the viewer. It gives it what he calls "resistant otherness". This is a

point he develops further in *Colour and Form* than in *Stones*. Here he makes a fundamental distinction between "surface colour", which locates surfaces in space, and "film colour" – the grey behind closed eyes or the mistiness associated with visionary experiences – in which spatial location is "indefinite." He is concerned, not with film colour, but with surface colour – colour which is both attached to the picture surface and locates forms in pictorial depth, colour whose prime characteristic is as "something 'out there', resistant to the eye".[65] His idea of successful painting-as-carving is a chromatic version of his idea of successful relief carving: it is solidified space brought onto the surface and given life by the light it seems to emit.

On two levels Stokes's idea of successful painting and relief sculpture is directly opposed to Mondrian's Neo-Plastic theory of painting. First, it identifies "rhythm" as fundamentally alien to the objectification of the work of art, because it binds the work into all that is impermanent and fragmentary about subjective experience. "Resistant otherness" is surrendered by artists who want "an emphatic movement or rhythm".[66] Secondly, Stokes directly opposes his idea of "carving" in art to the kind of dialectical logic for which Mondrian stood. He specifically disapproves of colour used to create contrasts and so to encourage a dialectical mode of composition, aiming at a "balance between hostile forces, between stresses and strains … between forces … which come together in a kind of truce because of their equal resistance to one another".[67] Mondrian may go unmentioned, but this is almost a paraphrase of his theory of Neo-Plasticism. Stokes is absolutely clear about what he is after: not work that finds balance in a succession of impacts, but work that "by means of uniform insistence and inter-relationship, provides us with a total identity, something laid out and instantaneous … something that is calm, clear and demarcated".[68]

Now, the determinedly non-theoretical Nicholson cannot be imagined thinking through his art as a deliberate emulation of Stokes's theory of "carving conception" in art, but Stokes himself certainly responded to Nicholson's reliefs and paintings as a manifestation of it. The dynamic oppositions, negations and affirmations of Mondrian's paintings are indeed experienced as successive impacts, over time. Nicholson

gives the viewer a clear and instantaneous experience of integration.

In the white reliefs, line and light are fused together so that line is rarely a rhythmic beat, but is almost always integrally related to forms and at the same time is always a marker, by weight of shadow, of depth. Again, when he moves into the use of saturated and neutral colour together in 1936–37, in works such as *1937 (painting)* (cat. 14) and *June 1937 (painting)* (fig. 12), he does not, like Mondrian, bind colour to the surface with line and use wide expanses of white to give it the energy of a pulse acting against silence, he allows colours to come forward or retreat in direct contact with each other, to construct spaces. Moreover, he does not reduce his colour to the three primaries and pitch them against each other, he uses smaller areas of saturated primaries with larger areas sometimes of white and black but mostly of neutral colours (i.e. colours muted often by the admixture of grey) to bring out the inter-relationships between them. Alongside his wish for painting that gave "equal intensity" to every part of the picture surface, Stokes developed an elaborate theory of chromatic integration by means of what he called "identity in difference".[69] Different hues in different tones and intensities (degree of saturation), he argues, can come together through the mutual interaction of neighbouring colour areas: a small area of saturated colour can produce an after-image that tinges neighbouring neutrals – white can lighten a neighbouring black, the components in mixed colours can find echoes in areas of unmixed colour. Reviewing Nicholson's 1937 exhibition, Stokes finds an "organic" oneness in his colour, picking out a particular work (no longer identifiable): "Beyond the central saturated colours with white and black, there extend greyish and brownish zones of equivocal hue. These are the earth from which the saturated colours grow. The neutralized zones, then, are no mere background: for they suggest to the fantasy an organic progression, as if they were potent to contain the seed of the saturated hues and even of the white, sum of all colour."[70]

Instantaneity and integration are the two essential qualities sought by Stokes in Nicholson's reliefs and paintings, and in all art where "carving conception" takes precedence. Expressed as a profound need, not merely a preference, this followed from his analysis at the time by Melanie Klein and his very particular Kleinian engagement with psychoanalysis.

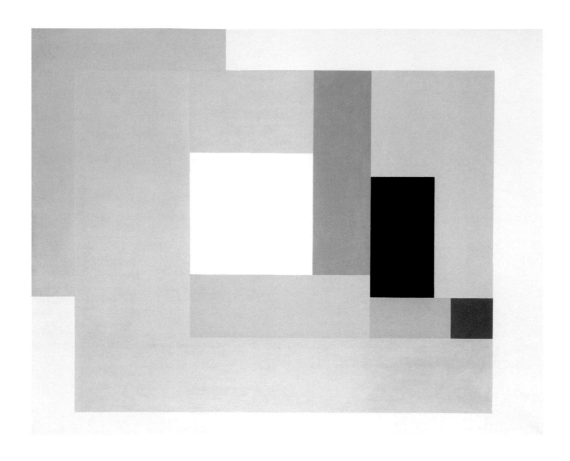

He rejected Surrealism, which he considered the pointless recording of the "raw material of the unconscious".[71] He wanted a reparative not a disruptive role for art. To experience total integration as a reality "out there" was, for him, to find deeply satisfying calm, because it was a projection of the good, whole "archetypal" figures of our "guardians" surviving from infancy and childhood in the deepest interior spaces of our psyche, those figures that made it possible to counter our (his) murderous impulses towards them.[72] Mondrian shifts colour to the very edges of his compositions to threaten disintegration while holding on (just) to "equilibrium". Nicholson's paintings of 1936–37 place saturated colour towards the centre from which the less intense or neutral colour areas can be felt to have "grown" outwards. I use the word "grown" for a reason: Stokes's metaphor for painting as already unfolded surface is the face of a rose presented to the sun.[73]

The difference between Mondrian seen in terms of the "implacable" Hegelian "logic" of his Neo-Plasticism, and Nicholson seen in terms of Stokes's Kleinian need for integrated wholes "out there" marks the distance between two dominant twentieth century engines for thought and action – dialectics and psychoanalysis.

MONDRIAN ‖ NICHOLSON
IN PARALLEL

1 Myfanwy Evans, 'Dead or alive', in *Axis: A Quarterly Review of 'Abstract' Painting and Sculpture*, London, no. 1, January 1935, p. 3.

2 Letter from Ben Nicholson to Barbara Hepworth, 29 December 1935 (Hepworth Archive). I am grateful for the invaluable help given to me by Sir Alan Bowness, who has allowed me to consult the archive.

3 Barr and his wife had visited Mondrian in Paris at the end of June 1935. The speed of reaction to Barr's book in both Paris and London shows how eagerly it was awaited (see note 5 below).

4 Barr illustrated Nicholson's *October 2 1934 (white relief – triplets)* (fig. 44) and two of Mondrian's Neo-Plastic paintings, including the first state of *Composition No. III White-Yellow* (cat. 18): Alfred H. Barr Jr., *Cubism and Abstract Art*, Museum of Modern Art, New York, 1936 (reprinted Seckler & Warburg, London, 1975), pp. 152 and 201.

5 Mondrian agreed with Nicholson about *"le livre de Mr Barr"* (he destroyed all correspondence received, so we do not have Nicholson's letter to him). He continues: *"…mais c'est difficile à constater. A Paris, le nombre d'artistes geom..abstr. – n'augmente pas, mais cela ne veut pas dire que le mouvement soit en descendance, n'est-ce pas? Moi je trouve qu'il est toujours... ascendant, étant la vraie plastique où l'art se dirige"*: Piet Mondrian to Ben Nicholson, 9 May 1936 (TGA 8717.1.2.2993).

6 Both Hans Erni and J.M. Richards paired them with very little discussion of the actual relationship in *Axis* in 1935: Hans Erni, 'The Lucerne Exhibition', *Axis*, London, no. 2, April 1935, p. 27; J.M. Richards, 'Ben Nicholson at the Lefevre', *Axis*, London, no. 4, November 1935, pp. 21–24.

7 The exhibition 'Constructive Art', was held in July 1937 at the London Gallery to accompany the publication of J.L. Martin, Ben Nicholson and N. Gabo (eds.), *Circle: International Survey of Constructive Art*, Faber & Faber, London, 1937 (reprinted 1971). Mondrian's correspondence with Nicholson in 1936–37 (Ben Nicholson Archive, Tate Archive) makes very clear how far *Circle* was thought of as a counter-blast to Surrealism and "literary" painting. 'The International Surrealist Exhibition' was held at the New Burlington Galleries in London, 12 June– 4 July 1936. The rivalry was not unfriendly; both Henry Moore and Herbert Read were good friends of Nicholson and Hepworth, and at the same time directly involved with Surrealism.

8 To track Van Doesburg's movements across Europe, see Iria Candela, 'Chronology', in Gladys Fabre and Doris Wintgens Hötte with Michael White (eds.), *Van Doesburg and the International Avant-Garde: Constructing a New World*, exh. cat., Tate, London, 2010, pp. 242–45.

9 The evidence points towards the date of Mondrian's and Nicholson's first meeting being 5 April 1934. It is true that a letter from Ben to Winifred of November 1933 mentions that, encouraged by László Moholy-Nagy's admiration of Mondrian, he already planned to see him: letter from Ben Nicholson to Winifred Nicholson, November 1933; cited in Jeremy Lewison, 'Art and Architecture', in Lewison, *Ben Nicholson*, exh. cat., Tate Gallery, London, 1993, p. 44. However, there is no evidence that they met that December, when Nicholson was in Paris. It is almost certain that their first encounter was the key visit of 5 April 1934, when Nicholson visited Mondrian at home and saw his work in its (for him) unforgettable studio setting. In his note to "cher Monsieur Nicholson" making the date, Mondrian says that he will be happy *"de faire votre connaissance"*, which suggests that no earlier meeting had taken place: letter from Piet Mondrian to Ben Nicholson, 1 April 1934 (TGA 8717.1.2.2984). Notable among Mondrian's other artist allies were Jean Gorin, Jean Hélion, César Domela and Georges Vantongerloo in Paris, the Russian brothers Naum Gabo and Antoine Pevsner in Paris and London, the Hungarian Moholy-Nagy in Paris and London, the Swiss Max Bill, and the American G.L.K. Morris in New York. The American painter Harry Holtzman, who would later be given charge of Mondrian's legacy, made his first visit to him in his Paris studio the same year as Nicholson, in 1934.

10 The nationalities represented include, besides England, in no particular order, France, Germany, The Netherlands, Russia, Hungary, Romania, Switzerland and the USA.

11 A central role in this has been played by Charles Harrison, first and most influentially in Harrison, *English Art and Modernism 1900–1939*, Allen Lane and Indiana University Press, London and Indiana, 1981. For his view of the relationship between the internationalism represented by Nicholson's white reliefs and insularity in English modernism, see also Charles Harrison, 'England's Climate', in Brian Allen (ed.), *Towards a Modern Art World*, Yale University Press, New Haven and London, 1995, pp. 207–25. For a more recent reiteration of Nicholson's international status, see Jeremy Lewison, 'Ben Nicholson – An English Modern', in Lewison (ed.), *Ben Nicholson*, exh. cat., Institut Valencià d'Art Modern, Valencià, 2002, p. 12.

12 John Summerson, *Ben Nicholson*, Penguin Books, West Drayton, 1948. Summerson and Nicholson worked in close collaboration on this monograph; Summerson was Hepworth's brother-in-law.

13 This is an argument made persuasively in Chris Stephens, 'Ben Nicholson: Modernism, Craft and the English Vernacular', in David Peters Corbett, Ysanne Holt and Fiona Russell (eds.), *Geographies of*

Englishness: Landscape and the National Past, Yale University Press, New Haven and London, 2002, pp. 225–43.

14 Letter cited in Lewison 1993, pp. 46–47. Nicholson had just sold two small white reliefs to Stokes.

15 So can the "scientific" functionalism of the English Modern Architectural Research Group (MARS) formed in 1933, whose first chair was Wells Coates, architect of the Lawn Road flats; Ben and his brother Christopher (Kit) Nicholson both exhibited with them in 1938. Kit collaborated in the design of the exhibition poster.

16 Lucy Inglis, 'Being International in Paris and London: International Style Abstraction of the 1930s', unpublished Ph.D dissertation submitted to the Courtauld Institute of Art, 2007, p. 138.

17 An important instance was the AIA-organised exhibition in December 1936, 'Artists Help Spain'.

18 Herbert Read, *Art and Society*, William Heinemann Ltd., London and Toronto, 1937. I discuss this at greater length in 'The Picassos of British Criticism, c.1910–c.1945', in *Picasso and Modern British Art*, exh. cat., Tate, London (forthcoming 2012).

19 Ben Nicholson, 'Notes on Abstract Art', *Horizon*, vol. 4, no. 22, London, October 1941; reprinted in Maurice de Suasmarez (ed.), *Ben Nicholson: A Studio International Special*, London and New York, 1969, p. 33. Sophie Matthierson situates Nicholson's abstraction of the 1930s as the partner to a liberal democratic politics of individualism: Sophie Matthierson, 'Raising the Flag of Modernism: Ben Nicholson's "1938", *Art Bulletin of Victoria*, vol. 48, 2008.

20 Letter from Piet Mondrian to Ben Nicholson and Barbara Hepworth, 17 February 1940 (TGA 8717.1.2.3013).

21 Particularly important in this regard is the text discussed below, on which he worked between 1929 and 1931–32, and to which he returned in 1938 and 1940: Piet Mondrian, 'The New Art – The New Life: The Culture of Pure Relationships' (1931), in Harry Holtzman and Martin S. James (eds. and trans.), *The New Art – The New Life: The Collected Writings of Piet Mondrian*, Thames & Hudson Ltd., London, 1987, pp. 244–76.

22 The published draft is dated 1940, before he left London; he seems to have finalised the text in December after his arrival in New York. The piece was meant for *Partisan Review*, but was not published there, because Mondrian would not cut it; it did not appear until after his death, when it was published in Piet Mondrian, *Plastic Art and Pure Plastic Art*, New York, 1945.

23 Piet Mondrian, 'Liberation from Oppression in Art and Life', in Holtzman and James 1987, p. 327.

24 "Now [with his "little book"] I succeeded better I think. I have still to copy it and send it to the Nicholsons to ask what they think of it. His wife will correct the English and perhaps they know a way to publish it". Piet Mondrian to Harry Holtzman, 6 May 1940, quoted in Holtzman and James 1987, p. 245.

25 Mondrian, 'The New Art – The New Life: The Culture of Pure Relationships' (1931), in Holtzman and James 1987, p. 259.

26 The evidence concerning the white reliefs is clear. The studio visit can be dated precisely to 5 April 1934; Mondrian wrote inviting him on 1 April (TGA 8717.1.2.2984), and on 2 February 1934 Nicholson wrote to Winifred: "… have had a most lovely painting day today. My last ptgs are completely white": cited in Lewison 1993, p. 44.

27 Herbert Read, 'Introduction', in Read, *Ben Nicholson, Paintings, Reliefs, Drawings*, vol. 1, Lund Humphries, Aldershot, Hants, 1948, p. 20. In positive response to Nicholson's exhibition of white reliefs at the Lefevre Gallery in 1935, J.M. Richards could write of the reliefs as "inspired by Mondrian": Richards 1935, p. 21.

28 Letter from Ben Nicholson to Barbara Hepworth, 9 May 1935 (Hepworth Archive). It is worth adding that Mondrian had enough faith in Nicholson's abilities to write asking him to remove any marks on his paintings caused by their transport to the 'Abstract and Concrete' exhibition of 1936, advising the use of benzene.

29 Letter from Ben Nicholson to Barbara Hepworth, 29 December 1935 (Hepworth Archive).

30 Letter from Piet Mondrian to Ben Nicholson, 6 December [1939] (TGA 8717.1.2.3012). The review, probably by Henry Mc Bride, was published in *The New York Sun*, 11 November 1939, p. 9.

31 Piet Mondrian to Carel Mondriaan, 28 October 1938 (Beinecke Rare Book and Manuscript Library, Yale University); published in translation (by Wendy Shaffer) in Els Hoek, 'Mondrian in Disneyland', in *Art in America*, New York, February 1989, p. 138.

32 In 1930, Mondrian declares that in Neo-Plasticism "there are creators and there are imitators". Only with "creators" could there be "mutual equivalence": Piet Mondrian, 'Le Cubisme et la Néo-plastique', typescript dated 25 March 1930 of a text published in shortened form as 'Réponse de Piet Mondrian' in *Cahiers d'art*, Paris, January 1931; translated in Holtzman and James 1987, p. 237.

33 Nelly van Doesburg, 'Some Memories of Mondrian', in *Piet Mondrian, 1872–1944*, exh. cat., Solomon R. Guggenheim Museum, New York, 1971, p. 67.

34 Van Doesburg 1971, pp. 67–73.

35 For Mondrian on dance and Neo-Plasticism see Piet Mondrian, 'The New Plastic in Painting', first published in *De Stijl*, 1917–19, in Holtzman and

Martin 1987, p. 43. Leslie Martin recalled Nicholson musing over a dream tennis match across generations between Lacoste and Hoad. Nicholson himself compared the forces in play in "'abstract art'" to "Arsenal v. Tottenham Hotspur": Sir Leslie Martin, 'Statement', in Sausmarez 1969, p. 27, and Nicholson 1941. My thanks to Lady Sarah Bowness for the information that Nicholson disliked dancing.

36 'The New Plastic in Painting', first published in *De Stijl*, 1917–19, in Holtzman and Martin 1987, p. 42.

37 The disagreement between Yve-Alain Bois and Carel Blotkamp concerning the importance of Mondrian's involvement with Theosophy centres on its relevance to any evaluation of his work, especially within its long Neo-Plastic phase, between 1917 and his death in 1944. I would agree with Bois that Hegel and his Dutch interpreter Bolland have more to offer in providing a theoretical starting point for an engagement with his work and its "evolution" (despite the Theosophical aura surrounding that term). It is difficult, however, to gainsay Blotkamp's point that Theosophy remained important to Mondrian where his thinking was concerned until his death. See Yve-Alain Bois, 'The Iconoclast', in Yve-Alain Bois, Joop M. Joosten, Angelica Zander Rudenstine and Hans Janssen (eds.), *Piet Mondrian, 1872–1944*, exh. cat., The National Gallery of Art, Washington, D.C., 1995; and Carel Blotkamp, *Mondrian: The Art of Destruction*, Reaktion Books, London, 1994.

38 Ben Nicholson, 'Quotations', in J.L. Martin, Ben Nicholson and N. Gabo (eds.), *Circle: International Survey of Constructive Art*, Faber & Faber, London, 1937 (reprinted 1971), p. 75.

39 Nicholson writes to Hepworth in 1935 of a visit to Mondrian where man's "capacity to deal with ill-health" came up, and reports that "when I looked as if I didn't agree he said – 'but you think on the lines of Christian Science'": letter from Ben Nicholson to Barbara Hepworth, 8 May 1935 (Hepworth Archive).

40 In 'The New Plastic in Painting', first published in *De Stijl*, 1917–19, in Holtzman and Martin, 1987, p. 43.

41 Piet Mondrian, 'Plastic Art and Pure Plastic Art (Figurative Art and Non-Figurative Art)', in Martin, Nicholson and Gabo 1937, p. 47.

42 She writes to Nicholson about this opening passage as "a sort of poem or idea": letter from Barbara Hepworth to Ben Nicholson, 23 December 1933 (postmark) (TGA 8717.1.1.169).

43 Ben Nicholson, 'Statement', in Herbert Read (ed.), *Unit One: The Modern Movement in English Architecture, Painting and Sculpture*, Cassell & Co. Ltd., London, 1934, p. 89.

44 The openness of Mondrian's working process is discussed in cat. 7.

45 In *Circle*, Mondrian identifies two "diametrically opposed human inclinations": "One aims at the direct creation of universal beauty, the other at the aesthetic expression of oneself, in other words, of that which one thinks and experiences. The first aims at representing reality objectively, the second subjectively": In Martin, Nicholson and Gabo 1937, p. 41.

46 See Yve-Alain Bois, 'The Iconoclast', in Bois, Joosten, Rudenstine and Janssen 1995.

47 Peter Khoroche, *Ben Nicholson: Drawings and Painted Reliefs*, Lund Humphries, Aldershot, Hants, 2008, p. 38.

48 'The Life and Opinions of an English "Modern" in conversation with Vera and John Russell', *The Sunday Times*, 28 April 1963; in Sausmarez 1969, p. 51.

49 One instance suffices. Mondrian writes to Winifred (15 January 1935) that he has heard from Jean Hélion that Nicholson approved of the article he was sending to Myfanwy Evans at *Axis* (which Winifred translated into English but Evans did not publish): letter from Piet Mondrian to Winifred Nicholson, 6 May 1935 (TGA 8717.1.2.2989). Writing to Hepworth that month, Nicholson indeed calls the piece "very beautiful": letter from Ben Nicholson to Barbara Hepworth, "Sunday evening", January 1935 (Hepworth Archive). Most obviously, in his role as painting editor of *Circle*, having commissioned Mondrian, Nicholson would have read Mondrian's piece for it attentively. Mondrian conscientiously sent him the two sections well in time before publication.

50 "He [Nicholson] consistently repudiated the abstractions of conceptual thinking": Adrian Stokes in Sausmarez 1969, p. 14. Nicholson, however, did confess to Norbert Lynton that he liked some of Stokes's writing "very much", even though he could only read "a little at a time": cited from a letter dated 29 April 1966, Norbert Lynton, *Ben Nicholson*, Phaidon Press Ltd., London, 1993. It is worth also noting that Stokes has been taken as one route into new readings of Hepworth's carving in the 1930s, in particular by Alex Potts and Anne Wagner. Alex Potts, 'Carving and the Engendering of Sculpture: Adrian Stokes and Barbara Hepworth', in David Thistlewood (ed.), *Barbara Hepworth Reconsidered*, Liverpool University Press and Tate Liverpool, 1996, pp. 43–52; and Anne Middleton Wagner, *Mother Stone: The Vitality of Modern British Sculpture*, Yale University Press, New Haven and London, 2005.

51 Hepworth and Nicholson had begun really to fasten their friendship with Stokes at the time of his reviews of their joint exhibition at the Lefevre Gallery in October–November 1933. Her correspondence with Nicholson in Paris between that date and mid-December 1933 is full of references to Stokes, who gave her considerable help on her *Unit One* 'Statement'; in a letter dated 6 December, she calls him "a beautiful person" (TGA 8717.1.2.148 to 161).

52 Adrian Stokes, 'Mr. Ben Nicholson's Painting' and 'Miss Hepworth's Carving', *The Spectator*, 27 October and 3 November 1933, reprinted in Lawrence Gowing (ed.), *The Critical Writing of Adrian Stokes*, vol. 1, '1930–1937', Thames & Hudson, London, 1978, pp. 307–08 and 309–10; Adrian Stokes, *Stones of Rimini*, Faber & Faber, London, 1934, reprinted in Stokes, *The Quattro Cento and Stones of Rimini*, with a foreword by Stephen Bann, Ashgate, Aldershot, Hants, 2002.

53 Adrian Stokes, 'Ben Nicholson at the Lefèvre Galleries', *The Spectator*, London, 19 March 1937, reprinted in Gowing 1978, pp. 315–16.

54 For the evidence concerning Moholy-Nagy's role and Nicholson's first meeting with Mondrian, see note 8.

55 Having brought in the rhythm of "American jazz", Mondrian writes in 1930 that when Neo Plastic work is carried to the extreme, "Then the rectangular planes (formed by the plurality of straight lines in rectangular opposition, which are necessary in order to determine color) are dissolved by their homogeneity and rhythm alone emerges, leaving the planes as nothing": Piet Mondrian, 'Le Cubisme et la Néo-Plastique', published abadged in *Cahiers d'art*, Paris, January 1930, in translation in Holtzman and James, 1987, p. 240.

56 The other is *Composition B, with Double Line and Yellow and Grey*, 1932, oil on canvas, 50 × 50 cm, B231, private collection.

57 In the text drafted between 1929 and 1932, but returned to in 1938 and then in London in 1940, Mondrian: "The equilibrium in the new art is not a static state without action, as is generally thought, but, on the contrary, a continuous opposition of unequal but equivalent elements": Mondrian (1932) in Holtzman and James 1987, p. 252.

58 Yve-Alain Bois, 'The Iconoclast', in Bois, Joosten, Rudenstine and Janssen 1995, pp. 316, 339.

59 Yve-Alain Bois, 'The Iconoclast', in Bois, Joosten, Rudenstine and Janssen 1995, p. 339.

60 Naum Gabo, statement from 'Reminiscences of Mondrian', *Studio International*, London, vol. 172, no. 884, December 1966, p. 291.

61 Stokes 1934, p. 110.

62 Adrian Stokes, 'Mr. Ben Nicholson's Painting', *The Spectator*, 27 October 1933, p. 575, reprinted in Gowing 1978, pp. 307–08.

63 Letter referred to by Lewison, Nicholson to Stokes, 12 August [1955]; Lewison 1993, p. 41.

64 "The painter of a carving proclivity is manifestly at pains to show that the forms … have each a face which he discloses": Adrian Stokes, *Colour and Form*, Faber & Faber, London, 1937, reprinted in Gowing 1978, p. 22.

65 Stokes 1937, pp. 16–17.

66 Where colour is concerned what is to be resisted is "homeless" colour which forces the eye to "grope for things," where form is "in the making," and so is grasped over time. Stokes 1937, pp. 16–17 and 20.

67 Stokes 1937, p. 28.

68 Stokes 1937, p. 34.

69 His ideas on colour are developed partly on the basis of a serious study of colour theory. He cites as fundamentally important to him David Katz, *The World of Colour*, Kegan Paul, London, 1935 (1st German edition 1911), and F.W. Eldridge-Green, *The Physiology of Vision* G. Bell & Sons, London, 1920, as well as the more practical manual of Walter Sargent, *The Enjoyment and Use of Colour*, Scribner, New York, 1923. He also references Bergson and Goethe on colour. However, his own acutely observant responses to colour directly experienced in London and in Italy play a determining part in what is as much an intensely personal account of the importance of colour to him as the presentation of a theory.

70 Adrian Stokes, 'Mr. Ben Nicholson at the Lefevre Galleries', *The Spectator*, 19 March 1937, p. 517, reprinted in Gowing 1978, p. 315. Just as Stokes's colour theory is driven by his direct experiences of colour, so direct experience was a powerful driver behind Nicholson's turn towards colour in 1936; see the entry for cat. 13.

71 Stokes 1937, pp. 13–14.

72 Stokes 1937, pp. 12 and 23. Stokes is more explicitly Kleinian in *Colour and Form* than in *Stones of Rimini*.

73 As metaphorically the face of a rose turned towards the sun, "a true painting" is "an augmentation upon the surface of wall or canvas": Stokes 1937, p. 22.

OPPOSITE
Detail of fig. 32
A view of Piet Mondrian's studio, 26 rue du Départ, Paris, 1926, showing *No. IV / Composition No.II*, 1920, B104, and *Pier and Ocean 5*, 1915, B78
Photographer: Paul Delbo
RKD The Hague
© 2012 Mondrian/Holtzman Trust c/o HCR International Washington DC

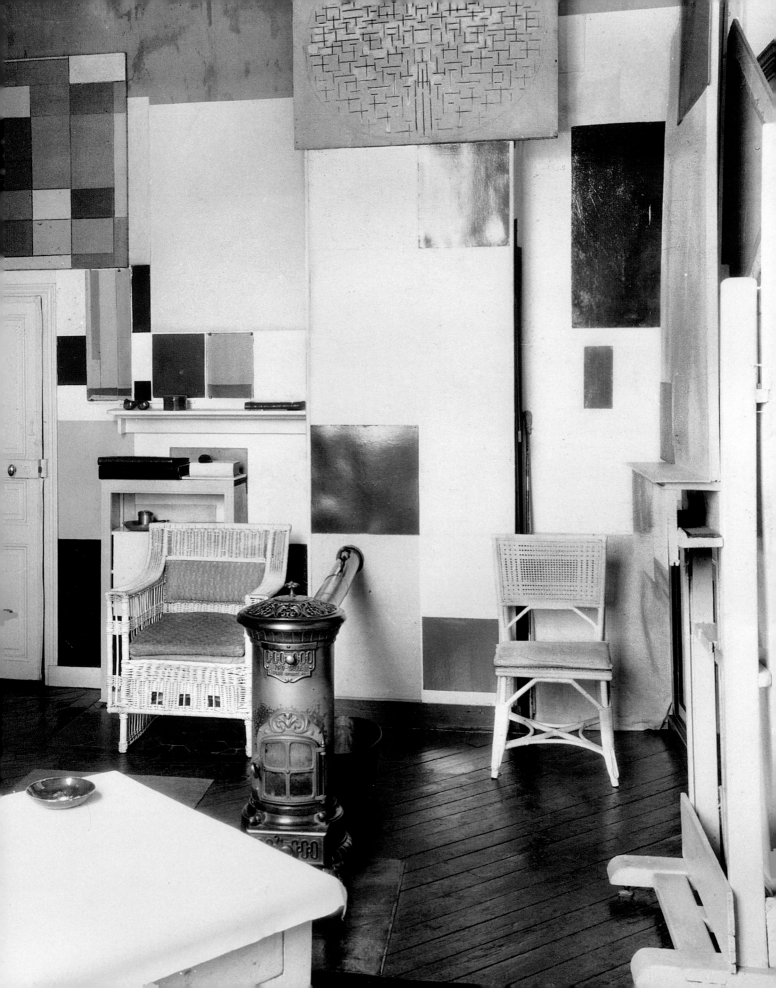

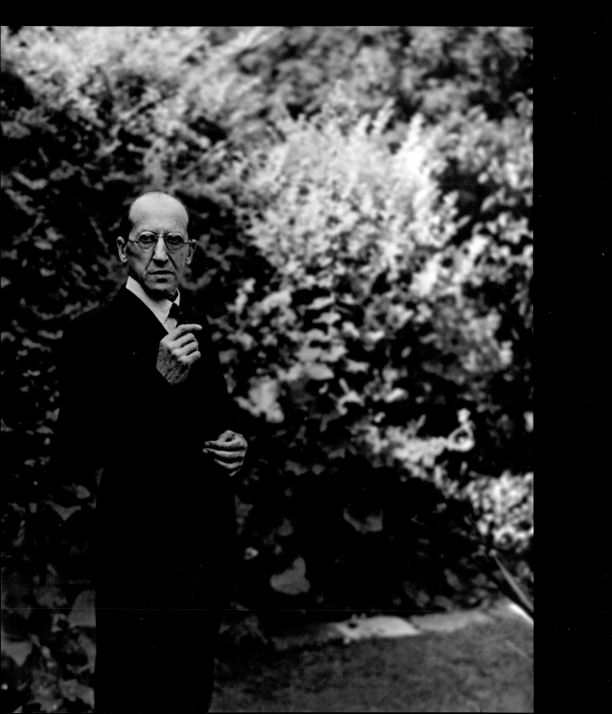

Mondrian and London

SOPHIE BOWNESS

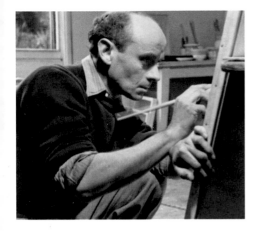

FIG. 14
Ben Nicholson in his garden studio,
60 Parkhill Road, Hampstead,
probably early 1938
Photographer: Hans Erni
Tate Archive, London

Mondrian arrived in London on 20 September 1938.[1] Ben Nicholson had urged him to leave Paris and Winifred Nicholson accompanied him on the journey. He lived there for almost exactly two years (fig. 13). In London he found other exiles from continental Europe, such as Naum Gabo; others, including Gropius, Breuer and Moholy-Nagy, had already left for the USA.[2] His closest friends in London, whom he had met while living in Paris, were Ben Nicholson and Barbara Hepworth (figs. 14 and 15). It was a friendship based on mutual understanding of one another's work, dedication to the international abstract movement, and warm personal sympathy. Mondrian immediately felt at home and he found his work greatly influenced by his new surroundings. His arrival gave impetus to the Constructivist cause. For the first year he, Nicholson and Hepworth were immediate neighbours in Hampstead; in August 1939 Nicholson and Hepworth left for St Ives and were unable to persuade Mondrian to go with them and their triplets. Mondrian stayed for a further year before departing for New York. The period has received relatively little attention in the literature on Mondrian.[3] His three and a quarter years in New York have by contrast been extensively documented and discussed.

There are over sixty surviving letters from Mondrian to Nicholson and Hepworth, covering the ten years of their friendship. These are at the heart of this essay. They reveal the closeness of their relationship and provide a strong sense of Mondrian's character and idiosyncrasies.[4] (Mondrian did not keep letters, so their side of the correspondence is, tantalisingly, missing.) All three were very good correspondents. Mondrian wrote in French, moving immediately to English as soon as he arrived in London. His most accomplished turns of phrase seem borrowed from his English friends.

Nicholson first visited Mondrian's studio at 26 rue du Départ on 5 April 1934 (see fig. 29).[5] Mondrian was only free for an hour at 4 o'clock, as he explained in his reply to Nicholson's request to visit: "Although I'm very busy with my work, I would be happy to meet you."[6] This was the first of eight documented meetings in Paris, and was an epiphany for Nicholson, as he recalled in 1944: "The paintings were entirely new to me and I did not understand them on this first visit They were merely,

PLATE XLIII

I
NE can express a thought by taking a piece of stone & shaping it, or 2 pieces of stone & shaping them for 200 years, one in relation to the other & both in relation to time in space, or one can take a piece of cardboard & cut out a circle one depth, or 2 circles 2 depths, or 600 circles 6,000 depths, or one can take a board & paint it white & then on top put a tar black & then on that a grey & then a small circle of scarlet ——then scrape off some grey leaving black, some black leaving white, some white leaving board, some board leaving whatever is behind & some of that leaving whatever is behind that——only stop when it is all the form & depth & colour that pleases you most, exactly more than anything has ever pleased you before, something that pleases you even more than please yourself then you will have a living thing as nice as a poodle with 2 shining black eyes.

II
I have been asked to answer a great many questions, I would like to quote the following from a speech made by Eddington, at Cambridge in 1931:—
"Of the intrinsic nature of matter, for instance, Science knows nothing, . . . for all we know matter may itself be mental.
"The old view therefore, that atoms or electrons are the ultimate reality, and that by interacting on one another in accordance with the laws of Nature, they produce our minds, with all their hopes and aspirations, has no longer any scientific basis. Indeed, not only the laws of Nature, but space and time, and the material universe itself, are constructions of the human mind. . . . To an altogether unexpected extent the universe we live in is the creation of our minds. The nature of it is outside Scientific investigation. If we are to know anything about that nature it must be through something like religious experience."
As I see it, painting and religious experience are the same thing, and what we are all searching for is the understanding and realisation of infinity—an idea which is complete, with no beginning, no end, and therefore giving to all things for all time. Certainly this idea is to be found in mind and equally certainly it can never be found in the human mind, for so-called human power is merely a fantastic affair which continues to destroy itself until it finally evaporates.
Painting and carving is one means of searching after this reality, and at this moment human reason has reached what is so far its most profound point. During the last epoch a vital contribution has been made by Cézanne, Picasso, Braque, Brancusi, and more recently by Arp, Miró, Calder, Hepworth, and Giacometti. These artists have the quality of true vision which makes them a part of life itself.

Mondrian
BN

Léger, Gris
BN

PORTRAIT AND HANDS
88

89

FIG. 15
Barbara Hepworth in her studio,
7 The Mall, Parkhill Road, Hampstead, 1933
Photographer: Paul Laib,
Hepworth Archive

FIG. 16
Double page from Barbara Hepworth's
copy of Herbert Read (ed.), *Unit One: The
Modern Movement in English Architecture,
Painting and Sculpture*, Cassel and Company,
London, 1934, with Ben Nicholson's later
hand-written amendments, courtesy
Bowness

for me, a part of the very lovely feeling generated by his thought in the room The feeling in his studio must have been not unlike the feeling in one of those hermits' caves where lions used to go to have thorns taken out of their paws."[7] It took him time to absorb Mondrian's work, two or three years, he wrote twenty-five years later.[8] It is significant that Mondrian was not named by Nicholson among vital recent artists in his contribution to *Unit One*, which he wrote in December 1933 – January 1934, although he was aware of Mondrian's work by then: Nicholson later added Mondrian's name in pencil on Hepworth's copy (additions here are italicised; fig. 16): "During the last epoch a vital contribution has been made by Cézanne, Picasso, Braque, *Léger, Gris*, Brancusi, and more recently by *Mondrian*, Arp, Miró, Calder, Hepworth, and Giacometti. These artists have the quality of true vision which makes them a part of life itself."[9] The key event for Nicholson was the first studio visit.

Nicholson visited Mondrian's studio for the second time in mid May 1934, when he was again in Paris. He may have been accompanied by Winifred on this occasion (Mondrian invited her to come with him). She had just met Mondrian through the painter Jean Hélion, who in turn she had been introduced to by Ben.[10] Winifred had been living for part of each year in Paris with their three children since autumn 1932. A great warmth and sympathy developed between Winifred and Mondrian (fig. 17).[11] He joked to Winifred about always being spoiled by women.[12] He felt that Winifred saw "so well the essence of things and beauty at its purest."[13] He valued her opinion on his work and writings. She brought paints from England at his request, including a large tube of a blue she

used which he found magnificent.[14] It was also Winifred who was the first English purchaser of a painting by Mondrian, buying *Composition with Yellow and Double Line* in 1935 (cat. 4). Her sister-in-law, Nan Roberts, bought a second painting by Mondrian in 1936 and both works can be seen in photographs of Winifred's house in Cumberland, Bankshead, of late 1936 (figs. 18 and 43).

Nicholson saw Mondrian on three occasions during his stay in Paris in December 1934 – January 1935. At the end of December, he visited with Winifred. Hepworth then joined him in Paris for a short visit and he took her to see Mondrian a few days' later (who must have been bewildered). This was Hepworth's first meeting with him, and her only visit to the Paris studio. She recalled that the studio "made me gasp with surprise at its beauty".[15] It was "the romance, daring & intensity of Mondrian's work"

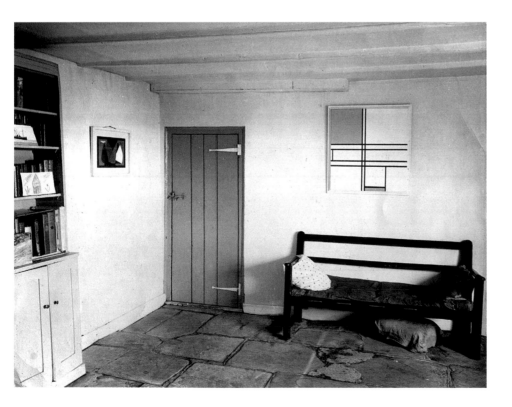

that most moved her.[16] Following this visit, Nicholson wrote to Hepworth that Mondrian had said "the v. nicest things to the Hélions about you & about your work."[17] Mondrian came to supper at Winifred's Quai d'Auteuil apartment on 18 January, seeing Ben there again. "Mondrian was delightful," he wrote to Barbara. "He is such a beautiful person".[18] At Myfanwy Evans's request, Mondrian had written an article for the review *Axis*, which Ben judged "very beautiful", and which Winifred translated for Mondrian from the French. He was very pleased with this, but Evans rejected the translation and the article was not published there.[19]

In February 1935 Hepworth and Nicholson travelled to Lucerne for the opening of the exhibition 'These – Antithese – Synthese', the first occasion on which Nicholson showed alongside Mondrian (Hepworth was not included). Shortly afterwards, Nicholson wrote to the American collector and painter A.E. Gallatin: "Mondrian's recent work is as fine as Picasso at his best! It is a unique & very remarkable achievement."[20] Hepworth recalled some years later: "I shall always remember seeing one of his [Mondrian's] paintings in a simple white room in Switzerland."[21]

Once again in Paris in May, Nicholson visited Mondrian in his studio on 8 May and wrote immediately afterwards to Hepworth: "Mondrian very charming He said nice things about your understanding of his work. He asked me for a photo of a relief to pin on his wall with the small Arps & Hélions etc he has there."[22] Nicholson asked Hepworth to send a photograph of *1935 (white relief)* (cat. 8), as well as one of her recent sculptures (probably *Two Forms*, 1935),[23] so that he could give them to Mondrian. "There is such a lovely feeling in his studio ——", he continued. Nicholson showed Mondrian photographs of Hepworth's work and he liked "the 2 egg one best",[24] and also "the gruyère cheese one",[25] as Nicholson described them.

On his next visit to the studio, at the end of December 1935, together with Winifred, Nicholson observed with surprise the hand-done character of some of Mondrian's paintings compared to his own recent work. Nicholson wrote to Hepworth that he felt his own work "seemed v. like his pt of view when I was in London but really it is very different ... particularly in colour."[26] At 2 o'clock on 21 January 1936 Nicholson visited Mondrian again (see fig. 19).[27] A few days later Nicholson wrote to Herbert

Read: "I find myself here [in Paris] most in sympathy with the ideas of Giacometti, Gabo, Mondrian", and he continued: "Mondrian is very well & in very good form – really he is a most delightful person. He has any quantity of new work – new developments"; "he is working now very much in the present <u>& in relation to the future</u> whereas Brancusi is working now in the past."[28] This was to be their last meeting for over two and a half years, until Mondrian's arrival in London: Nicholson and Hepworth never saw his final Paris studio at 278 Boulevard Raspail, to which he moved in March 1936 (see frontispiece).

In later years Nicholson was eager to express his great admiration for Mondrian's work, but he was no epigone, and he had a very clear perception of the distinctive characters of their painting. "What I value particularly in Mondrian's work is a marvellous poetic spirit," he wrote to the American artist and critic G.L.K. Morris in 1956, continuing: "Surely the movement in England was <u>not derivative</u> but <u>inspired by</u> Paris & all it stood for."[29] In 1968 Nicholson described Mondrian as "a magnificent painter" who had "opened up endless possibilities" and to whom he would like to be the first to acknowledge his debt. And yet, "Mondrian's & my development is astonishingly different".[30] Writing in 1948, Nicholson felt Mondrian's work had been at its peak in around 1936 and he was dismissive of *Broadway Boogie Woogie* (which he had then only seen in reproduction): "I think the USA did something pretty curious to his work".[31] His view was that it "needed another 3 or 4 years to become convincing."[32]

"I'm happy that you like my things. It was a pleasure to see yours", Mondrian wrote to Nicholson in February 1935.[33] Mondrian showed great interest in the work of his English friends. Nicholson and he regularly

exchanged photographs of new work. In May that year he commented on the photographs Ben had recently sent of his and Barbara's work: "I find the work of both of you very beautiful." However, he was very direct in offering advice on a Nicholson relief: "... isn't there a danger with the relief: I think the circle should go a little behind."[34] In September 1940 he again suggested a different placing of a circle in a relief: "I do like your photo of relief only I should like the big round a little otherwise placed: it goes to the left".[35] In May 1936 Mondrian agreed with Nicholson that Hepworth's work had developed further and judged *"cette découpure des sphères"* a very good idea (perhaps a reference to *Two Segments and Sphere*, 1935–36, and related works).[36] On Winifred's recent paintings, he wrote to Ben that he found them "very pure and true".[37] When he arrived in London, Ben showed him his latest work, which Mondrian told Winifred he liked very much.[38] "I liked your latest projects I saw when you were here", he wrote to Barbara in March 1940.[39] In his final letter, of April 1943, Mondrian felt Ben's newest work was even better than the work in the last photograph he had sent.

Mondrian also lent his support to getting his friends' work exhibited. For example he suggested to Willem Sandberg of the Stedelijk Museum in Amsterdam that Hepworth should be included in 'Tentoonstelling Abstracte Kunst' held there in April 1938. Her *Pierced Hemisphere II*, 1937–38, was shown as a result.[40] Just before leaving London in 1940, Mondrian wrote to Nicholson and Hepworth: "Of course I shall support your exhibition idea in New York: I suggested it already my self to Stephenson."[41] This was a reference to the idea of an exhibition of English abstract artists at Gallatin's Museum of Living Art (John Cecil Stephenson was their painter friend and neighbour in the Mall Studios). Mondrian discussed this with Gallatin in New York, but the war prevented it from taking place.[42] The support was reciprocal: Nicholson was constantly trying to place Mondrian's paintings in exhibitions and to introduce friends who were potential buyers, aware of Mondrian's precarious financial situation. In March 1937 he suggested a one-man exhibition for Mondrian at the London Gallery: Mondrian accepted, but requested that it should take place in the winter, or the following year, because he was already committed to a show in New York (the London exhibition never

took place). Nicholson took work on consignment from Mondrian in Paris to try to sell for his friend. Mondrian responded to such an offer in June 1938: "Thank you very much for your friendship and appreciation of my work."[43] He was very grateful for Nicholson's efforts on behalf of the movement, as he was for the sales Nicholson brought about. For example, when Nicholson's friend the advertising executive Marcus Brumwell bought *Composition with Lines and Colour: III*, 1937,[44] through Nicholson, Mondrian was full of gratitude: "…this sale helps me to continue my work; last season was very bad; in America too I didn't sell anything."[45] Mondrian was very generous in offering reduced rates to friends or sympathisers, adjusting these according to what people could afford; he preferred to sell to someone he liked who would really appreciate a painting than to receive more for it from another buyer (his prices were already modest). He offered a very generous discount, for example, to Leslie Martin on the painting *Composition (A) in Red and White*, 1936 (fig. 47), on the recommendation of Nicholson, who commented to Martin that it was "rather sweet of him [Mondrian] as he always has v. few ptgs & I know will not reduce his price at all for ordinary chaps."[46]

The majority of Mondrian's English collectors, who are strongly represented in this exhibition, were introduced by Nicholson, with Winifred also playing a key role. Following Winifred's purchase of cat. 4 in 1935, her sister-in-law Nan Roberts bought a painting in 1936 (B 256). In the same year, Nicholson's long-term supporter Helen Sutherland bought *Composition B/ (No. II) with Red*, 1935 (cat. 6) from the seminal exhibition 'Abstract and Concrete', organised by the young art historian Nicolete Gray (figs. 20 and 45). This was the first exhibition devoted to abstract art in England, and the first time Mondrian's work had been seen in this country. It was also the first occasion on which Hepworth had shown alongside both Mondrian and Nicholson. The exhibition opened on 15 February 1936 at 41 St Giles, Oxford (two weeks before the opening of 'Cubism and Abstract Art' at The Museum of Modern Art, New York), and travelled to the School of Architecture, Liverpool (March), to London's Lefevre Gallery (April), and finally to Cambridge (28 May–13 June). Mondrian was very happy to be able to show his works in England.[47]

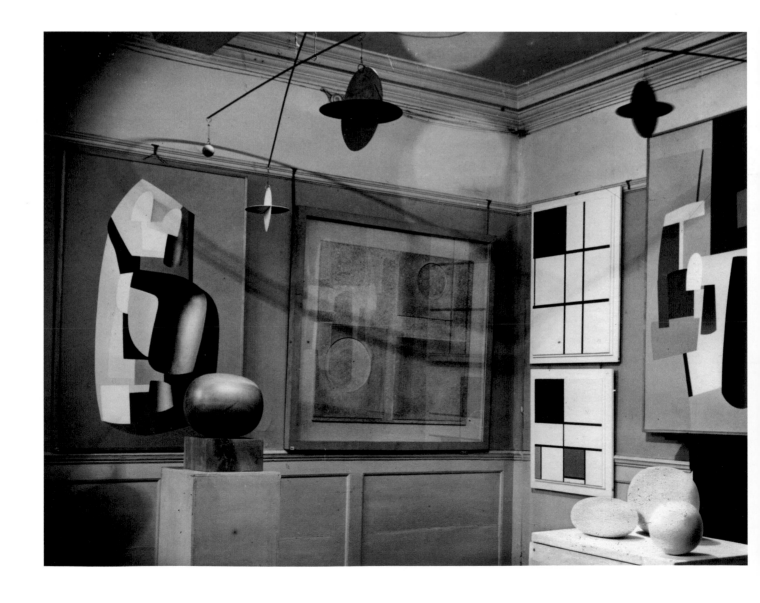

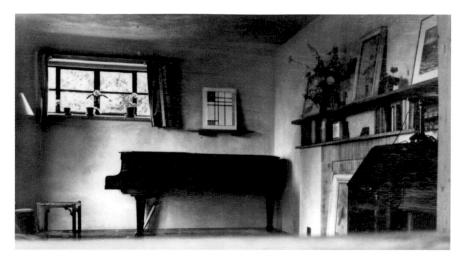

FIG. 21
A view of Vera Moore's Sussex
cottage showing her Piet Mondrian,
Composition with Blue and Yellow, 1937,
B270, hanging above her piano,
probably autumn 1938, Tate Archive,
London
© 2012 Mondrian/Holtzman Trust
c/o HCR International Washington DC

Nicolete Gray, who had been introduced to Mondrian by Nicholson, bought another work included in 'Abstract and Concrete' (cat. 7). Leslie and Sadie Martin also made their purchase in 1936: this painting had first been consigned to Ben and shown in a second exhibition held in London in April 1936, 'Modern Pictures for Modern Rooms', at Duncan Miller Ltd. (fig. 38). Winifred introduced the New Zealand-born pianist Vera Moore to Mondrian and she bought *Composition with Blue and Yellow*, 1937, in Paris in 1938 (fig. 21).[48] Also in this year, before Mondrian left Paris, Brumwell purchased his painting. Ever generous, in London Mondrian gave Hepworth and Nicholson the painting he had consigned to Nicholson in 1938, *Composition in Red, Blue and White: II*, 1937 (cat. 12). On Herbert Read's advice, Peggy Guggenheim bought *Composition with Red*, 1939 (cat. 16), in winter 1939–40. Lastly, Robert Ody, a friend living in 3 Mall Studios, bought a London painting, *Composition No. 2*, 1938, in early 1940.[49] The latter two works were among the few Mondrian painted entirely in London. Otherwise a painting – or an essay – begun in Paris might be taken up again in London and further revised in New York (see for example cat. 18).

Ironically these purchases were largely made before Mondrian arrived in London. He was selling to the USA, Britain and Switzerland, very little to France. As Mondrian wrote to Nicholson when he was about to leave Paris, he would not be losing any selling opportunities, and perhaps he would gain some, by moving to London. By his own estimation, England and the USA had become the most important markets for his work.[50] The worsening international situation and then the outbreak of war meant that Mondrian made very few sales in England during his stay. "1938 to 1939 were the years of attrition. It became harder and harder to sell any work", Hepworth recalled.[51] Mondrian wrote to his friend the Swiss architect Alfred Roth on 30 January 1939: "Sales are the same here as everywhere else – But there is understanding."[52] He told the French

Neo-Plastic painter Jean Gorin in May 1939 that he had not yet sold anything in England: "I can live, but that's all!"[53]

Mondrian had an exacting, uncompromising streak, which emerges in his letters to Nicholson. It came from his absolute commitment to the movement. He could be very exercised over inclusions – or exclusions – in exhibitions and publications, and he was rigorous over the translation of his writings and over terminology. He checked Winifred's English translation of his article for *Axis* "down to an infinitesimal meaning of words!", Nicholson wrote to Hepworth in January 1935.[54] Nicholson recalled in a letter to John Summerson that Mondrian was "incredibly difficult" about terminology, always wanting 'neo-plastician' "(horrible term!)", but he eventually agreed to exhibit in a "Constructivist" exhibition in London.[55] In the catalogues of two exhibitions held in London in 1939 (discussed further below), Mondrian was described as 'Constructivist' – 'Living Art in England', organised by E.L.T. Mesens in January–February, and 'Abstract and Concrete Art' held at the Guggenheim Jeune Gallery in May, and in which he showed alongside Gabo, Hepworth, Arthur Jackson, Alastair Morton, Nicholson, John Cecil Stephenson, as well as Arp, Calder, Van Doesburg, Hartung, Hélion, Kandinsky, Taeuber-Arp, Vantongerloo and others.[56]

Nicholson invited Mondrian to write for *Circle: International Survey of Constructive Art* in 1936. The economist Eric Roll translated the essay, with help from Leslie Martin on the ideas expressed.[57] This was the first significant publication of Mondrian's writing in English. He was very happy with the translation, while adding (over-modestly): "... my English is very poor."[58] His friendship with Nicholson deepened – and was tested – over preparations for *Circle*, the key document of Constructivism in England, and the associated exhibition 'Constructive Art'. Mondrian expressed astonishment when he heard from Antoine Pevsner that Nicholson had asked Miró for photographs of his work to reproduce in *Circle*. Mondrian judged this inappropriate in what he understood was to be a review of purely abstract art (he rated Miró *"un véritable artiste"* though was himself against all the "sentimental tendencies" that were to be found in Miró's work). At the same time, Mondrian added that he was just a collaborator and that it was for Nicholson and the other editors to

decide: "I can accept anything". [59] (Miró was not included.) By way of explanation for his passionately expressed views, he wrote a few days later: "I'm so interested in your endeavour that I had to write what I thought to you."[60] (He also told Nicholson he did not really understand the title 'Circle'.)[61] Nicholson's response to his criticism cleared the air, because on 24 November Mondrian wrote: "It's good to work with you: you are so precise. (I find that precision is one of the most important things for anybody.)"[62] When it was published he wrote to say he found Circle *"très beau",* even though, as Nicholson knew, he was not entirely in agreement with the selection of artists for the book: "I'm very happy that my article will be read".[63]

An exhibition, 'Constructive Art', was held in July 1937 at the London Gallery to accompany the publication of *Circle*. In March 1937 Mondrian commended Nicholson for organising it and proposed two works for inclusion, while expressing the hope that it would be as purely abstract as possible. In April, however, he took Nicholson to task over the selection of artists for the exhibition: he felt it must include Arp, Taeuber-Arp, Gorin and Vantongerloo and he was adamant that he would not show otherwise. They were not, and he did not.[64] He regretted this difference of opinion very much, as he told Winifred, and was pleased when Ben told him of the exhibition's success.[65]

We "agreed to disagree" was also Gabo's recollection of discussions with Mondrian.[66] In character, his letters show him to have been generous, dignified, courteous, sensitive, considerate, solicitous, forbearing, direct. He was invariably happy when a colleague sold a work, and hopeful of sales for them. He was always appreciative when given assistance. Mondrian's dry sense of humour also comes through. "I thought there was only water at St Ives!" he wrote on hearing that Hepworth and Nicholson had found a house (Dunluce in Carbis Bay) with working conditions.[67]

Fearing that war was imminent, Mondrian wrote to Nicholson on 7 September 1938 seeking his advice. He wanted to try to go to New York, but was also thinking about coming to London first for a time: "Moholy would like to have me at the Bauhaus in Chicago, but he wrote to me saying that at the moment it's not open."[68] He continued: "Mon cher, I am very sad that I have to break off my work here, brutally forced by

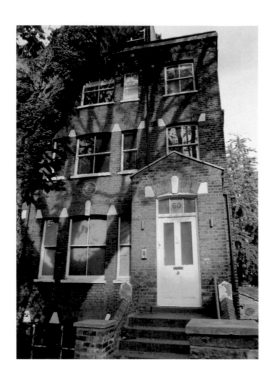

FIG. 22
60 Parkhill Road from the
front, showing the blue plaque
dedicated to Piet Mondrian,
photograph 2011
Photographer: the author

FIG. 23
60 Parkhill Road from the rear,
showing Ben Nicholson's
garden studio directly below
the windows of Piet Mondrian's
room, photograph 1966, Tate
Archive, London

necessity. I had just found the solution to two paintings of a metre
square and to three others." He asked Nicholson how much a room in
London would cost to rent, in which he could cook (a studio, he felt,
would be too expensive).

Nicholson replied with alacrity, sending a letter of invitation, reassuring
Mondrian about the cost of a room and offering to lend him a bed. He
told Nan Roberts that he had written to Mondrian to say that "Gabo
& I will give him all possible help & that he'll get a v. good welcome".[69]
Greatly encouraged, Mondrian's reply of 11 September is full of his
preparations for departure and enquiries about the cost of an easel,
mattress, bed covers and casseroles. He felt he must leave Paris and
was glad to do so: "…one no longer breathes easily here", the atmosphere
having become psychologically so tense as to be unbearable.[70] "Thank
you for your great friendship", he wrote to Nicholson on 15 September.[71]

Mondrian arrived on 20 September, two weeks after first seeking
Nicholson's advice on coming, crossing in fine weather from Calais to
Dover with Winifred.[72] He stayed for the first few days at the Ormonde
Hotel at 12 Belsize Grove, which had been recommended by Gabo.
Winifred's brother Wilfred Roberts, who was Liberal MP for North
Cumberland, helped to obtain a permit for him.[73] Mondrian had written
to his friends Harry Holtzman, Frederick Kiesler and Jean Xceron in
the United States at the same time, but their replies arrived too late:
Mondrian was already in London.

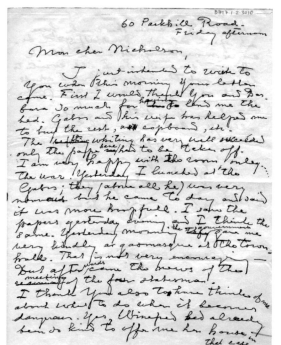
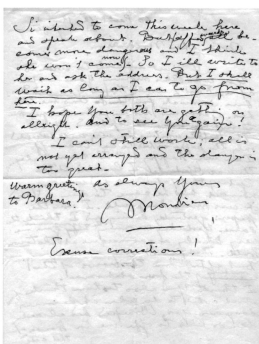

Nicholson found him a room at 60 Parkhill Road, Belsize Park, in very close proximity to himself and Hepworth (fig. 22). Nicholson's studio was immediately below Mondrian's windows, in the garden of Mondrian's house (fig. 23), and Nicholson and Hepworth lived just beyond in the Mall Studios. His "best friends" (as he called them in a letter to his brother) lent him a bed. Gabo, whom Mondrian had known in Paris and who had been based in England since 1936, and his wife Miriam helped him to buy a cupboard and other furniture.[74] "The landlord has had my room cleaned by Snow White and the squirrel has whitewashed the walls with its tail", he wrote to his brother Carel on 2 October.[75] To Nicholson he reported that "the whiting has very well succeeded" and he declared himself very happy with the room (fig. 24).[76] "Yesterday morning the gouvernment gave me very kindly a gasmasque at the town-hall. That is not very encouraging", he wrote on 30 September, just before news came of the Munich Agreement. (Nicholson and his family were staying with his sister Nancy outside Oxford during the Munich crisis, from 15 September until the beginning of October.) Winifred had offered him her house in Cumberland at this anxious time, but Mondrian was reluctant to leave London.[77]

The Parkhill Road studio is a light, high-ceilinged room with two large sash windows reaching to the floor and giving onto the garden. "My room measures 7 by 4½ by 3¼ metres and has the advantage over my studio in Paris that the windows are on the long side so that I have more space to

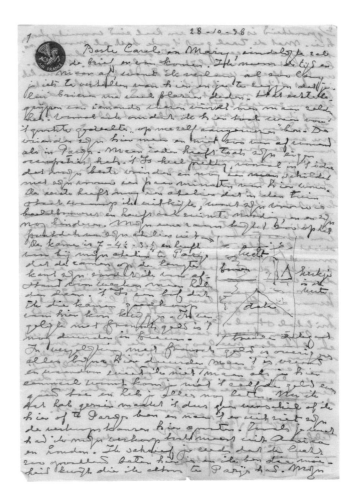
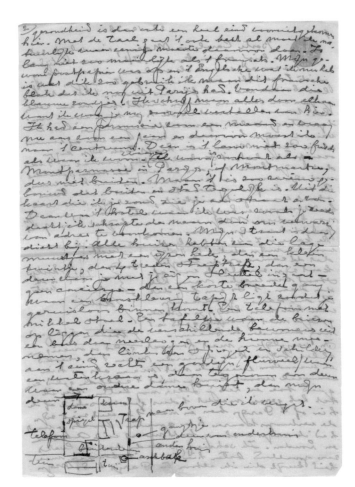

work with", Mondrian told his brother (fig. 25).[78] Here Mondrian quickly
recreated his Paris environment: "Very soon the same intensity and clarity
of whiteness glowed in his new surroundings", Hepworth recalled.[79]
(No photographs of the studio are known.) Nicholson remembered how
Mondrian transformed the room "with orange boxes and the simplest,
cheapest kitchen furniture bought in Camden Town and then painted an
immaculate, glowing white. No one could make a white more white than
Mondrian."[80] To Dutch friends the Hoyacks he wrote in April 1939: "My
room is now white, as always: I mean its contents, such as cupboard,
seats etc. I had the walls whitewashed when I moved in. White with the
odd patch of red. It suits me very well here".[81] Trees in the garden were
the victims of his famous antipathy towards nature: "Too many trees",
he would complain, with more than a hint of self-parody (he wrote with
sensitivity of the changing colours of leaves there during his first autumn
in a letter to Carel, for example).[82] On one occasion he came to tea in
the Mall and scandalised the four-year-old Hepworth-Nicholson triplets

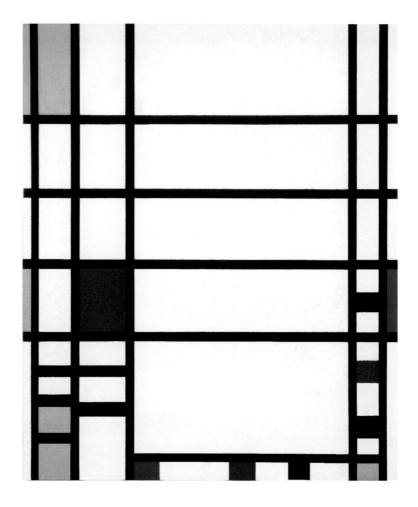

by licking his jam off the end of his knife with complete equanimity. "Mondrian seemed to love this family life", Hepworth remembered.[83]

Mondrian always declared his liking for London. He repeatedly told Winifred he was glad he had come: "The air also is good for my health, but above all the spiritual surrounding is here better than in Paris to me."[84] "There is more space here!" he added on 10 October.[85] "Where I live," he wrote to Carel at the end of October, "the buildings are so spaciously placed, that it combines countryside and city." "I like it very much indeed here", he continued: his friends "carried me to a very good spot ... the most important thing is that I can get going better with my work here. I see that my work is greatly influenced by these different surroundings."[86] He had just begun a large painting, working on a table-top set on trestles lent by Nicholson.[87] This was to be the painting *Trafalgar Square* (fig. 26), which Mondrian completed in New York in 1943 and titled in homage to London. "The work is getting on well", he reported to Winifred on 20 December. To his friend Jean Gorin he wrote

in January 1939: "I've noticed that the change has had a good influence on my work The artistic situation doesn't differ greatly here from that in Paris. But one is even more 'free' – London is big. Paris more intimate."[88] Sentences from Herbert Read's introduction to the catalogue of the 1939 exhibition 'Living Art in England' seem particularly apt: "In so far as such artists [exiles] come to London hoping to find better material conditions, they are deceived. [...] But if they feel, however obscurely, that they will find a better atmosphere for work, a greater potentiality for a renaissance of some kind, then I think they may be right."[89]

Mondrian showed in two exhibitions in London during his years there. At the 'Living Art in England' exhibition organised by E.L.T. Mesens at the London Gallery (where the 'Constructive Art' exhibition he had refused to participate in had taken place in 1937), he showed alongside Gabo, Hepworth, Jackson, Morton, Nicholson and Stephenson, as well as Moore, Nash, Piper, Surrealists and others (18 January – 11 February 1939).[90] In May he showed in the 'Abstract and Concrete Art' exhibition, referred to above, at Peggy Guggenheim's Guggenheim Jeune Gallery, also in Cork Street. He was impressed that there was a critical response, "which was never the case in Paris."[91]

In postcards and a letter to his brother Carel, Mondrian describes his life in terms of *Snow White and the Seven Dwarfs*, a favourite film that he had seen in Paris on its release in 1938, casting himself as 'Sleepy' and his friends as the woodland creatures who had rescued him (see, for example, figs. 27 and 28).[92] He had a passion for Disney and went to see *Pinocchio* as soon as it was released in London in March 1940.[93] He also went to the cinema with Nicholson, Hepworth, Gabo and Pevsner (who was visiting his brother from Paris) in October 1938.[94] He sent postcards to Carel of historic London sites – the Jewel Tower in the Tower of London, the Chapel of St Michael and St George at St Paul's Cathedral, the Peers' Lobby at the Houses of Parliament and the Royal Exchange and Bank of England (though he makes no reference to having visited them) – as well as of local streetscapes. He found the steep escalators on the deeper stations of the London Underground frightening at first. Nelly van Doesburg visited him in London in November 1938 and recalled that he had adopted English habits with the same dedication he had shown to

SNOW WHITE TELLS THE DWARFS
A FAIRY STORY.

FIGS. 27 and 28
Two *Snow White and the Seven Dwarfs*
postcards from Piet Mondrian to
Carel Mondriaan, 10 October 1938
and 18 November 1938, Beinecke
Rare Book and Manuscript Library,
Yale University.

French ones.[95] He asked Peggy Guggenheim to recommend a night-club:
"…he was a very fine dancer", she remembered.[96] He read *The Evening
Standard* and may have looked to it for a model when he wanted to
make his own writing "in news-paper style, very simple".[97] "The Facts.
Art Killed", for example, was a punchy sub-heading in his May 1940 manu-
script 'Art shows the Evil of Nazi and Soviet Oppressive Tendencies'.[98]

Hepworth, Nicholson and their family left for Cornwall shortly before
the outbreak of war. "The last person we saw was Piet Mondrian in the
street", Hepworth recalled. "We begged him to come too, or to follow us",
so that they could look after him, but he would not.[99] "We did our best
to get him out – & he has places to go to – but perhaps he is happier in his
Studio", she observed perceptively on 14 September to their mutual friend
the painter Stephenson, who lived at no. 6 Mall Studios.[100] They were
soon joined by the Gabos, but Mondrian felt that moving was impossible
for him, as he lacked the money to keep his room in London and rent one
in St Ives, adding: "I know by experience how much time garden-culture
takes ….I don't speak of that that the country upsets me."[101] He would
only move to the country "in utmost emergency", he told Nicholson on
1 October. America was too difficult and too expensive.[102]

It took Mondrian two weeks to black-out his windows at Parkhill Road cheaply and in a way that allowed him to see his work during the daytime. Hepworth gave him the use of the trench she had had dug in the garden of no. 3 Mall Studios for use during air raids ("if Mondrian can be induced" to use it, she wrote to Stephenson). She was anxious about his health and financial situation and feared he must be very lonely. Herbert Read visited Mondrian on 31 October 1939 and reported back to Hepworth and Nicholson: "He seemed very happy (he had already got Mrs G's cheque) [a reference to the purchase by Peggy Guggenheim of *Composition with Red* (cat. 16)] but he hasn't done any work since the beginning of the war. But he promised to finish Mrs G's painting, so that it can if necessary be taken to a place of safety".[103]

Mondrian remained stoical and expressed his absolute dedication to his work in letters to Hepworth and Nicholson: "In this inperfect world we – inperfect too – must find our life by work, and we have a great privilege that our work is a nice and good work."[104] To Nicholson on 6 December he wrote: "…as long as we can continue our work we have, for us, no complaints, isn't?"[105] On Christmas Eve he wrote to Winifred: "I am still always glad having come here. And having remained. My work goes better than ever. In spite of all."

In February 1940 Mondrian wrote to his friends in St Ives that "mostly I am trying to get the old pictures better", but that he had started a new, small composition and an article, 'Art shows the Evil of Totalitarian Tendences', which absorbed him greatly over the next few months.[106] He wanted Nicholson and Hepworth to read it when it was ready and hoped Hepworth would correct his English. He observed that writing was "refreshing for my painting".[107] "Most of my paintings are nearly finished but not technically yet", he wrote to Winifred in March.[108] In May he was working constantly but not too much, and had made several new compositions.[109] The German occupation of Holland shocked him greatly: "I did my painting inspite of the events", he told Winifred on 11 June, and he hoped to be able to stay in London. However, after the fall of Paris he did no more painting. "I am very pessimist", he wrote to Hepworth on 4 July: "I often think of you and Nicholson." Despite his depression, he told Winifred on the same day: "I did not lose my confidence in Human's future and Progress."[110]

The surrender of France convinced Mondrian he must leave London. With Harry Holtzman's help, he began to try to get to America (New York had always been his ultimate destination). His neighbour Robert Ody, a solicitor, assisted him with his papers.[111] He had his Dutch passport stamped with permission to leave England on 26 June. There followed a long wait. Mondrian's American visa arrived in August. He sent his paintings on ahead to New York, but he was still waiting for a berth on a boat when the indiscriminate aerial bombing of London began on 7 September. Less than two days later, on the night of 8–9 September, his windows were blown in when Hampstead was first hit: "…(fortunately I had my blackout but shutters were blown half open all the same!) by a bomb a little farther in Parkhill rd. I was on bed but had only dust in a eye. Lucky! Then there is still quite near a time-bomb."[112] He moved to the Ormonde Hotel on 12 September, where there was a good shelter in the basement, and spent the nights there, dressed, in an armchair. He stayed at the hotel for two weeks until a boat was available from Liverpool. He sailed on 23 September, almost exactly two years to the day after he had arrived. "I believe in our end-victory!" he repeatedly declared.[113] Mondrian was greatly shaken by his experience of the first weeks of the Blitz, but he did at least escape the bombing in October of the two houses next door to his, numbers 56 and 58 on the corner of Tasker Road.[114] Hepworth wrote to G.L.K. Morris in New York: "He left just in time to escape a 'stick of bombs'."[115]

"I do like New-York but in London I was of course more at home. I always believe in the victory of Britain", Mondrian wrote soon after arriving in New York on 3 October.[116] He "had learned to love London very much", in his two years there, "but for Art it was impossible to go on any longer so I followed the way that was open to New-York."[117] He thanked Hepworth and Nicholson for advising him to leave France: "I also felt an inner pressure then to leave Paris, just as I felt it now to leave London. But I am sure Britain will win in the end."[118] The last words he wrote to his "Dear friends" were: "I feel always grateful to you for your help in coming to London."[119]

1 Mondrian's passport was stamped at Calais and Dover on 20 September (Beinecke Rare Book and Manuscript Library, Yale University); see note 72 below.

2 Gropius was in England from 1934–37, Breuer and Moholy-Nagy from 1935–37.

3 See especially the reminiscences of Ben Nicholson, Winifred Nicholson, Barbara Hepworth, Naum Gabo, Miriam Gabo and Herbert Read in 'Mondrian in London', introduced by Charles Harrison, *Studio International*, London, vol. 172, no. 884, December 1966, pp. 285–92; see also my article, with transcriptions of Mondrian's letters from London, 'Mondrian in London: Letters to Ben Nicholson and Barbara Hepworth', *The Burlington Magazine*, London, vol. 132, no. 1052, November 1990, pp. 782–88. Els Hoek published an important London letter written to his brother Carel (see fig. 25 and note 78 below) in 'Mondrian in Disneyland', *Art in America*, New York, vol. 77, no. 2, February 1989, pp. 136–43, 181. Simon Grant has recently written on Mondrian in London: see 'Hello from "Sleepy"', in *Tate etc*, London, no. 20, Autumn 2010, pp. 112–15 (see also guardian.co.uk, 25 June 2010). I would particularly like to thank my father, Alan Bowness, for his help.

4 The majority are in the Ben Nicholson Archive in Tate Archive (TGA), and eight are in the Hepworth Archive there (addressed to Hepworth or to both of them). Others have come to light since 2006 and are in the Felicitas Vogler Archive, Scottish National Gallery of Modern Art Archive (SNGMA; nine letters of 1936–37), and another eight, from 1936–37, were sold at auction by Galerie Kornfeld & Cie, Bern, from Vogler's estate on 17 June 2010, lot 524; one further letter of 6 January 1937 is in Leslie Martin's professional archive at the RIBA (*Circle* papers). Mondrian's words have been left as written. Quotations from his letters have been translated into English, with the French original given in the notes.

5 There appears to be no contemporary evidence that Nicholson and Mondrian met in late 1933, as has been suggested and as Nicholson had intended; if they did, it was a perfunctory meeting. See Christopher Green's essay in this publication, p. 36, note 9. Nicholson wrote to Winifred in November 1933 that Moholy-Nagy had highly recommended Mondrian's work: "I could not tell this from 'Abstraction-Création' could you?" (letter of "Sat. night", quoted by Jeremy Lewison in Lewison (ed.), *Ben Nicholson*, exh. cat., Tate Gallery, London, 1993, p. 44). This is a reference to the Paris-based group of international abstract artists that Nicholson and Hepworth had joined in April 1933 and of which Mondrian was a founder member. The work of all three artists was reproduced in the second and third numbers of the review *Abstraction-Création: Art Non Figuratif*, published in 1933 and 1934 respectively.

6 "Bienque je suis très occupé des différentes oeuvres, je serai heureux de faire votre connaissance." Letter from Piet Mondrian to Ben Nicholson, 1 April 1934 (TGA 8717.1.2.2984). Nicholson also wrote to Hepworth: "I shall be interested to meet him." Letter from Ben Nicholson to Barbara Hepworth, 3 April [1934] (Hepworth Archive).

7 John Summerson, *Ben Nicholson*, Penguin, West Drayton, Middlesex, 1948, pp. 12–13, based on Nicholson's letter to Summerson, 3 January [1944] (TGA 20048.1.38).

8 Letter to Nicolete Gray, "Jan. 9" [1962] (Gray Archive; on loan to Tate Archive). To Summerson he said that he "only partially understood them [Mondrian's paintings] on my second visit a year later": letter from Ben Nicholson to John Summerson, 3 January [1944] (TGA 20048.1.38). His second visit was in fact the following month.

9 Ben Nicholson in Herbert Read (ed.), *Unit One: The Modern Movement in English Architecture, Painting and Sculpture*, Cassel and Co. Ltd., London, 1934, p. 89.

10 See letter from Piet Mondrian to Ben Nicholson, 13 May 1934 (postmark) (TGA 8717.1.2.2985).

11 Mondrian's letters to Winifred, over fifty in number, are in the Rijksbureau voor Kunsthistorische Documentatie (RKD), The Hague.

12 Piet Mondrian to Winifred Nicholson, 12 April [1935] (RKD).

13 Winifred saw "*si bien l'essentiel des choses et la beauté pure.*": letter from Piet Mondrian to Winifred Nicholson, 8 July 1935 (RKD); reproduced in facsimile in Andrew Nicholson (ed.), *Unknown Colour: Paintings, Letters, Writings by Winifred Nicholson*, Faber & Faber, London, 1987, p. 112.

14 Letter from Piet Mondrian to Winifred Nicholson, 5 November 1936 (RKD). He also asked her to find a red and a yellow for him.

15 Barbara Hepworth, '1934–1939' section in Herbert Read (ed.), *Barbara Hepworth: Carvings and Drawings*, Lund Humphries, London, 1952.

16 Letter from Barbara Hepworth to Herbert Read, 8 December [1940] (Herbert Read Archive, McPherson Library, University of Victoria, British Columbia).

17 Letter from Ben Nicholson to Barbara Hepworth, "Sunday evening" [13 January 1935] (Hepworth Archive).

18 Letter from Ben Nicholson to Barbara Hepworth, "Sunday" [20 January 1935] (Hepworth Archive).

19 Piet Mondrian, 'La vraie valeur des oppositions dans la vie et dans l'art'. 'The True Value of Oppositions in Life and Art', in Harry Holtzman and Martin S. James (eds. and trans.), *The New Art – The New Life: The Collected Writings of Piet Mondrian*, Thames & Hudson

Ltd., London, 1987, pp. 283–85. Winifred's translation is in the RKD, The Hague. *"Vous savez que j'étais si content de votre traduction de mon article pour Axis et j'étais bien étonné que l'on avait des remarques là dessus"*: letter from Piet Mondrian to Winifred Nicholson, 8 July 1935 (RKD).

20 Letter from Ben Nicholson to A.E. Gallatin, 10 April 1935 (Gallatin papers, Archives of American Art, Smithsonian Institution, Washington D.C.). Writing to John Summerson just after Mondrian's death, Nicholson used similar words: "I think he made a unique & rather magnificent contribution", and concluded that, after Picasso, Mondrian was "the most vital painter of his generation .../perhaps in the end nearly as far reaching as Picasso": letter from Ben Nicholson to John Summerson, 8 February [1944] (TGA 20048.1.50).

21 Letter from Barbara Hepworth to Herbert Read, 8 December [1940] (Herbert Read Archive, McPherson Library, University of Victoria, British Columbia). This was either at the Lucerne Kunstmuseum or, more probably, at the home of Jan Tschichold in Basel, which they visited on their way back to London (see entry for cat. 2).

22 Letter from Ben Nicholson to Barbara Hepworth, "Wed." [8 May 1935] (Hepworth Archive). Mondrian was ill for several months before this, so Ben and Barbara did not visit him in April.

23 *Two Forms,* 1935, Serravezza marble, 22.8 × 40.6 cm, BH 68, private collection.

24 Probably *Two Forms*, 1935 (see note 23, above).

25 *Two Forms,* 1934–35, white alabaster, 14.5 × 29.2 × 15.2 cm, BH 65, private collection.

26 Letter from Ben Nicholson to Barbara Hepworth, "Sun. 29" [29 December 1935] (Hepworth Archive). Twenty-five years later he remarked to Nicolete Gray: "This hand quality in Mondrian's ptgs is a vital factor [& one still not generally realised] –" letter from Ben Nicholson to Nicolete Gray, "Jan. 9" [1962] (Gray Archive: on loan to Tate Archive).

27 Ben Nicholson's engagement diary for 1936 (Hepworth Archive). Hepworth had joined him in Paris for a few days in mid January, but had returned to London by 21 January.

28 Letter from Ben Nicholson to Herbert Read, 24 January [1936] (TGA 8717.1.3.30).

29 Letter from Ben Nicholson to G.L.K. Morris, 25 August 1956 (Morris Archive, Archives of American Art). Nicholson underlined 'inspired by' three times.

30 Letter from Ben Nicholson to Charles Harrison, 29–30 December [1968] (TGA 839.2.19.46).

31 Letter from Ben Nicholson to G.L.K. Morris, 23 October 1948 (Morris Archive, Archives of American Art). The work in question is *Broadway*

Boogie Woogie, 1942–43, oil on canvas, 127 × 127 cm, B323, The Museum of Modern Art, New York.

32 Letter from Ben Nicholson to Nicolete Gray, "Jan. 9" [1962] (Gray Archive; on loan to Tate Archive).

33 *Je suis content que vous aimer mes choses. Moi j'ai vu avec plaisir les vôtres"*: letter from Piet Mondrian to Ben Nicholson, 17 February [1935] (TGA 8717.1.2.2986).

34 *"Je trouve tous les deux oeuvres très belles. Quant à la votre, n'y-a-t'il pas un danger avec le relief: il me semble que le cercle va un peu en arrière"*: letter from Piet Mondrian to Ben Nicholson and Barbara Hepworth, 6 May [1935] (TGA 8717.1.2.2989).

35 Letter from Piet Mondrian to Ben Nicholson and Barbara Hepworth, 13 September 1940 (TGA 965).

36 *Two Segments and Sphere*, 1935–36, white marble, 29 × 36 × 37.5 cm, BH 79, private collection: letter from Piet Mondrian to Ben Nicholson, 4 May [1936] (TGA 8717.1.2.2992).

37 *"très pures et vraies"*: letter from Piet Mondrian to Ben Nicholson, 20 July 1936 (Vogler Archive, SNGMA Archive GMA A 96.1.4.3). Mondrian uses the same words in a letter to Winifred, describing her naturalistic painting as *"très pure et vraie"*: letter from Piet Mondrian to Winifred Nicholson, 17 June 1936 (RKD).

38 Letter from Piet Mondrian to Winifred Nicholson, 10 October 1938 (RKD).

39 Letter from Piet Mondrian to Barbara Hepworth, 26 March 1940 (TGA 965).

40 *Pierced Hemisphere II*, 1937–38, 43.5 × 38 × 38 cm with base, BH 101, Tate, London; letter of 11 November 1937 (TGA 8717.1.2.2999).

41 Letter from Piet Mondrian to Barbara Hepworth and Ben Nicholson, 13 September 1940 (TGA 965).

42 Letter from Piet Mondrian to Barbara Hepworth and Ben Nicholson, 4 January 1941 (TGA 8717.1.2.3016).

43 *"Merci bien de votre amitié et appréciation de mon oeuvre."*: letter from Piet Mondrian to Ben Nicholson, 14 June 1938 (TGA 8717.1.2.3006).

44 *Composition with Lines and Colour: III*, 1937, oil on canvas, 80 × 77 cm, B277, The Hague, Gementemuseum.

45 *"...cette vente m'aide à continuer mon travail; la saison passée a été très mauvaise; aussi en Amérique je n'ai rien vendu."*: letter from Piet Mondrian to Ben Nicholson, 12 June 1938 (TGA 8717.1.2.3005). On 21 April Mondrian had written to Nicholson that he had not sold anything for a long time (TGA 8717.1.2.3001).

46 Letter from Ben Nicholson to Leslie Martin, "Sunday" [November 1936] (Martin (*Circle*) Archive, RIBA).

47 Letter from Piet Mondrian to Winifred Nicholson, 4 December [1935] (RKD). Ben told Winifred that he thought Mondrian's paintings were the finest work in the exhibition, followed by the Giacomettis:

letter from Ben Nicholson to Winifred Nicholson, 24 February 1936 (Winifred Nicholson Archive). Mondrian entrusted Ben with cleaning any marks on his paintings; this was reciprocated when in New York Mondrian cleaned Peggy Guggenheim's Nicholson relief.

48 *Composition with Blue and Yellow*, 1937, oil on canvas, 44 × 32 cm, B270 (with Davlyn Gallery New York, 1971).

49 *Composition No. 2*, 1938, oil on canvas, 44.6 × 38.2 cm, B284, Los Angeles Museum of Contemporary Art.

50 Letter from Piet Mondrian to Ben Nicholson and Barbara Hepworth, "Dimanche Soir" [11 September 1938] (TGA 8717.1.2.3008); and letter to his brother Carel, 28 October 1938 (Beinecke Rare Book and Manuscript Library); translated in Hoek 1989, p. 138.

51 Barbara Hepworth, *Barbara Hepworth: A Pictorial Autobiography*, Adams and Dart, Bath, 1970 (extended edition, 1978; since reprinted by Tate Gallery Publications, London), p. 41.

52 *"La vente est comme partout – Mais il y a de la compréhension"*: letter from Piet Mondrian to Albert Roth, 30 January 1939; in *Piet Mondrian/Alfred Roth: Correspondance*, Serge Lemoine (preface), Arnauld Pierre (notes), Gallimard, Paris, 1994, p. 113.

53 *"Je peux vivre, mais c'est tout!"*: letter of 15 May 1939, in 'Lettres à Jean Gorin: Vantongerloo, Torrès-Garcia, Mondrian, Hélion, Bill, etc.', edited by Yve-Alain Bois, *Macula*, no. 2, Paris, 1977, p. 134.

54 Letter from Ben Nicholson to Barbara Hepworth, "Sunday" [20 January 1935] (Hepworth Archive).

55 Letter from Ben Nicholson to John Summerson, 6 May [1944] (TGA 20048.1.60).

56 Catalogues published in *The London Bulletin*, The London Gallery, London, nos. 8–9, January–February 1939, and no. 14, May 1939. See Gabo's version of this story in *Studio International* 1966, p. 292.

57 Information from Leslie and Sadie Martin, March 1989. Roll (1907–2005, Lord Roll of Ipsden) was at that time Professor of Economics at University College Hull, where Martin was head of the School of Architecture.

58 *"mon anglais est très pauvre"*: letter from Piet Mondrian to Sadie Martin, 22 November 1936 (Martin (*Circle*) archive, RIBA).

59 *"Je peux tout accepter"*: letter from Piet Mondrian to Ben Nicholson, 5 October [1936] (TGA 8717.1.2.2995). Nicholson had already written to Leslie Martin on 2 October with reference to reproductions for *Circle*: "...the Mirós so far unearthed are impossible." (Martin (*Circle*) archive, RIBA). Mondrian's tolerance is shown, for example, in his reaction to Alfred H. Barr Jr's mistaken claim in *Cubism and Abstract Art* that Van Doesburg had influenced Mondrian, joking to Nicholson that *"Mad.[ame] van Doesburg a beaucoup*

causé avec Mr. Barr! Cela ne fait rien": letter from Piet Mondrian to Ben Nicholson, 9 May [1936] (TGA 8717.1.2.2993).

60 *"…je m'intéresse tellement à votre effort que j'ai dû vous écrire ce que je pense"*: letter from Piet Mondrian to Ben Nicholson, 8 October [1936] (Vogler Archive, SNGMA Archive GMA A 96.1.4.3).

61 Piet Mondrian to Ben Nicholson, undated letter, part only [October/November 1936] (Vogler Archive, SNGMA Archive GMA A 96.1.4.3).

62 *"Il est agréable de travailler avec vous: vous êtes tellement exact. (Je trouve que l'exactitude est une des premières choses pour l'homme.)"*: letter from Piet Mondrian to Ben Nicholson, 24 November 1936 (sold at auction, Galerie Kornfeld & Cie, Bern, 17 June 2010).

63 *"Je suis très heureux que mon article sera lu"*: Letter from Piet Mondrian to Ben Nicholson, 15 July 1937 (sold at auction, Galerie Kornfeld & Cie, Bern, 17 June 2010). He told his brother Carel it was an excellent book: letter from Piet Mondrian to Carel Mondriaan, 30 July 1937, cited in Joop M. Joosten, *Catalogue Raisonné of the Work of 1911–1944,* vol. II of Joosten and Robert P. Welsh, *Piet Mondrian: Catalogue Raisonné,* Harry N. Abrams Inc., New York, 1998, p. 168.

64 Letters from Piet Mondrian to Ben Nicholson, 8 March 1937 (TGA 8717.1.2.2998) and 12 April 1937 (TGA 8135.11). The artists shown were Calder, Dacre [Winifred Nicholson], Gabo, Hélion, Hepworth, Holding, Jackson, Moholy-Nagy, Moore, Nicholson, Piper and Stephenson. Nicholson's preliminary list of artists (sent to Leslie Martin in January) had also included Domela, Pevsner and Giacometti, as well as Mondrian: letter from Ben Nicholson to Leslie Martin, 27 January [1937] (Martin (*Circle*) Archive, RIBA).

65 Letters from Piet Mondrian to Winifred Nicholson, "Lundi soir" [April 1937] (RKD) and to Ben Nicholson, 15 July 1937 (sold at auction, Galerie Kornfeld & Cie, Bern, 17 June 2010).

66 'Memories of Mondrian', undated manuscript [*c.* 1966] (Gabo Archive, TGA 9313.2.3.14).

67 Letter from Piet Mondrian to Ben Nicholson and Barbara Hepworth, 17 February 1940 (TGA 8717.1.2.3013).

68 *"Moholy aimera bien m'avoir au Bauhaus à Chicago, mais pour le moment cela ne va pas encore, il m'a écrit." "Mon cher, je suis tellement attristé que je dois interrompre ainsi, brutalement forcé par la nécessité, mon travail. J'avais just trouvé la solution de deux tableaux d'un mètre carré et trois autres."*: letter from Piet Mondrian to Ben Nicholson, 7 September 1938 (TGA 8717.1.2.3007). Moholy's backers had gone bankrupt and the New Bauhaus had been forced to close in the summer; he re-opened his School of Design the following year.

69 Letter from Ben Nicholson to Nan Roberts, 9 September 1938 (Winifred Nicholson Archive). Ben here summarised what he had written in response to Mondrian's letter of 7 September.

70 *"…on ne respire plus ici"*: letter from Piet Mondrian to Ben Nicholson and Barbara Hepworth, "Dimanche Soir" [11 September 1938] (TGA 8717.1.2.3008). I am grateful to Yve-Alain Bois for clarifying Mondrian's meaning. To Gabo he wrote: *"Je ne sais pas ce qui me pousse intérieurement de quitter Paris et la Hollande … je ne peux y vivre!"*: letter of 11 September 1938 (Gabo Archive, TGA 9313.1.2.33).

71 *"Merci pour votre grande amitié"*: letter from Piet Mondrian to Ben Nicholson, 15 September 1938 (TGA 8717.1.2.3009).

72 Winifred gave the date of arrival in London as 21 September (in *Studio International* 1966, p. 287), but Mondrian's passport stamps clearly show that he made the crossing on 20 September. He told his brother Carel that they had left Paris Gare du Nord at about 12 o'clock and reached London by 7 o'clock (Hoek 1989, p. 141).

73 Information from Jake Nicholson, September 1989.

74 The Gabos, who had recently returned from a long trip to the US, were living in Cholmley Gardens, West Hampstead.

75 Postcard from Piet Mondrian to Carel Mondriaan, 2 October 1938 (postmark) (Beinecke Rare Book and Manuscript Library); see Hoek 1989, p. 138 (translation from Dutch kindly provided by Simon Grant).

76 Letter from Piet Mondrian to Ben Nicholson, "Friday afternoon" [30 September 1938] (TGA 8717.1.2.3010).

77 Her house was Bankshead, on Hadrian's Wall near Brampton. Her family's house nearby, Boothby, was another possibility – "he oughtn't to be in London": letter from Ben Nicholson to Leslie Martin, 28 September [1938] (Martin Archive, SNGMA Archive GMA A 70.3.4.6).

78 Letter from Piet Mondrian to Carel Mondriaan, 28 October 1938 (Beinecke Rare Book and Manuscript Library); see Hoek 1989, p. 138. In this letter he sketched the layout of the entrance hall and the view from his room.

79 Barbara Hepworth, '1934–1939' section in Read 1952.

80 *Studio International* 1966, p. 289.

81 Letter from Piet Mondrian to Ella and Louk Hoyack, 4 April 1939 (postmark), quoted in *Mondrian: From Figuration to Abstraction*, exh. cat., Seibu Museum of Art, Tokyo, and touring, 1987, p. 225.

82 Gabo's recollections, *Studio International* 1966, p. 292; letter from Piet Mondrian to Carel Mondriaan, 28 October 1938 (Beinecke Rare Book and Manuscript Library); translated in Hoek 1989, p. 138. See also the interview with him in *The New Yorker*, 1 March 1941, p. 10. Stories abound of Mondrian's distaste for nature.

83 Nicholson's reminiscences in *Studio International* 1966, p. 290 and Hepworth's *ibid.*, p. 288. The triplets, with a nurse and cook, lived at 3 Mall Studios, where Herbert and Ludo Read had lived between 1933 and late 1937.

84 Letter from Piet Mondrian to Winifred Nicholson, "Tuesday evening" [27 September 1938] (RKD).

85 Letter from Piet Mondrian to Winifred Nicholson, 10 October 1938 (RKD).

86 Letter from Piet Mondrian to Carel Mondriaan, 28 October 1938 (Beinecke Rare Book and Manuscript Library); translated in Hoek 1989, pp. 138 and 141.

87 See note 86 above; and letter from Piet Mondrian to Ben Nicholson and Barbara Hepworth, 19 December [1942] (TGA 8717.1.2.3017). He had had to leave an easel on board the ship coming over, but was happy working on the trestle table. When he wanted to look at a painting, he would stand it on a stool and lean it against the wall.

88 "…je peux remarquer une bonne influence du changement sur mon travail.…La situation artistique ici ne diffère pas beaucoup de celle de Paris. Mais on est encore plus 'libre' – London est grand. Paris plus intime.": letter from Piet Mondrian to Jean Gorin, 26 January 1939, reproduced in Bois 1977, p. 133.

89 Catalogue published in *The London Bulletin*, The London Gallery, London, nos. 8–9, January–February 1939.

90 He was pleased with the hang, he told Carel: postcard from Piet Mondrian to Carel Mondriaan, 25 January 1939 (postmark) (Beinecke Rare Book and Manuscript Library).

91 "ce qu'à Paris jamais n'était le cas.": letter from Piet Mondrian to Albert Roth, 30 January 1939; in Lemoine and Pierre 1994, p. 113.

92 See Hoek 1989. He also had a record of the soundtrack.

93 Letter from Piet Mondrian to Barbara Hepworth, 26 March 1940 (TGA 965). *Pinocchio* opened in multiplane technicolor at the New Gallery Picture Theatre, Regent Street, on 18 March 1940.

94 Letter from Ben Nicholson to Leslie Martin, 27 October [1938] (Martin (*Circle*) Archive, RIBA).

95 Nelly van Doesburg, 'Some Memories of Mondrian', in *Piet Mondrian: Centennial Exhibition*, exh. cat., The Solomon R. Guggenheim Museum, New York, 1971, p. 70. There is a parallel in the way in which he had immediately begun writing his letters in English when he arrived in London.

96 Peggy Guggenheim, *Confessions of an Art Addict*, André Deutsch, London, 1960, p. 56.

97 Letter from Piet Mondrian to Barbara Hepworth, 26 March 1940 (TGA 965).

98 Holtzman and James 1987, pp. 320–22.

99 *Studio International* 1966, p. 289.

100 Letter from Barbara Hepworth to John Cecil Stephenson, 14 September 1939 (TGA 200324.3).

101 Letter from Piet Mondrian to Barbara Hepworth, 24 September 1939 (TGA 965). This refers to the market garden started at Adrian Stokes's house, Little Park Owles, where Hepworth and Nicholson were staying, as a contribution to the 'Dig for Victory' campaign. On visits home, Mondrian's father had customarily put him to work in the family garden. See also p. 54 and note 82 above on Mondrian and nature. He had once visited Cornwall, probably in the summer of 1900.

102 Mondrian wrote to Vera Moore in August to ask if he could stay with her in Sussex, but she had just left for France. Herbert Read offered to put him up (see Nicholson, *Studio International* 1966, pp. 289–90; he says that this was in Hertfordshire, but must have meant Buckinghamshire, where Read lived at Seer Green near Beaconsfield). Read had visited Mondrian's Paris studio in 1935, writing to Nicholson: "…his paintings are as good as you made them out to be: a perfect thing, perhaps a chord rather than a melody.": postcard of "Raphael looking rather like Mondrian", 16 June 1935 (postmark) (TGA 8717.1.2.3649).

103 Letter from Piet Mondrian to Barbara Hepworth and Ben Nicholson, 2 November 1939 (Hepworth Archive). Mondrian was "fairly satisfied with the picture" by 12 November, when he wrote to Hepworth. He was "finishing the others that you saw" then, too. On Christmas Eve, he told Winifred he had "worked and changed on it until now and got it at last, I think, good." The picture in question is cat. 16.

104 Letter from Piet Mondrian to Barbara Hepworth, 12 November 1939 (TGA 965).

105 Letter from Piet Mondrian to Ben Nicholson, 6 December 1939 (TGA 8717.1.2.3012).

106 Letter from Piet Mondrian to Barbara Hepworth and Ben Nicholson, 17 February 1940 (TGA 8717.1.2.3013). On the history of this essay, see Christopher Green's essay in this publication, pp. 20–21; also see Bowness 1990, p. 786, footnote 4 to letter of 17 February 1940.

107 Letter from Piet Mondrian to Barbara Hepworth, 14 April 1940 (TGA 965). In May–June, however, G.L.K. Morris expressed an interest in it for *Partisan Review* and there was no time to send it to Cornwall. Robert Ody, a friend to whom Hepworth and Nicholson had sub-let no. 3 Mall Studios, corrected his English. Henry and Irina Moore took over no. 7 Mall Studios and invited Mondrian to supper one evening, but were interrupted by an air raid.

108 Letter from Piet Mondrian to Winifred Nicholson, 29 March 1940 (RKD).

109 Letter from Piet Mondrian to Barbara Hepworth and Ben Nicholson, 16 May [1940] (TGA 8717.1.2.3014).

110 Letter from Piet Mondrian to Winifred Nicholson, 4 July 1940 (RKD).

111 Mondrian was a witness at Ody's marriage at Hampstead Town Hall Register Office on 3 July.

112 Letter from Piet Mondrian to Barbara Hepworth and Ben Nicholson, 13 September 1940 (TGA 965). The high explosive bomb fell on the other side of the road and several houses along from 60 Parkhill Road. Several other bombs fell nearby. See *Hampstead News*, 12 September 1940, and *Hampstead at War: Hampstead 1939–1945*, Hampstead Borough Council, undated [c. 1946], pp. 7–9, which mistakenly says that no. 38 was hit. During the first month of the Blitz, 49 people were killed in Hampstead.

113 Letter from Piet Mondrian to Barbara Hepworth and Ben Nicholson, 13 September 1940 (TGA 965). He used the same expression to Winifred on the same day. See also his letters to them, both of 21 October [1940] (TGA 8717.1.2.3015 and RKD).

114 Probably on 17 October; evidence from rate books and casualty returns in the Hampstead Civil Defence Department collection (Camden Local Studies and Archives Centre). See also Ann Saunders (ed.), Robin Woolven (introduction), *The London County Council Bomb Damage Maps 1939–1945*, London, 2005.

115 Letter from Barbara Hepworth to G.L.K. Morris, 18 November 1940 (G.L.K. Morris Archive).

116 Letter from Piet Mondrian to John Cecil Stephenson, undated (TGA 200324.13).

117 Letter from Piet Mondrian to Winifred Nicholson, 4 January 1941 (RKD), and letter to Barbara Hepworth and Ben Nicholson, 21 October [1940] (TGA 8717.1.2.3015).

118 Letter from Piet Mondrian to Barbara Hepworth and Ben Nicholson, 21 October [1940] (TGA 8717.1.2.3015). He expressed the same sentiments in his letter to Winifred of the same day.

119 Letter from Piet Mondrian to Barbara Hepworth and Ben Nicholson, 23 April 1943 (TGA 8717.1.2.3018). At his funeral service on 3 February 1944, G.L.K. Morris reported to Ben and Barbara that "many remarked how sorry they were you could not have been there": postcard dated 3 February (TGA 8717.1.2.3045).

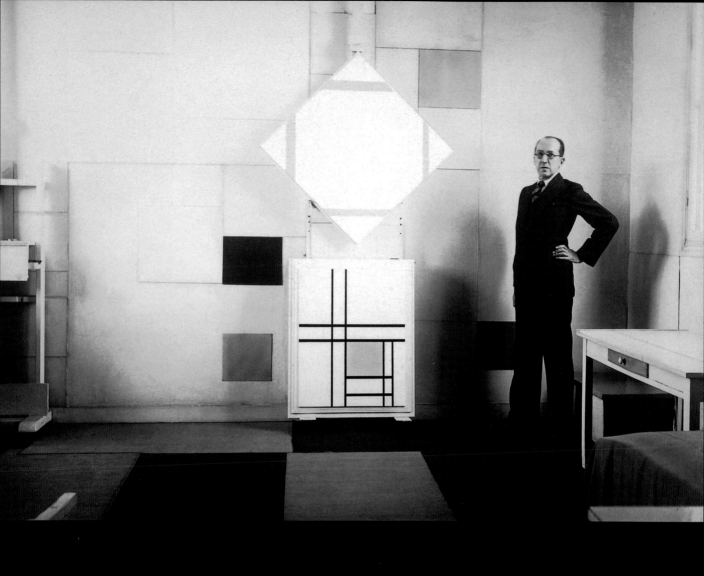

FIG. 29
Piet Mondrian in his studio,
26 rue du Départ, Paris, 1933, with
*Lozenge Composition with Four Yellow
Lines*, 1933, B241, and *Composition with
Double Lines and Yellow*, 1934, B242
Photographer: Charles Karsten
RKD The Hague

LEE BEARD

Ben Nicholson and Piet Mondrian: Art, the Studio and the Modern Interior

"I could not be bothered to read Mondrian's theories. What I got from him – and it was a great deal – I got *direct* from the experience of his paintings. The impact was very powerful, but writers on art cannot understand that you can have a vital life without being able to read or write."
BEN NICHOLSON, 1963[1]

Nicholson could of course both read and write. He also understood that by claiming such indifference to the theories of Mondrian he was open to accusations of insincerity. Nonetheless, whilst he certainly had been acquainted with some of the Dutch artist's published views during the 1930s (Mondrian's essay 'Plastic Art and Non-Plastic Art' included in *Circle: International Survey of Constructive Art*,[2] of which Nicholson was joint editor, being an obvious candidate) Nicholson's retrospective distancing of himself from Mondrian's literary output should not be considered deceptive.

What Nicholson initially 'got' from Mondrian's paintings was very much dependent on his *direct* experience of them, and this was an experience which importantly took place on a number of occasions in the artist's studio. In this essay it is the relevance of the studio context for Nicholson's initial understanding and appreciation of Mondrian's paintings that I wish to consider. Framed by wider contemporary debates on the interconnectivity between art, architecture and design, by 1934 Nicholson's own paintings and reliefs were regularly located and discussed in relation to modern interior spaces. Whilst for some this was a means by which to dismiss his recent abstract work as merely 'decorative', for Nicholson it was a relationship that could enhance the vitality of his work, enabling the painting or relief to become part of a lived experience.

As he set out in his rather short published statement in *Circle*, Nicholson felt that before a work of art could "take its place in the structure of the world, in everyday life", it was essential for it to first become an "actual experience" in the life of the artist.[3] The principal site for this experience was more often than not the artist's studio and, as Nicholson had realised in early April 1934, for Mondrian this was most definitely the case. Mondrian's studio was located in the Montparnasse district of Paris at 26 rue du Départ (fig. 29). Writing in a letter to John Summerson many years later Nicholson recalled the impact of visiting this extraordinary environment for the first time.

"His Studio … was an astonishing room: very high & narrow L shaped (or rather ⌐ shaped) with a thin partition between it & a dancing school & with a window on the 3rd floor looking down onto thousands of railway

lines emerging from & converging into the Gare Montparnasse. He'd lived there for 25 years & during that time had not been outside Paris & he'd stuck up on the walls different sized squares painted with primary red, blue & yellow – & white & pale grey – they'd been built up during those 25 years. The paintings were entirely new to me & I did not understand them at the first visit (& indeed only partially understood them on my second visit a year later). They were merely, for me, a part of the very lovely feeling generated in the room. I remember after this first visit sitting at a café table on the edge of a pavement almost touching all the traffic going in & out of the Gare Montparnasse, & sitting there for a very long time with an astonishing feeling of quiet & repose (!) – the thing I remembered most was the feeling of the light in his room & the pauses & silences during & after he'd been talking. The feeling in his studio must have been very like the feeling in one of those hermits' caves where lions used to go to have thorns taken out of their paws".[4]

Nicholson's portrayal of Mondrian's studio as a site of sanctuary and aesthetic contemplation within the bustling metropolis is in keeping with the accounts of others who visited the atelier during the same period. For Michel Seuphor the experience of entering the studio was like stepping into another world. Approached through a small courtyard off the rue du Départ, access to the studio was via a communal stairwell that led up to the third floor and to Mondrian's door. As Seuphor recalled, when "you entered, it was still dark, but when you went through that second door, when *that* opened, you went from hell to heaven. Beautiful! It was incredible An incredible feeling of beauty, of peace, of quiet and harmony."[5] The second door to which Seuphor refers separated the bedroom/kitchen space from the larger and much higher main studio. It was this room that Mondrian had transformed into a three-dimensional realisation of his Neo-Plastic aesthetic principles. As Nicholson observed, all around the white studio walls Mondrian had meticulously placed squares and rectangles of red, yellow, blue and grey. The same colours were applied to the few items of furniture, and on the black floor lay a number of coloured rugs. Also in the studio were two easels, on which Mondrian would meticulously position his paintings in relation to the rest of the room.[6]

For Nicholson, in early 1934, witnessing the extent to which Mondrian had created a studio environment in which art and interior were so completely interrelated must have been both inspiring and confirming. Two years earlier he had begun sharing a studio with his new partner Barbara Hepworth, a space that would play an important role in the development and presentation of his increasingly abstract work. Situated in Belsize Park, Hampstead, 7 The Mall was one of a group of studios that had been purpose-built in the late nineteenth century for artists living in the large houses on the adjacent Parkhill Road and surrounding area. However by 1928, when Hepworth first rented no. 7, the studios were being leased as combined work and residential spaces. Entrance to number 7 was through a door situated off the alleyway that ran the length of The Mall. This led in to a number of small rooms that acted as the kitchen and additional storage space with a further door leading into the main studio area. At no. 7 the mezzanine floor, which had originally been designed to store canvases, had since been converted into a joint bathroom and bedroom. To the rear of the building was situated a small garden, through which access could be gained to the lean-to that housed Hepworth's carving studio. Although The Mall contained eight studios in all no. 7 was located at the end of a terrace, no. 8 being a detached property. Next-door at no. 6 lived the artist John Cecil Stephenson and at no. 3 for a number of years during the 1930s lived the art critic Herbert Read and his wife Ludo.

For Nicholson and Hepworth the experience of painting and sculpting in such close proximity in the Mall studio soon led to the development of an interchange of ideas. Writing to his friend and patron Helen Sutherland, Nicholson enthusiastically explained, "Barbara & I are the same ... with Barbara & me, our ideas, & our rhythms, our life is so exactly married that we can live think & work & move & stay still together as if we were one person."[7] The resulting works from this intense and intimate period were put on display towards the end of the year in the couple's first joint exhibition at the Arthur Tooth & Sons Galleries in London. As contemporary photographs taken by the artists illustrate, in the exhibition Nicholson and Hepworth had positioned works in carefully judged groups, often pieces that had been produced

at the same time and which when seen together, Nicholson felt, came most "beautifully to life".[8]

The artists' new life together in The Mall studios was also alluded to in a number of Nicholson's paintings included in the exhibition. One particular example is *1932 (Au Chat Botté)* (fig. 30). Writing in his article 'Notes on Abstract Art', Nicholson later recalled that the theme of this painting was a shop-window he had seen on a visit to Dieppe. Nicholson and Hepworth had visited the French town in early August, and he had painted the work in the Mall studio on his return. On first inspection the composition can be seen to represent a number of objects displayed in the shop window, with the image of a female head (presumably Hepworth's) reflected in the glass with its boldly written sign. Yet this painting is as much about the art space of the studio as it is about a shop window. The jug and bowl were likely to have been from Nicholson's growing collection of ceramic objects (some of which he inherited from his father), and it is known that he also acquired at this time a number of musical instruments. In *Au Chat Botté*, however, rather than directly depicting one of these instruments, Nicholson chose to paint an image of a painting, namely *1932 (guitar)*, which he completed in the same month.[9] Likewise the face to the left of the composition can be seen to depict not Hepworth, but her 1930–31 carving, *Head*, a work that was on display in the studio at the time.[10]

In *1932 (Au Chat Botté)*, with its nod to Cubism and the 1920s still lifes of Picasso, Nicholson was developing an aesthetic that demonstrated his commitment to an ongoing modernist tradition whilst retaining a sense

of personal narrative. As his work moved towards complete abstraction in the following year this was a balance in which the contextualising presence of The Mall studio became all the more important. By 1933 Nicholson's exposure to recent developments in the visual arts was considerably enhanced by his new proximity to artists working in and around Paris. His first wife Winifred and their three children were now living in the French capital, a presence that provided him not only with a strong incentive to visit, but also a place where he could stay and work. In 1933 alone he visited on at least four separate occasions, and in the April of that year he was invited, along with Hepworth, to become a member of the Paris-based Abstraction-Création group. Whilst Nicholson had been familiar with the city's modern galleries for many years, he was now able to gain a much more intimate understanding of the works of the artists that he admired. This was an understanding in part shaped by the opportunity of experiencing these works in the context of artists' studios, and during the year he visited, amongst others, the ateliers of Brancusi and Arp, as well as the two studios belonging to Picasso at no. 23, rue Boétie and Château de Boisgeloup.

Nicholson's privileged access to these key art-world figures in Paris coincided with his own growing status as a leading exponent of modern art in England. With its significant concentration of progressive and ambitious young painters, sculptors and writers, Hampstead was beginning to develop something of a reputation as the Montparnasse of London – especially the Belsize Park area. At the heart of this community lay The Mall studios, and it appears that Nicholson, in line with his experiences in Paris, was eager to promote its status as a site of modernist values. During the period a number of exhibitions were held in the studio and, although Nicholson and Hepworth disliked disturbances to their daily working routine, it appears they were happy to invite interested guests in to no. 7 in order to present their aesthetic ideas.[11] One welcomed visitor was the Australian artist Margot Lewers, whose account of the experience was published in *The Sydney Morning Herald*.

"Barbara Hepworth and Ben Nicholson share a studio, and charmingly answered all the questions with which I plied them, bringing out their treasures with which to demonstrate as they talked. Their studio was one

of about six all in a row approached by a small alley known as the Mall. Herbert Read lives in no. 3 so it was no effort after we had afternoon tea in his distinctive spacious room, with its wall size window, his lines and lines of books, and his art gems, to slip along the little flagged alleyway and knock at no. 7. The lovely large window and the size and the shape of this studio were exactly the same as Mr. Read's but here in place of the orderliness were found a medley of frames and the grey circles and squares of different depths with which Ben Nicholson expresses himself. Here also we found the stone and marble compositions surrounded by hammers and other tools of the craft with which Barbara Hepworth so cleverly produces. A few hand-printed material lengths of their own creation and production were draped here and there. We were also shown the most delightful mat designed and carried out in the rarest colours, mechanical balances and movements of their own invention, many knick-knacks, and an immense box of simply designed and coloured pencils, of one of which I am the proud possessor. In all, the awareness of the primitive and the more simple shapes was strikingly apparent."[12]

Lewers's visit to The Mall studios corresponded with the first, and only, London show of the Unit One group, an exhibition that she went to see. Consisting of painters, sculptors and architects, it included amongst its members Henry Moore, Paul Nash, Wells Coates and Edward Wadsworth, as well as Nicholson and Hepworth.[13] Originally formed in 1933, the Unit One group signaled a bold statement of modernist intent, and at the Mayor Gallery Nicholson chose to exhibit three abstract compositions, including *1933 (six circles)* (cat. 1). To coincide with this event the group also launched a significant publication. With an introduction by Herbert Read, and individual texts written by all but one of the eleven members, the book provided a means by which the group could establish a wider context for the reception of their work.[14] Central to this was the inclusion of a large number of illustrations. Alongside images of artworks and a photograph of each artist, many of the members were represented by a close-up image of their hands and a photograph of the interior of their studio (see, for example, figs. 16 and 31). Whilst this tripartite framing emphasised the link between the artist, the gesture of the hand, and the

FIG. 31
A view of Ben Nicholson and
Barbara Hepworth's studio,
7 The Mall, Parkhill Road,
Hampstead, 1933, reproduced in
Herbert Read (ed.), *Unit One:
The Modern Movement in English
Architecture, Painting and Sculpture*,
Cassel and Company, London, 1934
Photographer: Paul Laib

authentic site of artistic creativity, by including studio photographs
the *Unit One* publication also signalled an awareness of a number of
avant-garde journals published on the Continent.

Of particular relevance were the series of studio photographs taken
by Brassaï that had recently appeared in the Surrealist journal *Minotaure*.
The first of these, which had focused on the two studios of Picasso, was
published in June 1933, little over a month after Nicholson had visited.[15]
Following the success of this edition (a copy of which Nicholson owned)
towards the end of the year *Minotaure* published a second series of
Brassaï's studio images, this time focusing on the working spaces of
contemporary sculptors, including Giacometti, Lipchitz and Laurens.[16]
Like the images of Picasso's ateliers, the vast majority of these photo-
graphs of the studios were unpopulated. With the artist figure absent,
or at most only implicitly present through their tools and their works,
emphasis was shifted away from the studio as predominantly a place of
work to its being also a place of display. Whilst to certain degree in the
Unit One publication a balance between the two was retained through
the juxtaposition of the additional images of the artist and their hands,
in each of the studio photographs included in the book the unpopulated
interior format was followed.[17]

By displaying and contextualizing groups of works in this way the photographs included in *Minotaure* and *Unit One* echoed the role of the studio visit, with the added advantages that not only could a wider audience be reached, but also the 'views' encountered by the visitor/viewer could be dictated by the artist (and photographer). The latter had been an important factor in the way that Mondrian had previously presented his own studio. In March 1926 the artist allowed his neighbour Paul Delbo to take a number of unpopulated photographs of the interior of 26 rue du Départ, one of which Mondrian chose to illustrate in his essay 'Neo-Plasticism: The Home – The Street – The City' published in the journal *International Revue i10* in the following year (fig. 32).[18] In these highly orchestrated images the relationship between forms, objects

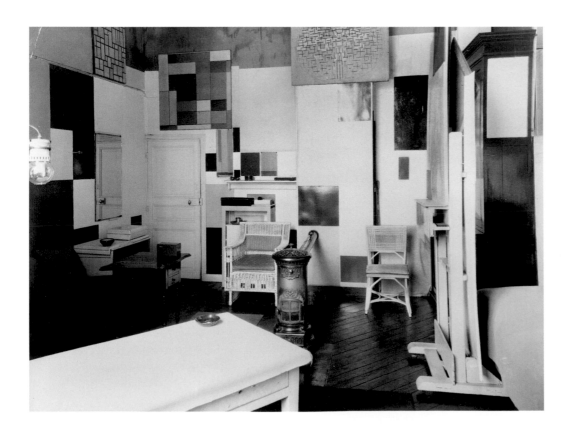

and art works could hardly have been more carefully arranged.[19] For Mondrian it was not enough to bring items into a room that displayed a certain aesthetic compatibility (this he considered to be a decorative approach), in order to create a Neo-Plastic interior it was essential that *all* elements worked "together as an entity".[20] In turn Mondrian believed that the Neo-Plastic interior should not be experienced in terms of "form-expression" (which he associated with the "dated" use of perspective in art), but rather viewed as a "multiplicity of planes" that could be perceived as a single "plane image".[21] In Delbo's shots of the studio both elements were to a certain degree facilitated. Whilst the photographic frame acted to unify the room and its contents, the image also had a flattening effect – a quality highlighted by the manner in which the reflection in the mirror to the right of the door is hardly distinct from the paintings and panels that surround it.

Although falling short of Mondrian's 'Neo-Plastic' requirements, the images of the Mall studio that appeared in Nicholson's section of *Unit One* were also clearly intended to illustrate the vital relationship between art and interior. The photographs had been taken by Paul Laib during the summer of the previous year, and it is clear that he and Nicholson had spent a great deal of time and thought in the positioning of the works and their relationship to other objects in the room. This was most evident in the carefully framed photograph of the studio's mantelpiece (fig. 33). By reducing the depth of the image to a minimum an effect is created in which the bottle, cacti and other items both echo and merge with the abstract paintings which surround them. In a manner that presents an interesting comparison with the tableau of artworks and objects brought together in *1932 (Au Chat Botté)*, the composition of the photograph mimics the abstract works contained within it.

In a statement that appeared designed to compliment Laib's photographs, in *Unit One* Hepworth made clear the underlying value of such objects for the development of their recent work.

"At the present moment we are building up a new mythology which is more easily understood when the things we care for are seen. Small things kept for their lovely shape, their weight, their texture and intense pure colour. Objects that we place near each other, in their different

FIG. 33
Photograph of the mantelpiece in
Ben Nicholson and Barbara Hepworth's
studio, 7 The Mall, Parkhill Road,
Hampstead, 1933, reproduced in
Herbert Read (ed.), *Unit One: The Modern
Movement in English Architecture, Painting
and Sculpture*, Cassel and Company,
London, 1934
Photographer: Paul Laib

aspects and relationships, create new experience. A scarlet circle on the wall, a slender white bottle and a shelf near it, a bright blue box and lovely shaped fishing floats that rest in the hand like a bird, weighty pebbles, dull grey, some gleaming white, all these move about the room and as they are placed, make the room gay or serious or bright as a frosty morning and nearly always give a tremendous feeling of work – because they are so much a part of the different seasons and varied light and quality of each day."[22]

Whilst most of the items listed by Hepworth can be identified in Laib's photographs of no. 7, the "scarlet circle" to which she refers was to be found in the studio of Herbert Read. According to Read, shortly after moving into his newly painted studio, with its pale blue woodwork and white walls, Nicholson had come to visit. In a gesture that provides an interesting parallel with Mondrian's positioning of coloured boards in his Paris atelier, after inspecting Read's studio for a moment Nicholson apparently left and returned with a round cork tablemat painted scarlet, which he then nailed to the wall. For Read, the "whole place was transformed by this accent of colour, perfectly placed".[23]

As can be seen in a photograph of Read's studio taken by Laib (fig. 35), the positioning of the tablemat high above the fireplace echoed both the design of Nicholson's *1933 (painting)* hung below,[24] and the circular shapes in the smaller *1933 (composition)* (fig. 34) propped up on the nearby bookshelf.[25] In November 1933 this photograph was published in *The Listener* as an illustration for Anthony Bertram's review of Nicholson and Hepworth's joint exhibition at the Lefevre Gallery. Under the heading 'Artists Indoors', in his article Bertram suggested that this was an "exhibition of objects created for interior decoration", observing that alongside

FIG. 35
A view of Herbert Read's
studio, 3 The Mall, Parkhill Road,
Hampstead, 1933
Photographer: Paul Laib

paintings, drawings, sculptures and collage, the artists had chosen to exhibit both rug designs and hand-printed fabrics.[26] However, whilst Bertram felt that this helped to demonstrate the compatibility of the paintings and sculptures with the modern interior, a reviewer writing in the *Yorkshire Post* argued that the presentation of abstract works in this context was rather problematic, for although many "will appreciate the delightful rugs and fabrics" they "will take exception to the framing as pictures of precisely similar arrangements of line and colour ... where indeed, does art end and decoration begin?"[27]

Such a negative response to abstract painting during the decade was not uncommon, but for Brian Price-Heywood, writing in direct response to Bertram's article, it was not with the works that he had a problem, but rather the categorisation of the interior shown in Laib's photograph as modern: "How can such a room, full of disconnected ornament and tables and jarring lines, be called Modern when the whole trend of interior decoration today is towards simplicity, tidiness, and reposeful?"[28] With the development of his white reliefs in the following year Nicholson was also considering the most appropriate setting for these new works, and in early 1935 he and Hepworth decided it was time to redecorate no. 7 The Mall. Writing to Nicholson in Paris on 12 January, Hepworth noted, "The studio is marvellous all white, it is v. roughly done – ought to have a 3rd coat but that can wait till we are richer. I can really think + I've hidden so many things I don't like now it is so peaceful. I've just had tea with Kit and EQ [Nicholson]. Kit has done a very good project for Dunstable Gliding club. I'm asking him to meet Gropius one night. I want to have several people.

Moholys came to dinner on Tuesday."[29]

As well as highlighting the degree to which the artists felt that their recent work required a more minimal setting, Hepworth's letter underlines the extent to which by the mid 1930s their social circle included many architects and designers.[30] In recent years, possibly encouraged by his architect brother Kit, Ben had become increasingly interested in the spaces and designs of modernist architecture. When in Paris he had twice visited Le Corbusier's Villa La Roche where he saw its impressive collection of Cubist and Purist paintings, and during the same period he

FIG. 36
Lawn Road Flats, Hampstead,
architect: Welles Coates, completed
1934, photograph c. 1950
Photographer: John Maltby
University of East Anglia Archives

also photographed the exteriors of the apartments on rue Mallet-Stevens, as well as the modern studio that Theo van Doesburg had designed for himself in Meudon.[31] By 1934, with the completion of Wells Coates's Lawn Road flats (fig. 36), Hampstead had its own modernist architectural icon, a building which, whilst providing refuge for many of the émigré architects, designers and artists passing though London (including Gropius and Moholy-Nagy), presented Nicholson with a model for considering the contextualisation of his new abstract work.[32]

As Christopher Green notes in his essay, Nicholson had taken great pleasure in seeing his new reliefs hung within the light clear interiors of the Lawn Road flats.[33] Around this time he wrote to Coates concerning a scheme that he had in mind for placing his new work "in a severe, rectangular white room", a project, he suggested, that they could possibly work on together.[34] Whilst this project was never realised, as the decade progressed Nicholson was keen to promote the alignment of his work with examples of modernist architecture and design. In April 1936 he participated in 'Modern Pictures for Modern Rooms' at Duncan Miller Ltd., organized by S. John Woods, an exhibition which alongside 'Abstract and Concrete', which opened at the Lefevre Gallery in the same month, marked the first showing of Mondrian's work in London (see figs. 37, 38 and 45).[35] Later in the year two of his works, a relief and a painting, were exhibited at the Royal Institute of British Architects as part of a discussion on the relationship between modern art and architecture. With contributions from Serge Chermayeff, Moholy-Nagy, Gabo, Herbert Read and Eileen Holding, the meeting opened with Chermayeff's claim that, for

those artists and architects that had accepted the "machine discipline", it was now necessary for them to form a united front through which they could sweep away previous "aesthetic and technical confusion".[36]

Whilst by the mid 1930s many of Nicholson's contemporary supporters were in no doubt that strong sympathies existed between his abstract works and modernist design, there did appear some disagreement on the nature of this relationship. Writing in an article in which he had already stated unequivocally that they were the best works to be seen in a modern interior, Herbert Read claimed that the nearest analogy for these new works was in fact the architectural façade: "...not facades for a functional building – that was the baroque fallacy. Facades divorced from function. Free facades."[37] Read possibly had in mind the designs for Massine's ballet production of Beethoven's 7th Symphony that Nicholson had been working on during the previous year (fig. 39). For this unrealised project, Nicholson had planned to create large free standing walls based on his white carved reliefs, yet these were, of course, to be placed within a theatrical context, rather than a permanent architectural setting.

FIG. 39
Photograph of Ben Nicholson's
designs for an unrealised project
for the staging of a Léonide Massine
ballet production, 1934
Photographer: Paul Laib
The Courtauld Institute of Art,
Witt Library, De Lazlo Collection

In *The Architectural Review* Paul Nash suggested a potentially more integrated role for the white reliefs, claiming that since they were "pre-eminently suitable as architectural features in the contemporary room" they could be "placed there as pictures or sunk into the wall".[38] Interestingly, in direct response to Nash, someone who warned against Nicholson's carved reliefs "becoming a unit in architectural decoration" was the architecture critic and historian J.M. Richards.

> "The public, always searching for a label to apply – for a comforting explanation of what it does not understand, or does not wish to – will no doubt recognise in these carvings an affinity with the superficial appearances of modern architecture and, having thus satisfactorily disposed of them, will turn away from them with relief, and Ben Nicholson's latest work will be relegated for ever to the same class as the plaster cornice and the marble mantelpiece … Ben Nicholson's reliefs *have* an affinity with modern architecture; that is a test of their vitality, as it is of the vitality of any art; but his reliefs are emphatically also carvings on their own account."[39]

The architect Leslie Martin felt it was not just the carved reliefs but also Nicholson's geometric abstract paintings that could offer a valuable contribution to the modern interior. As co-editor of *Circle,* and a keen collector of his art, Martin knew Nicholson's paintings of the 1930s better than most. In 1939 he included a number of photographs of Nicholson's works in domestic settings in *The Flat Book,* a directory of modern design that he had written with his wife Sadie Speight. In the same year, in an essay entitled 'Architecture and the Painter: with special reference to the work of Ben Nicholson', Martin argued that whilst "modern architecture and recent developments in painting [had] much in common", there was now "an opportunity for an even more intimate collaboration".

> "Since architecture has now shed its decoration, painting, if necessary, can be once again introduced in its own right, not decoratively as a means of covering blank walls, but as an architectural element

… But apart from paintings placed on walls, the placing of paintings
and reliefs in a modern setting offers many possibilities which
have yet to be explored. There seem to be ample opportunities in
modern planning, for example, for using works as free standing
screens where they may take up a functional position and act as
a point of special emphasis."[40]

Martin's proposal that Nicholson's paintings could act as "screens" within
the modern interior presents interesting parallels with the Neo-Plastic
ideas expressed in the earlier writings of Mondrian. As noted above, the
Dutch artist had envisaged the development of a form of architecture
that would be based on a "planar" model in which colour played a central
role, not as an accessory, but as an integral part through which the plane
would become "a living reality".[41] Acting as a solution to what he felt
to be the compromises that existed between 'building' and 'decoration',
Mondrian believed that Neo-Plasticism could lead to a form of construc-
tion in which art and architecture would reach a point of synthesis,
claiming in 1920 that the "abstract-realist picture will disappear as soon
as we can transfer its plastic beauty to the space around us through the
organization of the room into colour areas". [42]

As Yve-Alain Bois has observed, although Mondrian came to realise
that owing to contemporary cultural and economic conditions the
complete fusion of painting and architecture was at the time impossible,
it was an ideal that he continued to pursue on a reduced scale in his
rue du Départ studio.[43] On seeing this space for the first time in 1934
Nicholson had clearly been inspired and reassured by the centrality of
abstract art within this interior; however, for him the complete integration
of the individual canvas, or carved relief, was not desirable. Although he
valued the relationship that could be established between his art and
the environments in which it was experienced, for Nicholson, as had
been recognized by Richards, it was important that his work retained
its autonomous status.

As was evident in Laib's photographs of the Mall studio Nicholson had
a tendency to treat his works as objects, particularly the smaller pieces
that he placed on the mantelpiece alongside other items he had collected.

When the works were framed this was a quality that was partially preserved owing to his preference for a box frame design. Interestingly, as Bois has shown, the manner in which Mondrian chose to frame his own works also enhanced their appearance as objects, yet the resulting effect was somewhat different to that achieved by Nicholson.[44] As can be seen in photographs of the 'Abstract and Concrete' exhibition (see fig. 45), whilst Nicholson's white relief sits within its frame, Mondrian's canvases are placed on supporting boards, a framing technique that contributes to their projection forward into the viewer's space. The fact that the canvas surface sat proud of the surrounding framing strips also helped to enhance the expansive quality of Mondrian's paintings. Unobstructed, the horizontal and vertical black lines were permitted to imply a continuation of the composition past the canvas edge, a perception that was encouraged within the studio through the arrangement of coloured panels. In contrast, Nicholson's abstract compositions were fixed more firmly within the frame. As set out by Christopher Green in his essay, in Nicholson's compositions forms do advance and recede from the picture plane (literally in the case of the carved reliefs, and optically through the arrangement of colours in the paintings), yet expansion outwards is denied since not only do the frames sit forward of the work's surface but, unlike Mondrian's painting, lines or edges seldom traverse fully the complete width or height of the work.[45]

In the concluding paragraph of his essay published in *Circle* Mondrian looked towards a future in which, through the "unification of architecture, sculpture and painting" art would no longer exist *"as a thing separated from our surrounding environment"*.[46] As a driving figure behind the *Circle* project Nicholson also signalled his support for a closer working relationship between the artist and the architect. Although he did not necessarily commit fully to the Utopian social vision espoused by Mondrian, for Nicholson abstract art, when successful, did possess the potential to transform the environment in which it was experienced. Writing to the art dealer Andras Kalman many years later, he recalled that this was a quality that he felt he had achieved in his own work during the period. Discussing an unspecified painting that was with Kalman, Nicholson explained,

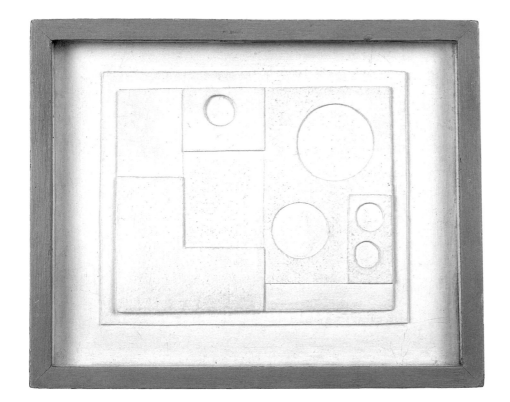

"The ptg has a certain history because it was hung on the jerry-built staircase at our war time house in Carbis Bay – + I used this as an explanation to Stephen Spender (whose approach to ptg is purely literary) of how a work of this kind could transform a rickety, creaking wooden affair into a monumental, marble, Venetian Staircase. And out of this arose my 'Notes on Abstract Art' publ. by Spender in Horizon."[47]

Published in 1941 and illustrated by two works dating from the seminal period that followed his move to the Mall studios – *Au Chat Botté* and a small 1934 white relief owned by Leslie Martin (fig. 40) – 'Notes on Abstract Art' was written during a period of reflection for the artist. With the events of the Hampstead years probably appearing misleadingly distant, through the essay Nicholson established what he felt to have been the achievements of the 'Constructive' project, as well as reasserting his commitment to it. For Nicholson, far from "being the withdrawal of the artist from reality (into the ivory tower)", abstract painting and sculpture had "brought art once again into common every-day life".[48]

1 Ben Nicholson, interviewed by Vera and John Russell, 'The life and opinions of an English "modern", in *The Sunday Times,* 28 April 1963, p. 28.

2 Piet Mondrian, 'Plastic Art and Non-Plastic Art (Figurative Art and Non-Figurative Art)', in J.L. Martin, Ben Nicholson and N. Gabo (eds.), *Circle: International Survey of Constructive Art*, Faber & Faber, London, 1937 (reprinted 1971), pp. 41–56.

3 Ben Nicholson, 'Quotations', in Martin, Nicholson and Gabo 1937, p. 75.

4 Letter from Ben Nicholson to John Summerson, 3 January [1944] (TGA 20048.1.38). A slightly edited version was published in Summerson, *Ben Nicholson*, Penguin, West Drayton, Middlesex, 1948, pp. 12–13. Whilst it added to his presentation of the studio as a monastic-like space, Nicholson's claim that Mondrian had lived in the studio for 25 years and had not left Paris during that time was incorrect. Although he had moved to Paris in 1912 Mondrian spent the war years in the Netherlands. Before the war Mondrian had lived in two different studios at 26 rue du Départ and on returning to Paris in June 1919 he moved back into the same building. In late 1919 he moved to a studio at 5 rue de Coulmiers, where he worked for two years before returning to 26 rue du Départ in 1921. He remained in this studio until 1936, when he moved to a studio at 278 Boulevard Raspail, before moving to London in 1938.

5 Michel Seuphor, 'Seuphor's Hat: Memories of 26 rue du Départ', in Frans Postma, *26, rue du Départ: Mondrian's studio in Paris, 1921–1936,* Ernst and Sohn, Berlin, 1995, p. 9.

6 Seuphor recalled that the white easel was only used for showing finished canvases. Michel Seuphor, *Piet Mondrian: Life and Work*, Thames & Hudson, London, 1957, p. 158.

7 Letter from Ben Nicholson to Helen Sutherland, 3rd May 1932, quoted in Sarah Jane Checkland, *Ben Nicholson: The Vicious Circles of his Life and Art,* John Murray, London, 2000, p. 105.

8 In a letter to Helen Sutherland written in the June prior to the exhibition, Nicholson would note: "It is going to be very exciting the show because each carving has 2 or 3 ptgs which were done at the same time, & the connection is very close. The big picture has a most lovely dark rosewood carving that goes with it – & each comes most beautifully to life with the other": letter from Ben Nicholson to Helen Sutherland, 13 June 1932, quoted in Peter Khoroche, *Ben Nicholson: Drawings and Painted Reliefs*, Lund Humphries, London, 2002, pp. 30–32.

9 *1932 (guitar),* oil, gesso and pencil on board, 76.5 × 107.5 cm, private collection.

10 *Head*, 1930–31, Cumberland alabaster, 29 × 17 × 40 cm, BH 32, Leicestershire Museums.

11 Winifred Nicholson wrote to Ben, 'I hope the exhibition in your studio will be very successful', 12 Nov 1934 (TGA 8717. 1.1.1743).

12 'Modern Art; An Australian in London; Where we fail; by Margo, 9 May 1934', *The Sydney Morning Herald.*

13 Nicholson had returned from Paris the week after his first visit to Mondrian's studio in order to hang his works for the 'Unit One' exhibition at the Mayor Gallery.

14 Herbert Read (ed.), *Unit One: the Modern Movement in English Architecture, Painting and Sculpture*, Cassell and Co. Ltd., London, 1934.

15 *Minotaure: Revue artistique et littéraire,* no. 1, June 1933.

16 *Minotaure: Revue artistique et littéraire,* nos. 3 and 4, December 1933.

17 It is worth noting the amount of space that Nicholson allotted to images of the studio interior in the *Unit One* book. Whereas most artists were represented by four images of individual works, and one of the interior, three of the photographs within Nicholson's section depicted a range of works on display within the studio context.

18 Piet Mondrian, 'Neo-Plasticisme: De woning – de straat – de stad' (dated Paris 1926), *Internationale Revue i10*, January 1927; translated as 'Le Home – la rue –la cité', in *Vouloir*, Lille, 1927; translated as 'Home – Street – City', in Harry Holtzman and Martin S. James (eds. and trans.), *The New Art – The New Life: The Collected Writings of Piet Mondrian,* Thames and Hudson Ltd., London, 1987, p. 209.

19 In Delbo's photographs there is no evidence of the tools and materials used by the artist. Accounts of the studio have also tended to focus on its role as a site of display, rather than of work, with Arthur Lehning recalling that in fact it was not obvious that you were in a place where painting took place at all – "no pots of paint or brushes, nothing like that": 'Three Voices: Arthur Lehning, César Domela and Maud van Loon', in Postma 1995, p. 51.

20 Piet Mondrian, 'Natural Reality and Abstract Reality' (1919–20), in Holtzman and James 1987, p. 110.

21 Mondrian, 'The Realization of Neo-Plasticism in the Distant Future and in Architecture Today' (1922), in Holtzman and James, 1987, p. 164

22 Barbara Hepworth, in Read 1934, pp 19–20.

23 Herbert Read, 'A Nest of Gentle Artists', *Apollo,* Vol. LXXVI, No. 7, September 1962, pp. 536–540.

24 *1933 (painting),* oil on board, 114.3 × 55.9 cm, private collection.

25 Although Read's account does not mention it, it appears likely that the mat and the paintings were originally arranged in his studio for Laib to photograph. Both *1933 (composition)* and *1933 (painting)* appear in various arrangements in contemporary photographs of no. 7.

26 Anthony Bertram, 'Artists Indoors', *The Listener*, 1 November 1933, p. 661.

27 *Yorkshire Post*, 31 October 1933, quoted in Michael T. Saler, *The Avant-Garde in Interwar England; Medieval Modernism and the London Underground,* Oxford University Press, 1999, p. 129.

28 Letter by Brian Price-Heywood, *The Listener*, 8th November 1933.

29 Letter from Hepworth to Nicholson January 1935 (TGA 8717.1.1.207).

30 Amongst the architects and writers on architecture who owned Nicholson's work in the 1930s were, Serge Chermayeff, Wells Coates, Frederick Gibberd, Jack Hepworth, Leslie Martin, Paul Nelson Christopher Nicholson, Jack Pritchard, J.M. Richards, John Summerson and Michael Ventris.

31 Evidence of this can be seen in the visitors' book (Fondation Le Corbusier, reference E 207). I would like to thank Sophie Bowness for bringing this material to my attention.

32 During the 1930s the Lawn Road flats acted as a refuge for a number of artists and architects fleeing Nazi oppression, including Marcel Breuer and Arthur Korn. Moholy-Nagy's wife Sybil recalled that for them the modernist building, and the sense of community that was fostered there, had acted as an "ideal transition" from their previous life in Germany: 'Comments by tenants and others' (The Pritchard Archives, University of East Anglia, PP.16.2.28.3.1).

33 See Christopher Green's essay in this publication, p. 18.

34 Letter from Ben Nicholson to Wells Coates, 2 August 1934, citied in Laura Cohn, *The Door to a Secret Room: A Portrait of Wells Coates,* Scolar Press, Hants, 1999, p. 215.

35 On 'Abstract and Concrete' see Sophie Bowness' essay in this publication, p. 47.

36 Reports of the Principal Speeches at the informal General Meeting on Wednesday, 9 December 1936', in *Journal of the Royal Institute of British Architects*, Vol. 44, No. 5, January 1937.

37 Herbert Read, 'Ben Nicholson's Recent Work', *Axis*, London, no. 2, April 1935, p. 16.

38 Paul Nash, 'Ben Nicholson's Carved Reliefs', in *The Architectural Review*, October 1935, p. 143.

39 J. M. Richards, 'Ben Nicholson at the Lefevre: 7 & 5 at Zwemmer's', *Axis*, London, no. 4, November 1935, p. 21.

40 J. L. Martin, 'Architecture and the Painter: with special reference to the work of Ben Nicholson', *Focus 3*, spring 1939, pp. 64–65. The function of colour within architecture had been discussed by Le Corbusier in *Circle* two years earlier. The architect would note, "It is by means of polychromy that a thrill of excitement may be introduced into the house, a coloured epic, soft or violent. I have been engaged for a long time in defining the wonderful resources of colour; and taking advantage of the organic necessities of the modern plan, I saw that we could restrain confusion by colour, create lyrical spaces, bring out its order, increase its dimensions and make the spirit of architecture rejoice": Le Corbusier, 'The Quarrel with Realism', in Martin, Nicholson and Gabo 1937, p. 72.

41 Mondrian, 'The Neo-Plastic Architecture of the Future' (1925), in Holtzman and James 1987, p. 197.

42 Mondrian, 'Realiteit', in *De Stijl,* no. 3, May 1920, p. 59; translated as 'Natural Reality and Abstract Reality', in Seuphor 1957, p. 339.

43 Yve-Alain Bois 'The Iconoclast', in Yve-Alain Bois, Joop M. Joosten, Angelica Zander Rudenstine and Hans Janssen (eds.), *Piet Mondrian, 1872–1944,* exh. cat., The National Gallery of Art, Washington, D.C., 1995.

44 Bois, Joosten and Janssen 1995, p. 340.

45 See cat. 6 and 14..

46 Piet Mondrian, 'Plastic Art and Non-Plastic Art (Figurative Art and Non-Figurative Art)', in Martin, Nicholson and Gabo 1937, p. 56.

47 Letter from Ben Nicholson to Andras Kalman, 17 March 1967 (Crane Kalman Gallery, London). I would like to thank the Crane Kalman Gallery for allowing me to quote from this letter.

48 Ben Nicholson, 'Notes on Abstract Art', *Horizon: A review of Literature and Art*, vol. 4, no. 22, October 1941, p. 272.

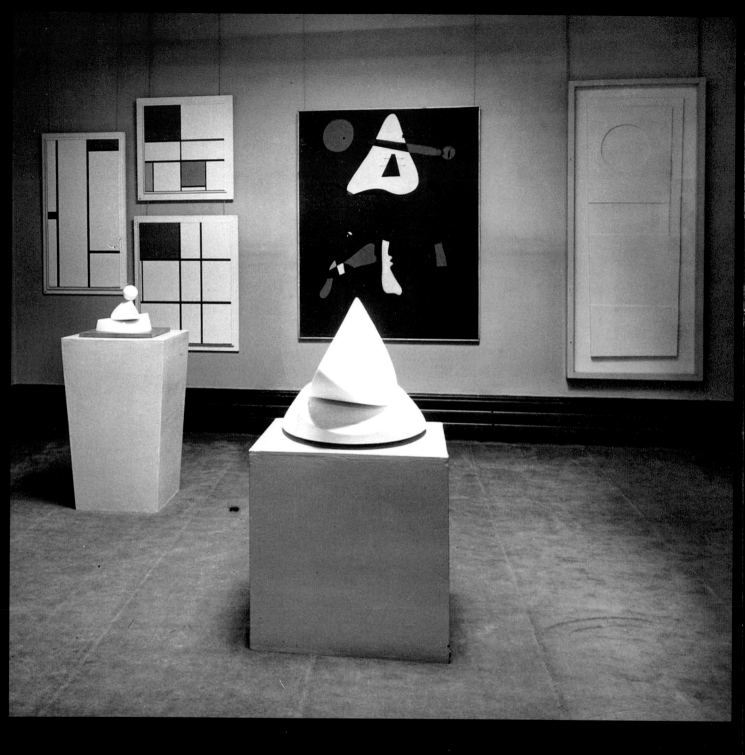

A view of the exhibition, 'Abstract and Concrete', at the Lefevre Gallery, London, 1936, including Mondrian's *Composition A (No.I)*, 1935 (first state), B260; *Composition B/(No.II)*, with Red, 1935, here cat. 6; *Composition C (No.III) with Red, Yellow and Blue*, 1935, here cat. 7, and Nicholson's *1936 (white relief)*, here cat. 11 (detail of fig. 45)

Catalogue

CG Christopher Green
BW Barnaby Wright

1

Ben Nicholson (1894–1982)
1933 (six circles)

1933
Oil on carved board, 114.5 × 56 cm
Private collection

Nicholson made this relief in mid December 1933, the month after his interest in Mondrian was first sparked.[1] It was made while Nicholson was in Paris to spend time with his first wife Winifred and their children. In November, just before leaving London, he had written to Winifred that the ex-Bauhaus artist László Moholy-Nagy had called Mondrian "a v. fine painter", something he himself had not been able "to tell" from the Mondrians reproduced in *Abstraction-Création* and so he planned to see him (see cat. 2).[2] This relief shows how different an artist Nicholson was from Mondrian at the moment when his attention turned towards him.[3]

1933 (six circles) was made almost immediately after *December 1933 (first completed relief)*, which was completed by 11 December, the day before Nicholson wrote to his lover Barbara Hepworth of carving all day and producing "a very amusing thing" which "looks like a section of some primitive game".[4] *Six circles* is another "primitive game". This analogy has led Jeremy Lewison to connect *first completed relief* with the carved bases found in Alberto Giacometti's sculpture of 1931–32, which Rosalind Krauss had in turn related to accounts of the violent hazards of ancient Toltec ball games.[5] Carving does violence to the wooden board (Nicholson recalled the destructive act of breaking into the plaster ground of a painting as his way into relief carving in the first place

altogether), but, for him, something "amusing" is extracted. Play offered a way of countering conscious control to other artists associated with Surrealism, in particular Joan Miró. Nicholson had made his move into abstraction earlier in 1933 in a series of paintings that invite comparison with certain of Miró's so-called 'dream paintings' of the mid 1920s and with certain of his collages and 'anti-paintings' of 1928–30 (though Miró himself rejected abstraction). The interaction of roughly shaped circles and spidery lines in *six circles* is in tune with those earlier works. Nicholson would later express a sense of indebtedness to a Miró seen in Paris in "1932–3" as "the first free painting I saw".[6] To be in tune with Miró in 1933 was to be out of tune with Mondrian, and Nicholson did not stop being responsive to the Catalan after meeting Mondrian. When he was beginning work on *Circle* in October 1936, Mondrian wrote to him of his astonishment at learning that he had written to Miró for photographs of his work, which seemed to go right against the "constructive" aim of the publication.[7]

1933 (six circles) was shown in the 'Unit One' exhibition, which opened at the Mayor Gallery in London on 10 April 1934. The month before, Nicholson had shown white reliefs for the first time, at the annual exhibition of the 7 & 5 group. The precise oblongs and circles cut into the boards of the white reliefs from the outset superficially set them apart, but

1 Jeremy Lewison is precise, giving the date of execution as "shortly before 20th December 1933": Lewison 1993, p. 217.
2 Letter from Ben Nicholson to Winifred Nicholson, "Sat. night" (18 November 1933), Winifred Nicholson Archive.
3 When Mondrian made the date with Nicholson for the Nicholson's first visit to his studio, which was on 5 April 1934, he wrote that he would be happy *"de faire votre connaissance"*, which indicates that they had not met earlier: letter from Piet Mondrian to Ben Nicholson, 1 April 1934 (TGA 8717.1.2.2984).
4 Letter from Ben Nicholson to Barbara Hepworth, 12 December 1933, cited in Lewison 1993, p. 216.
5 Lewison 1993, p. 216; Rosalind E. Krauss, 'No More Play', in Krauss 1985, p. 59.
6 Ben Nicholson, cited in Summerson 1948, p. 12.
7 Letter from Piet Mondrian to Ben Nicholson, 5 October 1936 (TGA 8717.1.2.2995). In the end Miró was not included in *Circle*: see Sophie Bowness's essay in this publication, pp. 50–51 and note 59.

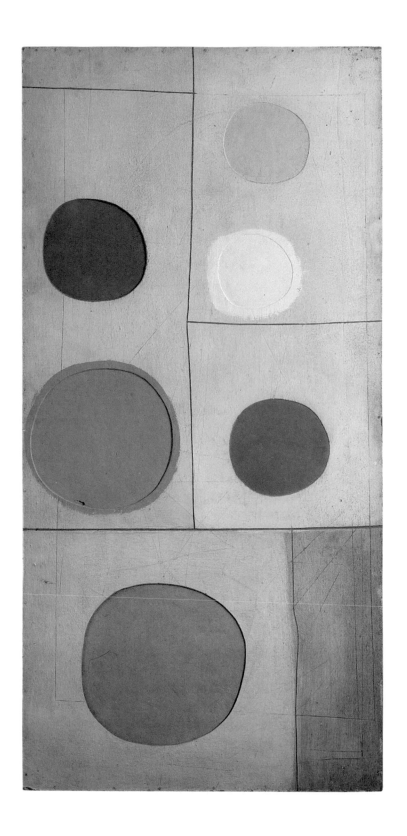

there are important continuities between them and a relief like *six circles*. Most obviously, they too are carved and the relative depths of the cuts matter; the flat surface of the picture plane is broken into. When Hepworth wrote to him, thrilled as a sculptor at his "new work idea", tellingly she used the phrase "carving out".[8] Space is opened up in a way alien to the uncompromising flatness of Mondrian's Neo-Plasticism.[9] Space as depth had been central to Nicholson's work from his earliest introduction to Cubism, and, despite the coarse roughness of the surface of *six circles*, the tonal modulations of the browns and the black and white of two of the circles suggest the opening up of a space whose depth is greater than the literal actual depth of the board. Moreover, the circle would not lose its place in Nicholson's repertoire; for Mondrian it was the most complete of "particular forms" and so the most sedulously to be avoided.[10]

Nicholson is close to Mondrian, however, in *six circles* as in the white reliefs, in one way – in the direct impulsiveness of the "carving out", something that comes across with force in Nicholson's evocation of the act of carving in his *Unit One* 'Statement'. The statement clearly does not apply directly to this work, but it was written almost exactly as he was making it. "One can express a thought ... one can take a piece of cardboard and cut out a circle of one depth, or 2 circles 2 depths, or 600 circles 6,000 depths, or one can take a board and paint it white & then on top put a tar black & then a small circle of scarlet – then scrape off some grey leaving black, some black leaving white, some white leaving board, some board leaving whatever is behind that – only stop when it is all the form & depth & colour that pleases you most."[11] CG

8 Letter from Barbara Hepworth to Ben Nicholson, 8 December 1933 (TGA 8717.1.2.157).
9 See my essay in this catalogue, p. 31.
10 "Real form is closed or round or curved in opposition to the apparent form of the rectangle, where lines intersect, touch at tangent, but continue uninterrupted": Piet Mondrian, 'Le Néo-Plasticisme: Principe general de l'équivalence plastique', Editions de l'Effort Moderne, Paris, 1920; translated as 'Neo-Plasticism: The General Principle of Plastic Equivalence', in Holtzman and James 1987, p. 138.
11 Ben Nicholson, in Read 1934, p. 89.

2

Piet Mondrian (1872–1944)
Composition with Yellow and Blue

1932
Oil on canvas, 55.5 × 55.5 cm
B 234
Fondation Beyeler, Riehen, Basel
(Purchased with the support of Hartmann P. and Cécile Koechlin-Tanner, Riehen)

This is one of the last pictures Mondrian painted in a series Yve-Alain Bois has dubbed the "classic" series.[1] Mondrian's mature abstract painting had consistently been produced in series. What is different about this one is the exactness with which he repeats the same linear division of the picture surface in a square format. The evidence is that he found this a particularly well balanced compositional type;[2] and it has been taken to represent the culmination of his work of the period 1921–29, in which his priority was to achieve balance between the opposed linear directions and chromatic forces at play with a maximum of economy.[3] There is only one crossing of vertical and horizontal, to the left of centre and the intersection of lines generates just one geometric figure, a near square, off centre to its right. What Mondrian varies in each of the eight canvases of the series is the weight and thickness of lines, the choice of which of the three primaries to use (usually two, sometimes one) and which of the planes left open at the picture edge to fill with colour. For him, as he explained writing of one of the series to a friend, such minimal variations were enough to "express the various aspects of life".[4]

Composition with Yellow and Blue and one of the earliest of the series, a work of 1929, now in Rotterdam, comes so close that they are almost identical twins.[5] In both, the smaller, denser blue plane to the right does the same balancing job against the larger, lighter but more radiant yellow plane upper left. But the earlier picture is crossed by thicker, more intensely black lines, and the intervals between them differ, producing differently proportioned planes, so that the weights of yellow and blue are differently balanced. So close is the relationship that it is almost as if at the end of the series Mondrian was trying to take the earlier idea just a little closer to the unalterably perfect (an impossible ideal for him). Alongside *Composition with Yellow and Blue* in 1932, Mondrian painted another variant in the series, now in Winterthur, which repeats the placing of the blue but replaces the yellow with red (fig. 41). The intervals between the lines in these two pictures are almost exactly the same, though the thickness of certain lines differs; in black and white reproduction the two works would have been almost identical. The Winterthur painting was one of four Mondrians reproduced as examples of his work in the first two *cahiers* of *Abstraction-Création*, to which Nicholson was a contributor in 1933. He could not have seen Mondrians in any Abstraction-Création group showing that year since Mondrian had not exhibited with them then. This painting, in the greys of reproduction, therefore, must have been among those in Nicholson's mind when he remarked to Winifred late in 1933 that he had not been able to see the quality

1 Yve-Alain Bois, 'The Iconoclast', in Bois, Joosten, Rudenstine and Janssen 1995, pp. 356–58.
2 In a letter of 1931 to his friend Albert van den Briel, Mondrian included annotated sketches of three compositions, finding one, the "classic" type, "more in balance" and thus (lacking the oppression of vertical over horizontal) "less tragic". The letter with its annotations is reproduced in the catalogue entry by Joosten and Rudenstine to no. 130, in Bois, Joosten and Rudenstine 1995, p. 248. Bois discusses it at p. 353.
3 Cf. Joosten and Rudenstine, in Bois, Joosten and Rudenstine 1995, p. 237.
4 Letter from Piet Mondrian to Alfred Roth, 6 March 1933. The letter is cited in the original French in Joosten 1998, p. 362.
5 *Composition No. II, with Yellow and Blue*, 1929, oil on canvas, 52 × 52 cm, B 215, Museum Boymans-Van Beuningen, Rotterdam. The work was sold to the Boymans Museum by the end of 1929, and so was not in Mondrian's studio when he painted cat. 2.
6 He wrote to Winifred Nicholson late in November 1933 that he could not tell from *Abstraction-Création* that Mondrian was the "v. fine painter" Moholy said he was: letter from Ben Nicholson to Winifred Nicholson, "Sat. night" (18 November 1933), Winifred Nicholson Archive.

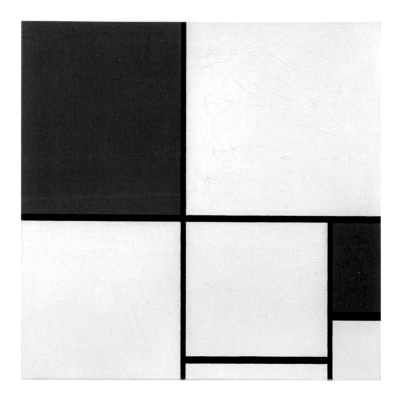

FIG. 41
Piet Mondrian, *Composition A,
with Red and Blue*, 1932, oil on canvas,
55 × 55 cm, B230, Kunstmuseum
Winterthur (Bequest of Emil und
Clara Friedrich-Jezler, 1973)
© 2012 Mondrian/Holtzman Trust
c/o HCR International Washington DC

in Mondrian's work from the reproductions in *Abstraction-Création*.[6]

Nicholson told John Summerson that when he made his first visit to Mondrian's studio, at 26, rue du Départ, on 5 April 1934, "the paintings were entirely new to me & I did not understand them on this first visit (& indeed only partially understood them on my second visit a year later). They were merely, for me, a part of the very lovely feeling generated by that room." He went on to talk of "hermits' caves where lions used to go to have thorns taken out of their paws".[7] It is possible that not a single picture from the "classic" series remained in Mondrian's studio at that time, though Nicholson would have seen one when he visited the Swiss graphic designer

Jan Tschichold in Basel early in 1935.[8] Of them all, only *Composition in Yellow and Blue* might have been in the studio in 1934.[9] If it had been there, among the things not understood could have been the way its brilliant white expanse combined with its open net of black lines to keep the gaze on the flat picture surface, and how the sheer intensity, against the white, especially of its primary yellow was kept in balance. But what he would have realised immediately was its kinship with the white reliefs he had now been working on for a few months, not just in the force and surface coverage of that opaque white, but in the economy, precision and balance of such a Mondrian. CG

7 Letter from Ben Nicholson to John Summerson, 3 January [1944] (TGA 20048.1.38); a slightly edited version of this letter was published in Summerson 1948, pp. 12–13. The passage is cited in full in Lynton 1993, p. 78. Nicholson's second visit was in fact the following month, in May 1934, and not a year later as he recalled in this letter; see Sophie Bowness's essay in this publication, p. 42.
8 Nicholson visited Tschichold seeing the 'These – Antithese – Synthese' exhibition in Lucerne, where both he and Mondrian showed. Tschichold bought one of the series in 1931, *Composition with Yellow*, 1930, oil on canvas, 46 × 46.5 cm, B221, Kunstsammlung Nordrhein-Westfalen, Düsseldorf.
9 It is unclear when it was sold. See Joosten 1998, B234, 'Provenance', p. 364.

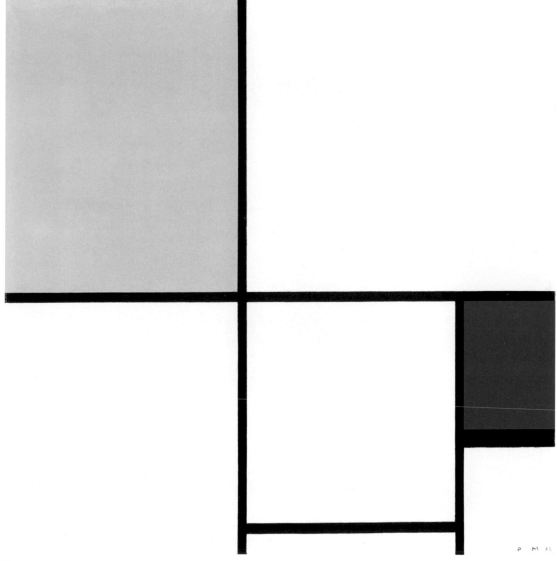

2

3

Ben Nicholson (1894–1982)
1934 (painting)

1934
Oil on canvas, 72 × 101 cm
Museum Kunstpalast, Düsseldorf

This is one of the largest of a group of abstract paintings that Nicholson produced in 1934, which was also the year of his first carved white reliefs (see for example figs. 40 and 44). The works mark the beginning of his sustained (although not exclusive) engagement with what Alfred H. Barr would soon define as "geometrical abstract art".[1] Unlike Nicholson's abstractions of the previous year, such as *1933 (six circles)* (cat. 1) and *1933 (vertical painting)*,[2] with their Miró-like spidery lines and decidedly wonky circles, this painting expresses a more tightly controlled repertoire of muted coloured planes and near-right angles, together with a fairly sharply described single circle. It is one of the first paintings in which Nicholson's exposure to Mondrian's art can be discerned. The work was produced some time after his probable first visit to Mondrian's Paris studio in April 1934.[3] Although Nicholson would later recall that "The paintings were entirely new to me & I did not understand them on this first visit",[4] it is clear in this work that something of Mondrian's rectilinear purity was beginning to mesh with Nicholson's developing abstract aesthetic

The distance between *1934 (painting)* and Nicholson's work of the previous year is an important measure of the extent to which he was disciplining his approach to abstraction. In doing so he shut out the more obviously figurative, biomorphic and even Surrealist aspects of his art of the preceding years. Mondrian played an important role in this development and continued to do so as the two artists grew closer as friends and as proponents of what Nicholson and others championed as 'Constructive' art during the 1930s. But as this painting demonstrates, from the outset Nicholson was not enacting a fundamental rupture with his earlier work. It is also apparent that his vision for abstraction was related to, but distinct from, Mondrian's. Although abstract, this composition is rooted in Nicholson's ongoing preoccupation with his late Cubist still-life paintings. Even at the height of his work on 'purely' abstract paintings and reliefs Nicholson continued to produce still lifes. In *1934 (painting)* the black right-angled form, on the right-hand side, echoes the partial tabletops and legs from his contemporaneous still-lifes (see, for example, fig. 7), supporting and framing Nicholson's arrangement of forms.[5] The painting also carries forward Nicholson's love of worked and weathered surfaces. It is most clearly expressed by the scratched and abraded greyish area, on the right-hand side of the composition, that appears to extend underneath the black form and is seen through the circle, which is now perceived as hole. This establishes a sense of depth, confirmed in the rest of the composition by Nicholson's chromatic and formal arrangement of the planes, which appear to advance or recede depending

1 For a discussion of Nicholson's place within Barr's categorisation of 'geometrical abstract art' see Christopher Green's essay in this publication, pp. 14–18.

2 *1933 (vertical painting)*, 1933, oil and pencil on wood, 47 × 14 cm, private collection, and *1933 (painting)*, oil and pencil on canvas, 20 × 35.5 cm, private collection.

3 See Christopher Green's essay in this publication, note 9, p. 36.

4 Letter from Ben Nicholson to John Summerson, 3 January [1944] (TGA 20048.1.38); a slightly edited version of this letter was published in Summerson 1948, pp. 12–13.

5 This crossover between Nicholson's tabletop still-lifes and his abstract works is made most explicit in his *1937 (painting)* (fig. 49).

on their colouring and seem complexly layered. Whereas Mondrian's paintings eliminate any trace of a figure/ ground relationship in favour of absolute surface flatness, Nicholson's abstractions are fundamentally concerned with arrangements of forms that create sensations of depth, in ways profoundly connected to his figurative art. Indeed, Nicholson's habit of setting his abstract compositions upon a neutral coloured background or framing surround, as seen here, gives the impression that the entire block of forms is an object in its own right and makes explicit the notion of figure and ground. These concerns, as expressed in paintings such as the present work, are also entwined with Nicholson's work on the white reliefs, which use the same basic vocabulary of forms (see for example cat. 5). Nicholson's developing language of abstraction emerged at this time as a dialogue between carving and painting.

Understanding the important differences between Mondrian and Nicholson's work is crucial to appreciating the nature of their creative relationship. However, overlaying those differences is Nicholson's developing alignment with the broad tenets of Mondrian's ongoing project to achieve taut equilibrium through a stripped-down vocabulary of linear form and an absolute clarity of colour relationships. *1934 (painting)* marks a beginning of this and anticipates works of the next few years in which Nicholson pushes the approach to his limits. They include the austerely black and white *1935 (painting)* (fig. 42), which is a distillation of the right-hand side of this composition. The present work also prefigures canvases such as *1937 (painting)* (cat.14), which develop the device, used here, of a near-central small block of strong colour around which the rest of the composition is arranged. BW

4

Piet Mondrian (1872–1944)
Composition with Double Line and Yellow

1932
Oil on canvas, 45.3 × 45.3 cm
B237
The Scottish National Gallery of Modern Art, Edinburgh

Mondrian wrote to Winifred Nicholson on 20 January 1935 giving her his price range, 5000 to 10,000 francs, and telling her that he was willing to accept a special price of 1500 francs from her and "other friends" for "the one with red".[1] Within a week, he was asking the same price for "the little white and yellow [one], the only [painting] that I still have from a few years ago".[2] In May she bought *Composition with Double Line and Yellow* by instalments.[3] Ben was in Paris to see Winifred and the children at the end of the year, and just after Christmas he wrote to Barbara Hepworth that a photograph of one of her recent sculptures on the mantelpiece of Winifred's flat "looks very nice in between my white relief ... and a new Mondrian ptg".[4]

By the time Winifred travelled with Mondrian to help him with his move to London in September 1938, they were friends who had seen each other often in the previous two years while Ben's contact with him had only been by letter. Winifred in Paris and Ben in London became, in effect, agents seeking sales for Mondrian among their friends.[5] Their efforts made England, with the United States, the most important market for Mondrian's work in the later 1930s.[6]

Winifred's purchase, *Composition with Double Line and Yellow*, may be small, but it is a work of considerable importance as a springboard for the new departure in Mondrian's work of 1932.[7] It is one of two

paintings of that year to deploy the double line, an initiative that he told his old De Stijl architect friend J.J.P. Oud in December was occupying much time and which made for "greater clarity".[8] Yve-Alain Bois sees its implications as not at all in the direction of clarity; he stresses a new ambiguity that is created between line and plane. Are the lines and the interval between them to be taken as a single strip-like plane, or a single line, or two lines separated by a narrow interval?[9] The very elements with which Mondrian worked have lost their clear distinctiveness. Moreover, if the double line is read as two separate lines, the white 'silence' of the painting is broken by a sudden double beat. The balance of Ben Nicholson's white reliefs is condensed and contained, so the possibilities opened up in this picture for the proliferation of lines giving a new rhythmic energy to Mondrian's composing may have escaped him when he saw it in Winifred's Paris flat. Its spare economy would not have.

There are just four lines and a single plane of yellow to activate the white expanse. From 1925, Mondrian had tended to minimise the size and quantity of his colour planes; in their increasingly white surroundings the intensity of primary colours was, he considered, so great that a little was usually enough. As he put it in 1926, "Generally, equilibrium implies a large area of non-colour or empty space opposed to a comparatively small area

1 *"Pour vous ou d'autres amis je demande 1,500 fr. pour cette chose ... (celui avec le rouge)"*: letter from Piet Mondrian to Winifred Nicholson, 20 January [1935], (RKD).
2 Letter from Piet Mondrian to Winifred Nicholson, 26 January 1935 (RKD).
3 The last instalment is mentioned in a letter from Piet Mondrian to Winifred, 8 July 1935 (RKD).
4 Letter from Ben Nicholson to Barbara Hepworth, 29 December 1935, (Hepworth Archive). Mondrian himself wrote to Winifred (2 January 1936): *"Je suis très heureux que mon tableau plaît à vous deux"* (RKD).
5 Winifred facilitated the sale of Mondrian's paintings to her sister-in-law Nan Roberts and to her pianist friend Vera Moore. Ben acted as intermediary with Helen Sutherland, Marcus Brumwell and Leslie and Sadie Martin. He even took receipt of a Mondrian sent via the Lefevre gallery. See also Sophie Bowness's essay in this publication, pp. 47–49.
6 This is a point made in Bowness 1990, p. 782.
7 This is discussed in my essay in this publication, pp. 29–31.
8 Letter from Piet Mondrian to J.J.P. Oud, 22 December 1932, cited in Joosten 1998, p. 366.
9 Bois explores Mondrian's new departure of 1932 in Yve-Alain Bois, 'The Iconoclast', in Bois, Joosten, Rudenstine and Janssen 1995, pp. 356–58.

of colour or material".[10] The painting is still in its original frame, which was made by Mondrian himself, another element of the utmost simplicity integral to it. By the early 1930s, he was using nothing more than a strip of wood painted white tacked to the flanks of the stretcher, the whole then fixed to a backboard also painted white. In this way he made the painting continuous with the white of the wall, allowing colour placed at the edges to radiate out into it, and by keeping the strip frame recessed from the picture surface he simultaneously enhanced the presence of the work as an object. Nicholson also considered framing to be an important aspect of his works, although he used his frames more to contain than Mondrian (see cat. 14).[11]

At one point in its early life this painting's status as an object was seriously threatened. In March 1936, Winifred left it at Bankshead, her Cumbrian farmhouse, where a pot of black ink was upset over it during spring cleaning, which left "a very large mark all over the yellow square".[12] Mondrian "went pale" when he heard about it.[13] Early in June, Winifred informed Ben that she and Domela in Paris had worked "all one afternoon and got the ink all off the Mondrian."[14] Its paint coats were so thick that it "stood a great deal". A little later Mondrian wrote to her that he had finally cleaned it off with sand paper himself and would soon finish the job by adding new coats.[15] She had the picture back by November; a photograph of it hanging in Bankshead (fig. 43) shows how well it fitted there. CG

10 Piet Mondrian, 'Neo-Plasticisme: De woning – de straat – de stad' (dated Paris 1926), in *Internationale Revue i10*, January 1927; translated as 'Le Home – la rue –la cité', in *Vouloir*, Lille, 1927; translated as 'Home – Street – City', in Holtzman and James 1987, p. 209.

11 For his framing, see Nicholson's letter written to the Tate Gallery, 28 June 1979, cited in Hackney, Jones and Townsend 1999, p. 162. Also see Matthierson 2008, note 43, pp. 112–13.

12 Letter from Winifred Nicholson to Ben Nicholson, 23 March 1936 (postmark) (TGA 8717.1.1.1761).

13 Letter from Winifred Nicholson to Ben Nicholson, undated [*c*. April 1936] (TGA 8717.1.1.1762).

14 Letter from Winifred Nicholson to Ben Nicholson, 4 June 1936 (postmark) (TGA 8717.1.1.1763).

15 *"Cela vous ferez plaisir d'apprendre que j'ai pu enlever l'encre du tableau tout à fait, grace à la couche épais de peinture. Je l'ai fait avec du papier verre et rien n'y est plus des taches. Je le donnerai quelques couches et après le tableau sera tel qu'avant le debacle"*: letter from Piet Mondrian to Winifred Nicholson, 17 June 1936 (RKD).

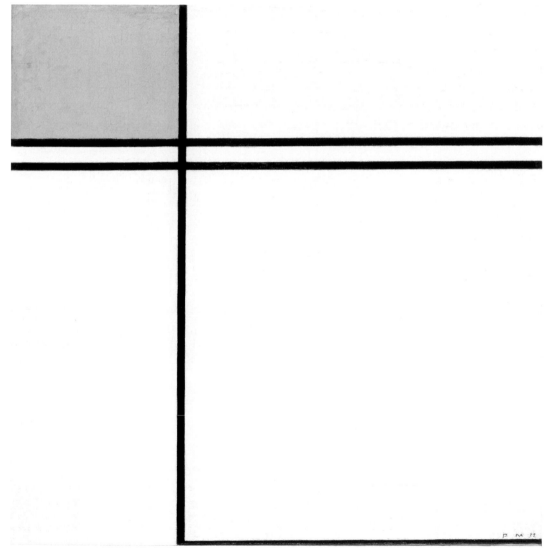

4

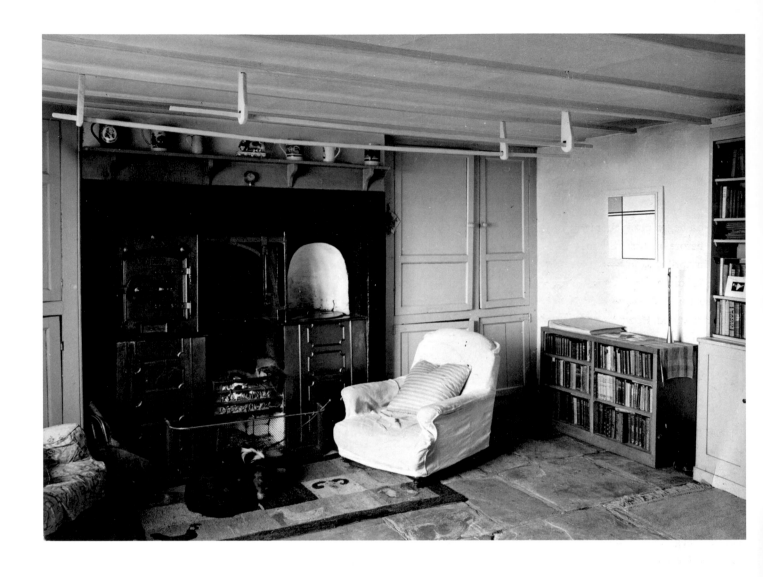

FIG. 43
A view of the front kitchen of
Winifred Nicholson's house Bankshead,
Cumberland, showing Mondrian's
Composition with Double Line and Yellow,
1932, here cat. 4, photograph
late 1936
Photographer: Arthur Jackson
Estate of Arthur Jackson Hepworth
© 2012 Mondrian/Holtzman Trust
c/o HCR International Washington DC

5

Ben Nicholson (1894–1982)
1935 (white relief)

1935
Oil on carved board, 54 × 64.2 cm
Scottish National Gallery of Modern Art, Edinburgh

Nicholson began producing white reliefs shortly before his first visit to Mondrian's studio in April 1934, having first experimented with relief carving the previous year (see, for example, cat. 1). The origins of Nicholson's reliefs are varied. However, this remarkable series, which he made – in their purest, whitest forms – until the early 1940s, is closely associated with his relationship with Mondrian, which spanned this same period. The white reliefs have often been seen as the high watermark of Nicholson's engagement with international modernism, white being the movement's signature colour – "the spiritual colour of our day" as Theo van Doesburg claimed in 1930.[1] John Russell suggested later that "BN's reliefs belong to a new world which had been begun by Gropius and Mies van der Rohe and Mondrian and not to the world which was still waving a last farewell to the nineteenth century".[2] The present work is a particularly refined example from the first phase of his work on the white reliefs, when he was working freehand and creating his forms without the aid of a ruler or compass. It distills the formal elements of Nicholson's major large relief of the previous year, *October 2 1934 (white relief – triplets)* (fig. 44) to create an apparently simple arrangement of a circle and a near-square, carved into one larger rectangular board. Its formal purity, absence of colour and relatively small scale make it particularly comparable with Mondrian's small *Composition with Double Line and Yellow*, 1932 (cat. 4), which Winifred Nicholson purchased in May 1935. Indeed, if one feature of Mondrian's and Nicholson's works of the 1930s brings them together most closely, it is their exploration – in different ways – of the possibilities of using white expanses in their compositions. Mondrian was reducing the size his planes of strong colour and pushing them to the margins, whilst Nicholson was covering his relief carvings in blankets of white oil paint.

However, the impact of Nicholson's white reliefs is not an assertion of some puritanical modernist fantasy of art purged of subjectivity, human touch and emotion, although this is what some early critics accused him of espousing (see cat. 8). Even a cursory look at *1935 (white relief)* comprehends the irregularities of its basic shapes and the different tool marks on its various carved surfaces, as well as the texture of the wooden board itself. These express the hand-made and idiosyncratic character of the relief – one senses its form emerging from the process of its making rather than conforming to a strict blueprint. Nicholson himself later underlined this by claiming, perhaps not entirely accurately, that he stumbled upon the idea of making reliefs by accident, when a piece of plaster had cracked and fallen out of a board he was preparing, inspiring him to carve it further.[3] Several art historians have argued that the

1 Theo van Doesburg, *Art Concret*, Paris, April 1930.
2 Russell 1969, p. 26.
3 Letter from Ben Nicholson to Charles Harrison, 30 November 1966 (TGA 839.2.19.2); cited in Harrison 1981, p. 262.

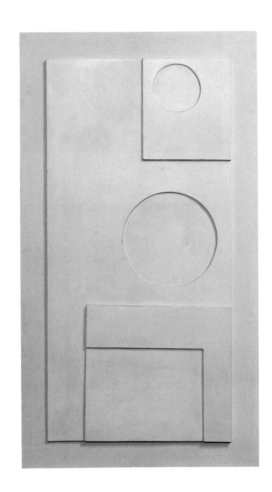

white reliefs relate strongly to the ethos of
'truth to materials', shared by artists and
writers in his immediate circle in Hampstead,
notably the sculptors Henry Moore and
Barbara Hepworth.[4] Nicholson's relationship
with Hepworth was important in this regard,
and her influence, not to mention the use
of her tools, fuelled his work on the reliefs.
Chris Stephens has also drawn attention to
the wider revival of English craft traditions
during this inter-war period, which he
connects with the hand-carved and worked
surfaces of Nicholson's white reliefs.[5]
Nicholson himself professed to his friend
Herbert Read that contemporary art had to
have its "grass roots" in indigenous culture.[6]
It is telling in this regard that Hepworth's
article for *Circle* is accompanied by a page of
photographs of Stonehenge, and later in the
publication one of Nicholson's white reliefs
is illustrated next to a pre-Columbian stone-
carving from Tiahuanaco.[7]

The apparent purity and simplicity of
1935 (white relief) belies the complex range
of meanings and contexts that it activates.
Like comparable Mondrians, the relief holds
out the promise of a pure transcendental
aesthetic experience. But for Nicholson
this did not involve erasing the marks of its
making, materiality and sense of rootedness.

BW

4 See, for example, Button 2007,
 pp. 35–38.
5 Stephens 2000, pp. 225–47.
6 Letter from Ben Nicholson to Herbert
 Read, 24 January 1936 (TGA 8717.1.3);
 cited in Button 2007, p. 36.
7 Martin, Nicholson and Gabo 1937,
 pp. 117 and 129.

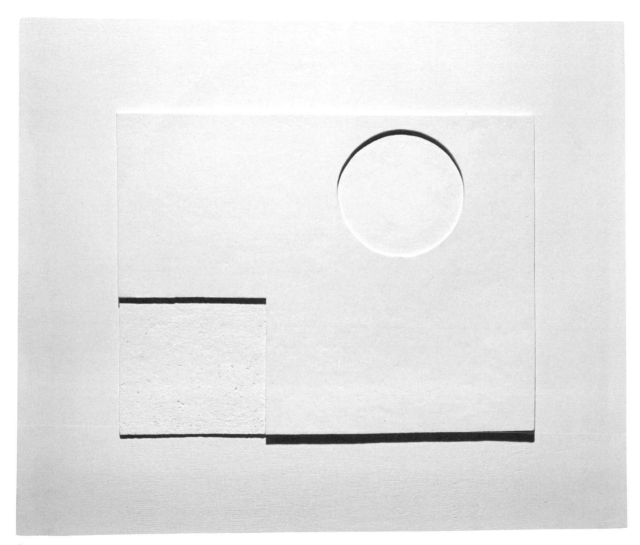

5

6

Piet Mondrian (1872–1944)
Composition B/(No II), with Red

1935
Oil on canvas, 80 × 63.2 cm
B254
Tate, London
(Accepted by H.M Government in lieu of tax with additional payment (General Funds)
made with assistance from the National Lottery through the Heritage Lottery Fund,
the Art Fund, the Friends of the Tate Gallery and the Dr V.J. Daniel Bequest)

This painting was exhibited in the mid 1930s with the title (supplied by Mondrian), *Composition B*. It was shown in two key exhibitions, 'These – Antithese – Synthese', in the new Kunstmuseum in Lucerne, and 'Abstract and Concrete', in Oxford, Liverpool, London and Cambridge. As its exhibition title suggests, the first of these, held February to April 1935, set up antitheses. Mondrian's *Composition B*, with two other canvases, was hung opposite a group of Kandinskys. The painter Hans Erni, the exhibition's organiser, wrote of Mondrian supplying "an impersonal, bare architecture which may serve the new generation as a basis for further organic creation." Nicholson was shown in the last room of the exhibition, with iron sculptures by Julio González, "concretions" by Jean Arp, heads by Alberto Giacometti and mobiles by Alexander Calder. Erni commented: "The basis created by Mondrian is used by Nicholson as a starting point for his reliefs."[1] He compounds the false impression that the white reliefs are directly based on Mondrian's Neo-Plasticism, but also presents Mondrian as an artist *from* whom Nicholson departs.

The second exhibition to which Mondrian sent *Composition B* was one in which Nicholson and Barbara Hepworth took a very active interest, though they seem not to have been able to dominate its organiser, a young Oxford graduate, Nicolete Gray. It was a project that caused enormous excitement among supporters of abstraction.[2] From October 1935, it repeatedly intrudes on Ben and Winifred Nicholson and Hepworth's correspondence, and Mondrian joins in too. In particular, they are appalled by publicity material that uses a "cribbed [cropped] Mondrian" for the cover.[3] The project was organised to promote abstract art in full competitive awareness of the International Surrealist exhibition which was due to open in June. In London, however, at the Lefevre Gallery, the three Mondrians – with *Composition B* double hung with *Composition C (No. III)* (cat. 7) – were crammed on to a wall with an enormous Miró of 1933, which is easily legible, despite its high degree of abstraction, as a figure from whom tumescent growths are extruded on all sides (fig. 45).[4] On the wall at right angles to the Mondrians a large Nicholson white relief only just finished made a much more sympathetic companion.[5] A further white relief by Nicholson hung on the other side of the Miró (cat. 11). Winifred, writing from Paris, says nothing about letting Miró crowd Mondrian, but comments: "What bad hanging I should have said to put 3 Mondrians so close to one another".[6] They seem to have had no room to expand.

Just slightly proud of its white painted strip frame and backing board, the activated picture surface of *Composition B*, its intense red plane pushed right up to the edge of the format and all but one of its lines hitting the

1 Hans Erni, 'The Lucerne Exhibition', *Axis*, London, no. 2, April 1935, p. 27.

2 *Axis* announced it as a major international project in its fourth number, November 1935, and dedicated its fifth number, Spring 1936, to it. See further Sophie Bowness's essay in this publication, p. 47.

3 Hepworth told Nicholson that Jean Hélion had said he would not exhibit "if the show was called abstract only and so Abstract and Concrete came into being": letter from Barbara Hepworth to Ben Nicholson, before 24 January 1936 (TGA 8717.1.1.235). She would have received a day or two later a letter from Nicholson in which he complained about an announcement in the *Gaceta de Arte*: "why a cribbed Mondrian for the cover?": letter from Ben Nicholson to Barbara Hepworth, 24 January 1936 (Hepworth Archive).

4 Joan Miró, *Painting*, 1933, oil on canvas, 146 × 114 cm, with Perls Galleries, New York, 1989.

5 Ben Nicholson, *1936 (white relief)*, oil on carved board, 106.8 × 135.9 cm, Dallas Museum of Art.

6 Letter from Winifred Nicholson to Ben Nicholson, [April] 1936 (TGA 8717.1.1.1762).

104

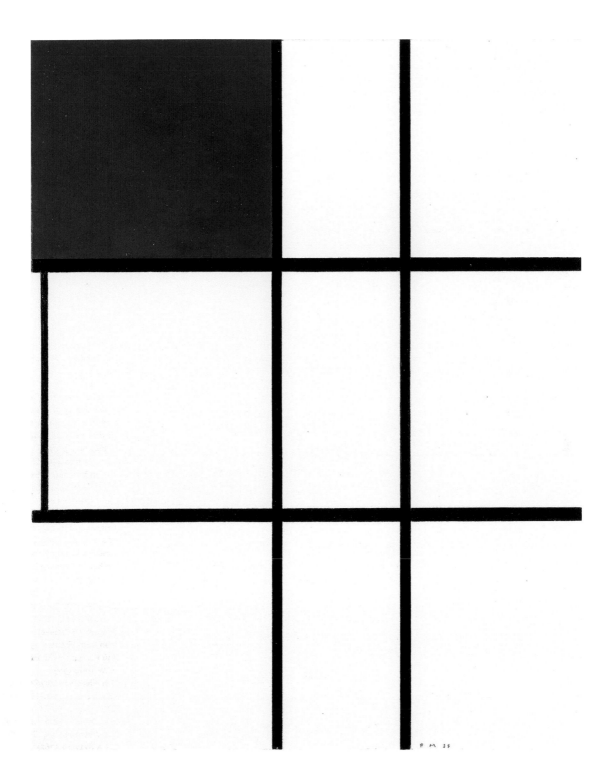

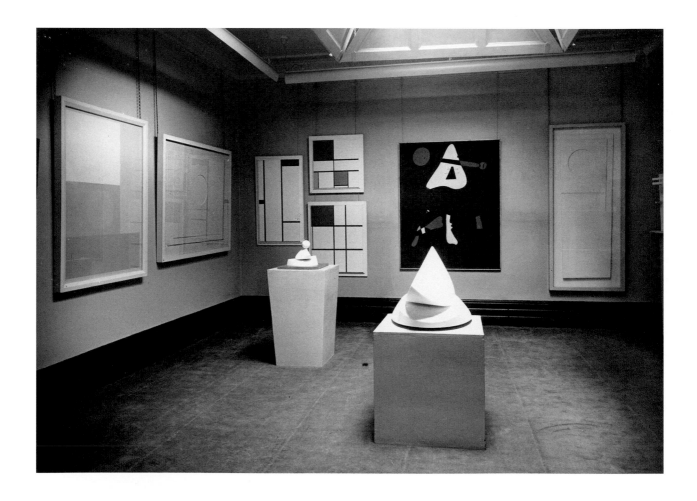

FIG. 45

A view of the exhibition, 'Abstract and Concrete', at the Lefevre Gallery, London, 1936, including, on the far wall, Mondrian's *Composition A (No.I)*, 1935 (first state), B260; *Composition B/ (No.II), with Red*, 1935, here cat. 6; *Composition C (No.III) with Red, Yellow and Blue*, 1935, here cat. 7, and Nicholson's *1936*

(white relief), here cat. 11
Photographer: Arthur Jackson
Estate of Arthur Jackson Hepworth

edges too, is indeed an expansive work. It is also a composition in which Mondrian begins to explore the dynamic potential of the double line. The central pair of verticals are just wide enough apart to avoid becoming a double line, but the interval between them is close enough for it to be read with them as a bounded white plane at the same time as being two lines being pulled apart by the horizontals that cross them. This pair of verticals is placed just minimally to the right of centre so that they tug back against the expanding force of the red upper left, and that rightward pull is strengthened by the way the vertical to the left has been shifted the merest few millimetres from the left flank of the canvas. This last adjustment has still another effect: it quickens the pulse of verticals once the line of the picture edge comes into play with the thin black line so close to it.

On 13 April 1936 Mondrian wrote to Nicholson anticipating the London opening of 'Abstract and Concrete', asking him to remove any marks that the earlier showings might have left on his pictures, for which he advised the use of benzene.[7] Less than a month later, he was writing very happy to have learnt from Hélion and "Mad[ame]. Winifred" that he has sold a picture, and adds that the success of the London exhibition is good for "all abstract art".[8] With Nicholson as intermediary, he had sold *Composition B* to Helen Sutherland, heiress to the P & O shipping-line fortune, a friend Ben had made with Winifred in the mid 1920s. With another of his friends, Marcus Brumwell (who would later buy a Mondrian too), she had been one of the sponsors of 'Abstract and Concrete'. She was also a buyer of Nicholson's work and a generous source of support for Ben and Barbara when the costs of parenthood became too much, though at the same time a strong champion of Winifred in her relationship with Ben. Mondrian's letter marking his sale of *Composition B* also records pleasure at hearing that his pictures "were not damaged" on their way to London.[9] CG

7 Letter from Piet Mondrian to Ben Nicholson, 13 April 1936 (TGA 8717.1.2.2991).

8 "...tout l'art abstrait": letter from Piet Mondrian to Ben Nicholson, 4 May 1936 (postmark), (TGA 8717.1.2.2992).

9 He was happy "...aussi que mes tableaux ne sont pas abimés": letter from Piet Mondrian to Ben Nicholson, 4 May 1936 (postmark) (TGA 8717.1.2.2992).

7

Piet Mondrian (1872–1944)
Composition C (No.III), with Red, Yellow and Blue

1935
B261
Oil on canvas, 56.2 × 55.1 cm
Private collection, on loan to Tate, London

Writing to Nicholson on 9 May 1936, Mondrian was pleased to report that he had sold a painting he had still to finish for 4,000 francs, and mentioned that Winifred Nicholson had changed her mind over which picture of his to buy next, meaning that "the other can stay for the moment in London with Mad[ame] Gray."[1] It would have encouraged him (and Nicholson) to be writing of buyers, because also in this letter he agreed with Nicholson that they could not accept Alfred H. Barr Jr's opinion in his recently published *Cubism and Abstract Art* that "geometric abstraction" was in decline. The "other" picture he mentioned was *Composition C*, and "Mad[ame] Gray" was Nicolete Gray, the organizer of the exhibition 'Abstract and Concrete'. That exhibition was still on in London at the Lefevre Gallery, where the picture was double hung with *Composition B* (fig. 45); it would re-open at the Gordon Fraser Gallery in Cambridge on 28 May. Opting as ever for the most deadpan titles possible, Mondrian had his three exhibits there listed as "Compostion A, B and C".

It is possible that this picture was never returned to Mondrian after the end of the exhibition's run in Cambridge in mid June 1936, because four months later he was writing to Winifred as intermediary in "Madm Gray's" possible purchase of "the picture with three colours", asking that she be offered it for 1,500 francs, the reduced price Winifred had

paid for her picture, and giving her the option of paying in instalments.[2] By November, he was accepting Nicolete Gray's agreement to that price and asking for a first payment of 1,000 francs. The following month he wrote again to her with advice about the cleaning of his paintings. He referred to "the other picture", but this may well be hers, because he mentions red, blue and yellow. He suggests using a *"chiffon"*, white soap and warm water, reassuring her that if there is some loss of the red and yellow it will not matter because the paint layer is thick enough.[3]

Between 1932 and 1939, *Composition C* was the only painting in which Mondrian brought all three primaries, red, yellow and blue together. It gives the work unusual punch. Between 1921 and 1925, this had been his usual practice, but since 1925 it had become increasingly rare. The last work in which he had done it was from the "classic" series, a variant on cat. 2, and *Composition C* is a development from the compositional type repeated in that series.[4] Mondrian shifts the central vertical to the left, replaces the central horizontal with a pair of horizontals just wide enough apart to avoid being read as a double line, and shrinks the not-quite-square so that it can remain squarish and fills it with blue. The weight of this blue plane, produced by the intersection of lines, is judged to counter the force of the expanding red plane above, and the two of them are countered by the smaller, more

1 *"Elle préfère prendre un autre tableau de sorte que l'autre peut rester pour le moment à Londres chez Mad. Gray"*: letter from Piet Mondrian to Ben Nicholson, 9 May 1936 (TGA8717.1.2.2993).

2 *"…le tableau avec les 3 couleurs"*: Piet Mondrian to Winifred Nicholson, 14 October 1936 (RKD).

3 Letter from Piet Mondrian to Nicolete Gray, 30 November 1936, cited in Joosten 1998. p. 382.

4 This is *Composition D, with Red, Blue and Yellow*, 1932, oil on canvas, 42 × 38.5 cm, B233, private collection.

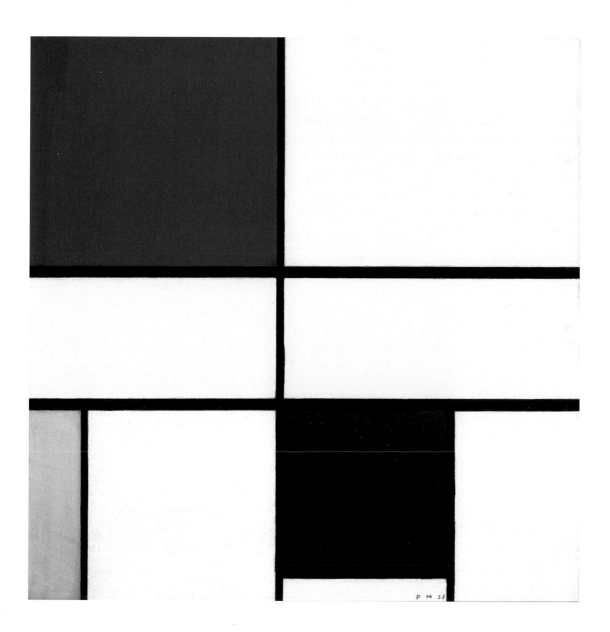

intense and radiant slat of yellow. Mondrian introduces complication where there was extreme simplicity, and by speeding up the linear rhythms (the paired horizontals squeezing together and pulling apart) and by heightening the force of his colours he destabilizes all relationships before working once more to achieve equilibrium.

In this instance the openness of the approach that led to this seemingly decisive moment of poise is conveyed by a small group of compositions, closely related to *Composition C*, which Mondrian left unfinished (see, for example, fig. 6).[5] They reveal the light sketching in charcoal directly on the primed canvas that only after successive partial erasures and tentative re-starts led to firm enough decisions for lines and crossings to be given real definition in black oil. Colour decisions are finalized late as well. A process that conveys something close to anxiety in the face of possible failure is in the end concealed by the clarity of Mondrian's divisions, the saturation of his colours and the opacity of his white. Nicholson saw unfinished work like this on his visits to the studio in 1934–35, as did Barbara and Winifred; they knew that Mondrian was not the rational intellectual in his working practice that hostile critics called him. What he saw in this open-ended state, Nicholson called "projects" – ideas which had possible but not certain futures.[6] CG

5 These are *Composition with Double Line (unfinished)*, 1934, oil on canvas, 57 × 55 cm, B246, private collection; *Composition with Double Line (unfinished)*, 1934, oil on canvas, *c.* 55 × 55 cm, B247, whereabouts unknown; and *Composition with Double Lines (unfinished)*, 1934, oil on canvas, 55.5 × 54.5 cm, B248, oil on canvas, 57 × 55 cm, Deutsche Bank, Frankfurt (fig. 6).

6 "A very good project," he remarks about the diamond composition he saw underway and sketched for Hepworth: letter from Ben Nicholson to Barbara Hepworth, 29 December 1935 (Hepworth Archive) (fig. 8). This composition was completed in 1938. It is *Lozenge Composition with Eight Lines and Red / Picture no. III*, oil on canvas, diagonal 140 cm, sides 100 × 100 cm, B282, Fondation Beyeler, Riehen, Basel (fig. 9).

Ben Nicholson (1894–1982)
1935 (white relief)

1935
Oil on carved mahogany, 101.6 × 166.4 cm
Tate, London
(Purchased with assistance from the Contemporary Art Society 1955)

This celebrated carving is one of Nicholson's largest white reliefs. Its monumental scale is a mark of his confidence in this new type of work, which he had only begun to produce the previous year. The relief is carved from a leaf of mahogany tabletop, which Nicholson apparently bought in Camden Town and transported back to his Hampstead studio on the number 24 bus.[1] The studio had recently been whitewashed – the white interiors of Mondrian's Paris studio having made a powerful impression upon him the previous year. Nicholson must have completed the relief in the first few months of 1935 because it was reproduced, along with essays on Nicholson by Herbert Read and Jan Tschichold, in late April in the second issue of *Axis*.[2] This journal had recently been founded by Myfanwy Evans with John Piper to promote abstract art in England. Later in the year, it was one of the works Nicholson exhibited at his one-man show at London's Lefevre Gallery, which included a group of his white reliefs. These events were part of a confluence of activities associated with abstraction in England at this time, which also included the first exhibition of exclusively abstract art by the 7 & 5 group, led by Nicholson and Hepworth and others, at the Zwemmer Gallery in October 1935.

Nicholson's white reliefs were an important part of the debates that arose in the English art world at the time about the cultural and social value of abstract art.

Because of its scale and public exposure, the present work was undoubtedly one of the white reliefs that informed critical thinking and provoked contemporary reaction. Virginia Button has characterised the majority of critical responses to the white reliefs at the Lefevre show as being fairly hostile. She suggests that critical opinion was led by the assumption that the works were "the product of foreign ideology" and that the "emptiness of the reliefs threatened to push painting to the edge of extinction".[3] Critics understood that Nicholson was striving for aesthetic purity, but the *Manchester Guardian* felt, for example, that they were "so rarefied" that only a "disembodied spirit" could appreciate them.[4] One critic went as far as to suggest that Nicholson's white reliefs were "a lavatory artform, a clean antiseptic bathroom art".[5] The most high-profile criticism came from Kenneth Clark, then Director of the National Gallery: after Nicholson's show had opened, Clark felt provoked to write a damning appraisal directed at the abstract movement in England; he spoke of its "fatal defect of purity", which expressed "the poverty of human invention when forced to spin a web from its own guts".[6]

Nicholson's supporters, such as Paul Nash and Herbert Read, defended the white reliefs. Read argued that they were part of the progression of Nicholson's artistic development from representation to the realm of

1 This is recounted in Lewison 1993, note 64, p. 220.
2 *Axis*, London, no. 2, April 1935, p. 15.
3 Virginia Button, *Ben Nicholson*, Tate Publishing, London, 2007, p. 38.
4 *Manchester Guardian*, 1 October 1935, cited in Checkland 2000, pp. 148–49.
5 Hugh Gordon Porteus, 'Mr Ben Nicholson', in *New English Weekly*, vol. 17, no. 27, 3 October 1935, p. 414, cited in Checkland 2000, p. 149.
6 Kenneth Clark, 'The Future of Painting', in *The Listener*, no. 14, 2 October 1935, p. 544; cited in Checkland 2000, p. 149.

pure forms. Both Read and Nash made the case for the white reliefs being ideally suited to the new living environments being introduced to England by modernist architects (Wells Coates's Lawn Road Flats had opened in Hampstead the previous year). "They are the best kind of painting to go with the new architecture …. They are integral with light and precision, with economy and cleanliness," wrote Read.[7] As Sarah Jane Checkland has noted, such a defence played into the hands of those already hostile to the importation of these modernist aspirations.[8] J.M. Richards argued, in the November 1935 issue of *Axis*, that defining the white reliefs as a decorative feature for modern architecture undermined their true status. "Ben Nicholson's reliefs have an affinity with modern architecture; that is a test of their vitality … but his reliefs are also emphatically carvings in their own right." He continued, "Ben Nicholson has returned in his present phase, inspired by Mondrian, to the reality of his, not the architect's, limitations: the rectangular frame, the panel, the personally conducted tool. With these Ben Nicholson is exploring the potentialities of light on differentiated surfaces."[9]

Richards gets close to Nicholson's intended project for his reliefs, as far as we can gauge from the artist's limited writings, but more importantly from the works themselves. In *1935 (white relief)*, the thickness of the mahogany table-leaf allowed Nicholson to explore the interplay of surfaces over a wider expanse and with greater sculptural depth than before. The role of the shadows in the composition is consequently given more prominence – something Nicholson liked to emphasise by lighting the reliefs from the side. Richards's point about Nicholson working intuitively – "the personally conducted tool" – is very much at stake in this relief. It combines the sort of freehand carving that had characterised most of his reliefs up to this point with the use of compass and ruler, which Nicholson would now favour for a period (see, for example, cat. 9). It seems likely that Mondrian had some bearing upon this move towards greater control and linearity. It is interesting to note that Nicholson chose to present Mondrian with a photograph of this relief as an example of his latest work that Mondrian had requested, to pin on the wall of his Paris studio.[10] BW

7 Herbert Read, 'On Ben Nicholson's Recent Work', in *Axis*, London, no. 2, April 1935, pp. 15–18.
8 Checkland 2000, p. 149.
9 J.M. Richards, 'Ben Nicholson at the Lefevre: 7 & 5 at Zwemmer's', in *Axis*, London, no. 4, November 1935, p. 21.
10 See Sophie Bowness's essay in this publication, p. 44.

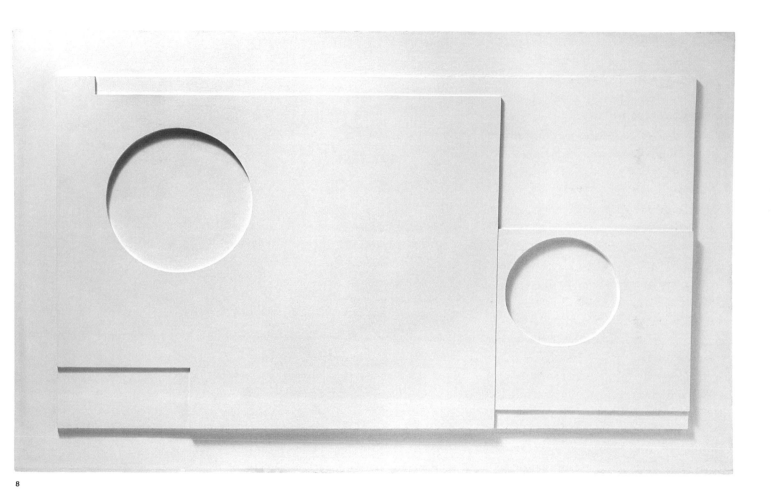

8

9

Ben Nicholson (1894–1982)
1936 (white relief)

1936
Oil on carved board, 73 × 99 cm
Bernard Jacobson Gallery, London

This was one of the four white reliefs that Nicholson chose to reproduce in the 1937 publication *Circle: International Survey of Constructive Art*, which he co-edited with Leslie Martin and Naum Gabo (see figs. 2-5).[1] *Circle* was the culmination of efforts to group, as a broad movement, an international array of principally abstract artists, together with architects and designers. These individuals were deemed to share what Gabo loosely defined as the "Constructive Idea in Art". This was understood as an abstract aesthetic, generated by constructions of lines, colours and shapes, which revealed ideal forms and fundamental harmonies underpinning human existence and the material world. 'Constructive' was also defined in the sense of individual and social improvement: "The Constructive idea prefers that Art perform positive works which lead us towards the best",[2] as Gabo put it. *Circle* was the major statement of this would-be artistic movement with utopian ambitions and it afforded Nicholson the opportunity to be paired with Mondrian at its forefront. The images of his four white reliefs were the opening sequence of illustrations, together with four paintings by Mondrian (including cat. 10; see also figs. 3–5).

The choice of the present work for inclusion in *Circle* is not surprising given that it is one of the most refined and iconic of the white reliefs. In many ways it was the successor of *1935 (white relief)* (cat. 5). Nicholson repeated the basic compositional elements of a circle and square, housed in one larger rectangle, but this time worked using ruled and compass-drawn lines. Its appearance in photographs is one of machine-finished perfection rather than hand-carved idiosyncrasy. It paired particularly well with the Mondrian paintings in *Circle*, not just in terms of the Dutchman's famously straight lines, but also because those chosen represented Mondrian's latest paintings in which white space commands large areas of the canvas. Also, Nicholson's insistence on having his white reliefs photographed in side-lit conditions, emphasising the shadow lines, meant that the images in *Circle* demonstrated very effectively the artists' shared use of black lines as a crucial compositional element – for Mondrian using paint; for Nicholson using light and shadow.

Photographs of Nicholson's and Mondrian's paintings and reliefs can blind us to important features of them. An actual encounter with the works immediately reveals that, even at their most austere, they are clearly hand made. Their physical reality also impresses upon us the fact that they are the product of an individual's considerable time and devotion. In some ways the smooth finish and ruled lines of *1935 (white relief)* actually heightens our awareness of the process of its making, because we begin to empathise with

1 Martin, Nicholson and Gabo 1937, pp. 17–19. The relief was also included in Nicholson's 1939 exhibition at the Lefevre Gallery (fig. 50).
2 Naum Gabo, 'The Constructive Idea in Art', in Martin, Nicholson and Gabo 1937, p. 9.

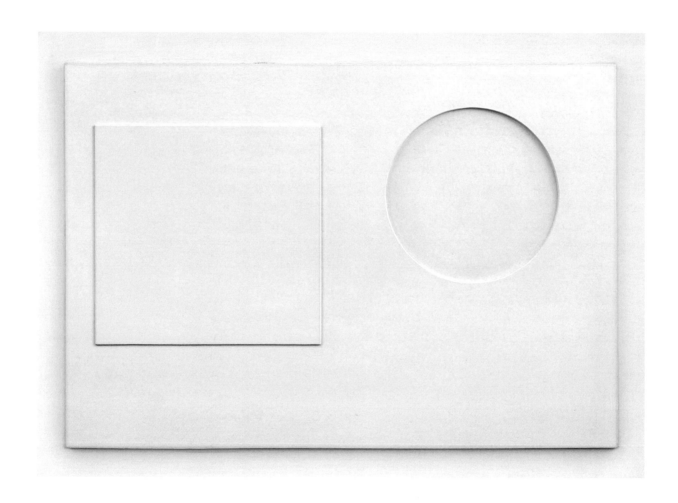

the concentration and effort involved in hand carving and finishing so precisely.

In the context of *Circle*, this relief could be thought of as a poster image for the new 'Constructive' art – a perfectly balanced and weighted arrangement of fundamental shapes. It is one of the most distilled of all Nicholson's reliefs, a synthesis of the elements that had gone into the development of this type of work over the past few years. We might think of it as the realisation of the ambition that Nicholson had stated to Winifred Nicholson in 1934, not long after his first visit to Mondrian's studio: "I know I need to work at logic and the whole building up of the true idea *marvellously and beautifully constructed*".[3] But if the relief makes the Constructive idea concrete, it does not do so baldly. The effect of light on the work is the crucial factor here. Nicholson's carved forms are in part sharply defined by the fall of light, and in part softened and smoothed by it into their surrounding surface. If Mondrian's black lines are fixed and emphatic then Nicholson's shadows are the opposite – mutable and subtly varied. The circle and square are not simply stated but are revealed through the interaction of light and shadows which shift very slightly as we alter our position in relation to the relief, inspiring thoughts of the infinitely variable nature of appearances. This chimes with Nicholson's later claim, "my reliefs are, when they succeed, not a 'picture' but a mental experience".[4] BW

3 Letter from Ben Nicholson to Winifred Nicholson, 30 April 1934, cited in Lewison 1993, p. 45.
4 Ben Nicholson, in *Ben Nicholson*, exh. cat., Galerie Beyeler, Basel, April–June 1968, unpaginated, cited in Virginia Button 2007, p. 48.

Piet Mondrian (1872–1944)
Composition White and Red: B

1936
Oil on canvas, 51.5 × 50.5 cm
B266
Philadelphia Museum of Art (A.E. Gallatin Collection, 1952)

Recalling the work he had seen in a visit to Mondrian's studio just after Christmas 1935, Nicholson told Hepworth that there were "some new ones where the black lines traverse the colours". Given the time that Mondrian took with every canvas, working on them alongside one another, it is probable that this picture was among these "new ones".[1] The new move made by Mondrian in this canvas was one Nicholson had the opportunity to consider closely, because one of the two other compositions dated 1936 where lines traverse a colour plane was a small painting shown in the exhibition 'Modern Pictures for Modern Rooms' held in Duncan Miller's London showroom that year, a picture which Nicholson had in his possession for a while (fig. 46). Mondrian consigned it to him for sale, so he had it to contemplate until he sold it before the end of the year to his architect co-editor of *Circle: International Survey of Constructive Art*, Leslie Martin and his wife Sadie.[2]

As in *Composition C (No. III)* (cat. 7), Mondrian breaks up the white surface of *Composition White and Red: B* with horizontals that squeeze together and pull apart activating the "empty" intervals between them, but now there are four of them. The two most central are close enough to make a pair but again are kept just far enough apart to avoid definitively fusing as a double line. They are thicker and so more intensely black

than the other lines and especially where they cross the two verticals they produce an optical 'popping' effect, which Mondrian would often allow to disturb the surface of his compositions from this date on. It is these thick, strong black horizontals that traverse the thin red slat placed up against the left edge of the painting. By interrupting the red in this way, Mondrian energizes it, pulling the eye back to its radiant leftwards expansion against the rightward pull exercised by the two verticals placed to the right of centre. Bois has argued, moreover, that by activating the intervals between the horizontals, especially where they traverse the white expanse, Mondrian counters the tendency to read a cross and so arrest movement by fixing attention on a static form.[3]

The story of this picture's sale in New York to the major American collector A.E. Gallatin is one that not only confirms Mondrian's international status in 1936 but also the degree to which Nicholson, with Mondrian and Hepworth, was bound into a three-way international network, connecting London, Paris and New York. *Composition with White and Red: B* was one of three Mondrians sent in October 1936 on consignment for sale to the New York Valentine Gallery.[4] Gallatin bought it almost immediately for the exemplary modernist collection on show in his Gallery of Living Art, which he had opened in Washington Square, New York, in 1927. His

1 Letter from Ben Nicholson to Barbara Hepworth, 29 December 1936 (Hepworth Archive). Also see note 10, below.
2 See letters from Piet Mondrian to Ben Nicholson, 4 May and 9 May 1936 (TGA 8717.1.2.2992 and 8717.1.2.2993). The work in question had been bought by Martin in December. The letter of 9 May shows that Nicholson refused to take any commission from Mondrian. The painting is *Composition (A), with Red and White*, 1936, oil on canvas, 43.2 × 33 cm, B262, 'Collection S'.
3 Yve-Alain Bois, 'The Iconoclast', in Bois, Joosten, Rudenstine and Janssen 1995, p. 357.
4 See Joosten 1998, B266, pp. 383–84.

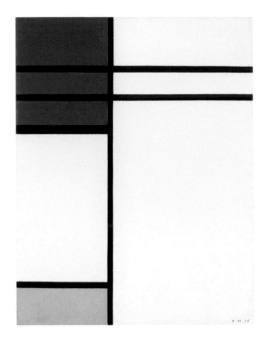

FIG. 46
Piet Mondrian, *Composition (A), with Red and White*, 1936, oil on canvas, 43.2 × 33 cm, B262, 'Collection S'
© 2012 Mondrian/Holtzman Trust c/o HCR International Washington DC

transatlantic role, helping with his funds to bind together English, European and American modernism, was crucial, as Lucy Inglis has shown.[5] A key intermediary between him, Mondrian, Nicholson and those around him was the French painter Jean Hélion, whose base moved between Paris and the United States, and who was close to both Mondrian and Nicholson. Gallatin and Hélion together had tried to get an international art magazine off the ground in 1934, keeping Nicholson apprised of the plan. As Hélion put it in a letter to Nicholson, it was to be "devoted to our art (those we like ...)", and should be "very strong against surrealism and litterature [sic] in painting".[6] Named *Plastic*, Hélion told Gallatin in September 1934 that he saw it as potentially being better received in England which "seems to be rather agitated with modern art problems", than in Paris, where "the interest for modern art is all platonic".[7] Indeed, in July he had visited England with Gallatin, having alerted

Nicholson that this was to meet artists and writers "who can work for the planned magazine".[8] Financial worries made Gallatin back out from funding it before the end of 1934, but Hélion's enthusiasm was carried over into support for Myfanwy Evans's closely related initiative, *Axis*, into which he poured his infectious energy, becoming an influential contributor. As Gallatin must have known, Hélion, like Nicholson, saw Mondrian's work not as a conclusion but as a starting point.[9] He bought from both Hélion and Nicholson as well as Mondrian; *1936 (Painting)* (cat. 13) was one of his purchases.

The final seal is set on *Composition – White and Red: B*'s international status in Paris, London and New York as a work and an image by the fact that Nicholson chose it as one of the four Mondrians illustrated to complement his four white reliefs in the painting section in *Circle* of which he was co-editor (figs. 3–5).[10] CG

5 My highly condensed account here depends on hers; see Inglis 2007, pp. 126–58.
6 Letter from Jean Hélion to Ben Nicholson, 18 June 1934 (TGA 8717.1.2.1564), cited in Inglis 2007, pp. 128–29.
7 Letter from Jean Hélion to A.E. Gallatin, 13 September 1934 (Archives of American Art, Gallatin Papers, roll no. 507), cited in Inglis 2007, p. 131.
8 Letter from Jean Hélion to Ben Nicholson, 27 June 1934 (TGA 8717.1.2.1565), cited in Inglis 2007, p. 130.
9 This was Hélion's strongly argued position in his two important contributions to *Axis*, 'From Reduction to Growth', *Axis*, London, no. 2, April 1935, pp. 19–24, and 'Poussin, Seurat and double rhythm', *Axis*, London, no. 6, Summer 1936.
10 Martin, Nicholson and Gabo 1937. It is captioned "2. Mondrian 1935–36". The dating supports the idea that this picture was started before the end of 1935 and could have been seen when Nicholson visited the studio late that December.

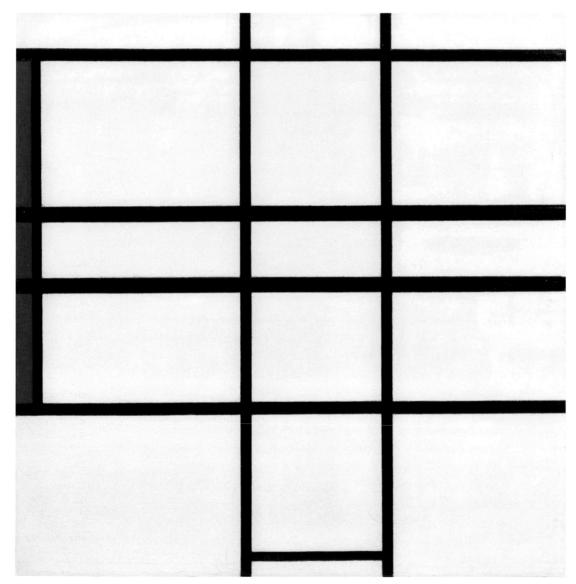

10

11

Ben Nicholson (1894–1982)
1936 (white relief)

1936
Oil on carved board, 178 × 73.5 cm
Private collection

Nicholson exhibited this monumental and large-scale white relief at the seminal exhibition 'Abstract and Concrete' in 1936. The exhibition was organised by the ambitious young art historian Nicolete Gray (with input from Nicholson and Barbara Hepworth, among others). After opening in Oxford it travelled to Liverpool, London and Cambridge.[1] It was an important platform for the cause of abstract art in England and offered a counterpoint to the 'International Surrealist Exhibition', which opened in London just as 'Abstract and Concrete' was closing in Cambridge. The artist Arthur Jackson took installation shots of the exhibition at its Oxford and London venues (see figs. 20 and 45). One of his shots of the installation of the exhibition at the Lefevre Gallery, London (fig. 45), shows the present relief hanging next to Joan Miró's huge canvas *Painting*, 1933,[2] on the other side of which were three paintings by Mondrian, including *Composition B/(No. II) with Red*, 1935 (cat. 6), and *Composition C (No. III), with Red, Yellow and Blue*, 1935 (cat. 7). There were two further works by Nicholson on the adjacent wall. This was the first time that Mondrian's work had been shown at exhibition in England and the pairing with Nicholson (despite the intrusion of Miró) was an important founding statement, for an English audience, of their shared aesthetic values.

The vertical format of this work had important predecessors in the development of Nicholson's reliefs, notably *1933 (six circles)* (cat. 1) and *October 2 1934 (white relief – triplets)* (fig. 44). Although it was not typical in his own work, Mondrian was also exploring the possibilities and difficulties of using a tall vertical format at this time (see cat. 18) and it was one of these works, *Composition A (No.1), with Red (First State)*, 1935, that was 'paired' with Nicholson's *1936 (white relief)* in 'Abstract and Concrete' – the two works 'bookending' the sequence of paintings on one wall. But whereas for Mondrian the challenge of a tall canvas lay in counteracting the force of his extended vertical lines, for Nicholson the interest lay in the idea of a stacked composition. In the present work the sense of stacking is more evident than in his earlier vertical reliefs, with the carved block-like forms having the appearance of being placed one on top of the other and being capped by the final block at the top, which has a circle carved into it. There is a certain degree of precariousness to the way in which the irregularly shaped blocks seem to be balanced, despite their sloping edges, which gives the composition an element of dynamic tension. This sense of forms just held in check, such that we can feel the forces acting within the composition, has important parallels in Mondrian's paintings, not least in his tall canvases.

However, with the present relief – which in fact appears more like a freestanding column – Nicholson's interests are above all

1 See Sophie Bowness's essay in this publication, p. 47.
2 *Painting 1933,* oil on canvas, 146 × 114 cm (with Perls Galleries, New York, 1989).

FIG. 47
Barbara Hepworth, *Monumental Stele*, 1936, blue ancaster stone, height 182.7 cm (damaged during World War II and destroyed)

sculptural, and in ways that connect most strongly to Hepworth's art rather than Mondrian's. The 'Abstract and Concrete' installation photographs show two of Hepworth's marble carvings arranged on the floor space in front of Nicholson's and Mondrian's works. Two of the works she included, *Two Segments and Sphere*, 1935–36, and *Carving (Two Segments)*, 1935–36, are among Hepworth's most radical explorations of stacked and balanced compositions of carved forms.[3] But it is her contemporaneous, large-scale *Monumental Stele*, 1936 (not part of the exhibition and destroyed during the Second World War; fig. 47) which relates most closely to this white relief. The comparison underscores the profound connections between Hepworth and Nicholson's artistic projects during this period. Hepworth's title, *Monumental Stele*, also makes explicit their shared fascination with ancient sculpture, from the prehistoric to the classical, and by no means limited to the European tradition. Like Hepworth's sculpture, Nicholson's *1936 (white relief)* prompts associations with ancient standing stones and totemic and monumental columns, without fixing a particular source.[4] The relief also explores what might be thought of as 'primary' or 'originary' sculptural acts – direct carving and stacking of forms. These concerns are intimately connected with Hepworth's sculptures but alien to Mondrian's paintings. BW

3 *Two Segments and Sphere*, 1935–36, white marble, 30.5 cm, BH 79, private collection, and *Carving (Two Segments)*, 1935–36, BH 77 (destroyed during World War II).

4 Hepworth's title, *Monumental Stele*, and the form of this work and cat. 11 prompts associations with a wide range historical cultures in which stelae are an ubiquitous feature of their different sculptural traditions, typically created as grave markers or commemorative monuments. Whilst the funerary stelae of ancient Greece are an obvious source, the stylised and large-scale Aksumite stelae also offer a compelling aesthetic comparison. It is interesting to note that 1936 was the year the Italian Army took possession of one of the largest and most famous ancient stele in Aksum, shipping it from Ethiopia to Rome the following year.

12

Piet Mondrian (1872–1944)
Composition in Red, Blue and White: II

1937
Oil on canvas, 75 × 60.5 cm
B272
Musée national d'art moderne, Centre Georges Pompidou, Paris

This is the one Mondrian that Nicholson was actually able to own. It was a picture that he could explore for himself over time. It first came into his life when Mondrian wrote to him on 21 April 1938 happy that Nicholson's friend Marcus Brumwell wanted to buy a picture. He was encouraged by this to send him more pictures to sell, and suggested the three then on show in the exhibition 'Abstracte Kunst' at the Stedelijk Museum in Amsterdam. One of these he sketches (fig. 48); it is *Composition in Red, Blue and White: II.* He mentions a special price for friends for a

picture this size of £40.[1] The picture comes up a second time in a letter of 14 June, which begins by thanking Nicholson for his "appreciation of my work." Here he sketches the composition again and offers to send him it at his own cost to await a buyer. The special price offered now, taking account of the strong pound sterling, is £20.[2] Nicholson was unable to find a buyer even at that price, and in the end, before Ben, Barbara and their children left London for Carbis Bay, St Ives, in August 1939, Mondrian gave the picture to them. It seems to have gone back to him

1 Letter from Piet Mondrian to
 Ben Nicholson, 21 April 1938
 (TGA 8717.1.2.3001).
2 Letter from Piet Mondrian to
 Ben Nicholson, 14 June 1938
 (TGA 8717.1.2.3006).

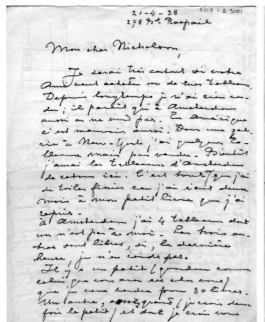
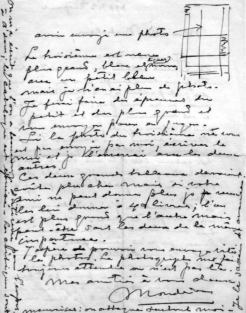

FIG. 48
Letter from Piet Mondrian to
Ben Nicholson, 21 April 1938,
which includes a sketch of cat. 12
Tate Archive, London

when he came to London in September 1938, because Nicholson later recalled him bringing them his "generous present" and staying for tea with the triplets. "As he walked away he remarked that all small children are barbarians."[3] It was temporarily left in the care of their friend Robert Ody, who subsequently took over 3 The Mall from them towards the end of 1939, after they had decided to stay in Cornwall. It was there when Mondrian visited Ody, also an English buyer of his work. "I forgot to tell you", Mondrian wrote to Ben and Barbara, "that I have had tea at Mr. Ody's and that I was agreeably surprised to see so well hung the picture you have of me."[4]

Composition Red, Blue and White II excludes even the suggestion of a cross, which the positioning of verticals and horizontals had risked in paintings of 1935–36, like *Composition B/(No. II)* (cat. 6), *Composition C (No. III)* (cat. 7) and *Composition White and Red* (cat. 10). While the two verticals to the left come close enough to be read together, they are shifted so far to the left that they cannot even begin to fix the central vertical of a cross. In tension here is the relationship between the lower and upper fields of the painting. The three horizontals piled up together close to the base of the composition create a pulsing oscillation between black line and white interval that is a magnet to the eye, the black adding weight where gravity would place it, but the red slat above to the right and the blue that threatens to exit the picture in the top left corner counter that pull. Placed at the picture's edges and bounded on their inside by black lines the two small but intense colour planes cannot combine to suggest relative spatial locations in the interior expanse of white, which remains to be felt as a flat surface on which rhythms and chromatic impacts are released. As in *Composition White and Red* (cat. 10), the optical popping effects discharged where lines cross help discourage the eye from resting and bringing movement to a stop. They are more insistent here, because of the increased thickness and depth of the black lines. There is a flat overall character to the painting that anticipates what the coloured lines and scattered accents of Mondrian's New York paintings would do after 1940. CG

3 Ben Nicholson, 'Reminiscences of Mondrian', in *Studio International* 1966, p. 290.
4 Letter from Piet Mondrian to Ben Nicholson, 6 December 1939 (TGA 8717.1.2.3012). For Ody's Mondrian purchase see Joosten 1998, B284, p. 396.

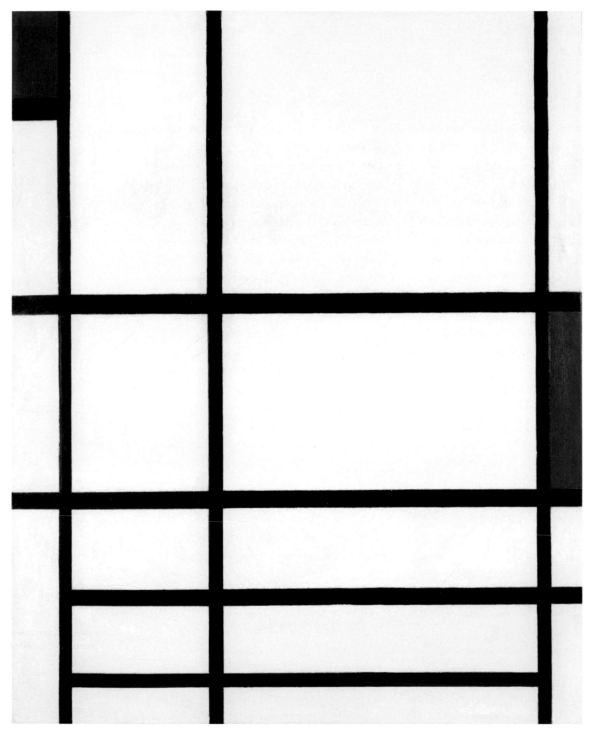

12

13

Ben Nicholson (1894–1982)
1936 (painting)

1936
Oil on canvas laid on board, 38.1 × 50.8 cm
Philadelphia Museum of Art
(A.E. Gallatin Collection, 1945)

This is one of the canvases that mark the beginning of a period when Nicholson returned to using colour in his abstract paintings. He had worked substantially (although not exclusively) on his white reliefs and on paintings with monochromatic or muted palettes over the previous two years. But between 1936 and 1937 Nicholson explored numerous variations on the theme of interlocking coloured planes which appear to advance or recede depending upon their size, placement and chromatic intensity. Several closely connected variations of this composition are known, including a group of gouaches.[1] His edges tend to be ruled and angles accurately plotted at 90°. Nicholson's rectilinear purity is such that circles – a familiar feature of many of his abstracts – are eliminated from these works. All this brings them closer to Mondrian's aesthetic, with which they are often aligned.

By this time Nicholson had had many opportunities to study Mondrian's work carefully during studio visits in Paris and at exhibitions. But, more importantly, he had direct access to certain works by Mondrian. For example, Winifred Nicholson had bought *Composition with Double Line and Yellow* (cat. 4) the previous year and for part of 1936 Nicholson had Mondrian's *Composition (A) with Red and Blue* (fig. 46), in his possession on consignment, until he sold it to Leslie Martin at the end of the year.[2] As demonstrated in the present work, the notable feature of Nicholson's coloured abstracts of 1936 and 1937 is his use of a small plane of intense colour (often red, as in this case) around which the rest of the composition seems to have unfolded. Although Nicholson had already begun to explore the possibility of using such a device in works of 1934 (see, for example, cat. 3), its re-emergence in the present painting, and those that followed (such as cat. 14 and 15), is informed by the Mondrian works that he was most closely acquainted with. It is significant that these particular paintings are strong examples of Mondrian's attempts to achieve maximum impact from the smaller areas of bright primary colour, though, unlike Nicholson, he almost always pushes his colour accents to the periphery.

Nicholson's turn towards colour in 1936 was not solely a response to Mondrian. Direct experience of the landscape seems to have been a powerful driver, as revealed in a letter he wrote to Barbara Hepworth, very early that year, when he was on the train between Marseilles and Toulon, *en route* to a skiing holiday with Winifred Nicholson and their children.[3] He writes eloquently to Hepworth of the southern landscapes he passed. Colour comes to the fore: "…such lovely stony country and strange winter colours," like "St Remy grey stony mountains with dark green patches of scrub and cyprus and olive trees and

1 For example, *1936 (gouache)*, gouache on paper, 30.5 × 42.2 cm, Victoria and Albert Museum, London.
2 *Composition (A) with Red and Blue*, 1936, oil on canvas, 43.2 × 33 cm, B262, private collection.
3 It is worth noting that Nicholson's friend and supporter, Adrian Stokes, who was closely concerned with the artist's work, founded his colour theory upon direct experience of colour during this same period. See Christopher Green's essay in this publication, p. 34.

occasionally a bay and the sea"; "It looks the oldest country I have ever seen and must be like Greece". He goes on to say that he would like to draw the landscape "and get, too, some of its marvellous quality into a relief". Later on in the journey he inserts a quick sketch into the letter of what he thinks was either Cassis or Le Ciotat and writes: "Such lovely country now – small bays one, now, with a liner with scarlet funnel and pines and olives and formalised cultivated vines brown earth and grey stone and houses baked in the sun and painted Southern colours – pink, reddish yellow and white with red roofs – lots of pungent dark blue". After this he describes the section from Nice into the Alpes Maritimes: "…up through an endless succession of gorges, deep black and brown gorges and mountains with formations like the stripes of tigers and the colour of rhinocerosses".[4]

This demonstration of Nicholson's ability to abstract the landscape into colour relation-ships offers a compelling way of understanding his abstract paintings from this time as rooted in the experience of nature. Without wanting to map his train journey observations too precisely on to his paintings, one can find the "deep black and brown" and "pungent dark

blue" he admired from the train window strongly echoed in the present work. It is also interesting that he singles out the small patch of alien colour in "the scarlet funnel" of a steamship comparable, of course, to his all-important small red plane that anchors the composition here. There is also a nice parallel to be drawn between this letter and Winifred Nicholson's recollection of the train journey she took with Mondrian on the trip from Paris to London in 1938. She remembered him, however, not enjoying the colour of the landscapebut becoming entranced by the vertical straight black lines of the telegraph poles, cutting the horizon line as their train sped past.[5]

This painting was bought in 1939 by the major American collector A.E. Gallatin and it joined Mondrian's contemporaneous *Composition White and Red: B* (cat. 10), which Gallatin had bought in 1936, to feature in his influential 'Gallery of Living Art' in New York. This purchase is one indication of the extent to which, by the end of the decade, Nicholson's reputation as Britain's foremost exponent of geometric abstraction had been secured and his international reputation substantially developed. BW

4 Letter from Ben Nicholson to Barbara Hepworth, between Marseilles and Toulon, 25–27 January 1936 (Hepworth Archive).
5 Winifred Nicholson recounts this story in her 'Reminiscences of Mondrian', *Studio International* 1966, pp. 286–88.

14

Ben Nicholson (1894–1982)
1937 (painting)

1937
Oil on canvas, 79.5 × 91 cm
The Courtauld Gallery, London; Samuel Courtauld Trust
(Alastair Hunter Bequest 1984)

Nicholson produced a group of related canvases in 1937, among which was the present work. They are closely comparable in their use of planes of intense colour, set against larger areas of different hues, often muted towards grey. The present work was originally in the collection of Leslie Martin, who co-edited *Circle* with Nicholson and Naum Gabo. It is dwarfed by a monumental version in Tate's collection (fig. 12) and it is possible that the Courtauld picture was an initial exploration of that painting's theme. At their core, both paintings deploy a powerful colour combination of white, black, yellow and red, moderated and cooled by a mid blue. However, the comparison reveals the extent to which the yellow of this painting has deteriorated from what one assumes was once a square of a vibrant yellow similar to that in the Tate painting.[1]

In terms of the clarity of its conception, uncompromising use of high-keyed colour and its assertion of a strictly rectilinear composition, *1937 (painting)* marks an extreme of Nicholson's coloured abstracts. It is one of the least hand-made looking paintings in his oeuvre. The surfaces are flat and evenly coloured, with little evidence of brushstrokes.[2] These qualities are enhanced by his prepara-tion of the canvas, which he stretched over a sheet of board. This ensured its absolute flatness and provided a solid surface for him to work on, free from the inevitable give of a

canvas traditionally stretched over a wooden framework. The coloured planes are precisely ruled and the seams between them are sharp and without a hint of colours bleeding into one another. This is painting disciplined to the point where the inherent fluidity of the painter's technique and materials have been almost completely suppressed (although the unforeseen deterioration of the yellow works against this in an ironic way).

The work is a classic example of Nicholson's habit of creating compositions, distinctly unlike Mondrian's, that appear to work outwards from a central or near-central point, in this case very clearly the red square. Sometimes this can have the effect of suggesting a gently spiralling motion, as the forms appear to grow from this central point. Christopher Green has emphasised a certain organic quality to this unfolding effect and compared it to aesthetic ideas proposed by Nicholson's friend Adrian Stokes, who likened his ideal painting to the opening of a rose presented to the sun.[3]

In this regard Nicholson's way of composing is different from Mondrian's whose paintings operate across a resolutely two-dimensional picture plane rather than creating a sensation of depth and the effect of structures produced organically. Although Nicholson's composi-tions seem to unfold, the concentration of strong colour towards the centre counters any suggestion of expansion of the kind typical of

1 This suggests that Nicholson used a different (and clearly less stable) batch or type of what is probably cadmium yellow for the Courtauld picture.
2 However, the area of white directly underneath the black plane is slightly uneven in texture and colour and has been reworked, suggesting that Nicholson altered the composition during the course of its painting. I am grateful to Maureen Cross for her insights into the technical aspects of this picture.
3 See Christopher Green's essay in this catalogue, p. 35.

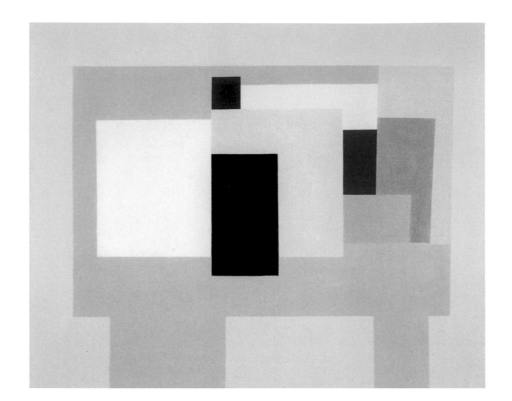

Mondrian's composing. Their respective attitudes towards the framing of their works are interesting in this regard. Whereas Mondrian often favoured mounting his canvases so that they appeared to project outwards from their frames (see cat. 4), Nicholson's frames were designed to contain and enclose the work.

He developed a particular method of joining the four corners of his frames, demonstrated by the original frame of this work; he later set it out thus: "I have considered the frame which surrounds a work of mine as a vital part of its presentation. Therefore, I have always seen to the framing of my work myself The corners of the frame should not be mitred diagonally. The four sides should abutt each other, aligned so that the top side extends over the left side vertical and that the right-side vertical rises so as to extend over the side of the top lateral. Similarly, the left-side vertical is to extend across the end of the bottom lateral while the bottom lateral is to extend across the end of the right-side vertical."[4] These alternating joints emphasise the interlocking construction of the frame and confirm its containing role. Nicholson's desire to present his works as self-contained can be seen in the context of 1930s debates about the independent status of his work as 'art' rather than a decorative panel that might blend seamlessly into a modernist interior.[5]

If, in the company of the Tate painting, the present work seems to present Nicholson at his most abstract, then a further comparison alters this impression considerably. Also part of the group of related works of this year is *1937 (painting)* (fig. 49), which shares a similar palette and compositional vocabulary but very clearly uses them to infer a blocky tabletop still-life. As Chris Stephens has noted, considered together with this third work, it is possible to see even the severely abstract Tate and Courtauld paintings as being rooted in Nicholson's ongoing fascination with still life.[6]

BW

4 Letter from Ben Nicholson to the Tate Gallery, 28 June 1979, cited in Hackney, Jones and Townsend 1999, p. 162.
5 See Lee Beard's essay in this publication, pp. 78–81; also see cat. 8.
6 Stephens 2008, p. 42.

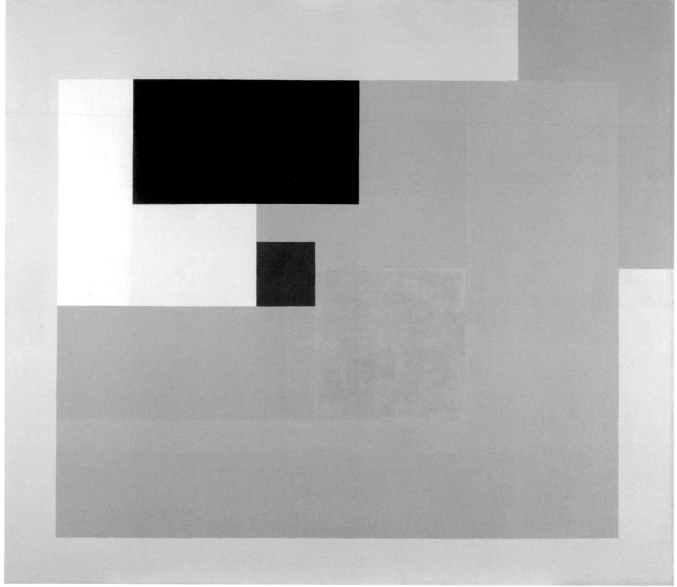

15

Ben Nicholson (1894–1982)
1938 (painting – version I)

1938
Oil on canvas, 123.5 × 141 cm
Private collection

If several of Nicholson's major abstracts from the mid 1930s tend towards simplicity and purity, an iconic example being *1936 (white relief)* (cat. 9), then his compositions from the late 1930s and early 1940s express greater complexity and dynamism. This is demonstrated, to a certain degree, by the present work, in which the forms seem just to hold their balance. The grey plane with the circle teeters on the edge of the black form, but is counterbalanced by the strong red rectangle. The grey plane is also baulked by the right-angled strip of lighter grey that runs along the top and right-hand side. The striking colour contrasts between the red, black and white give the painting considerable vibrancy and contribute to the drama of abstract forms that Nicholson condenses into this large canvas.

It is tempting to regard the painting as developing directly out of Nicholson's 1937 compositions (see, for example, cat. 14), but the reality is more complex. Jeremy Lewison has drawn attention to an album of photographs of Nicholson's works, put together by the artist in 1940, in which he dates this painting 1934–38.[1] This suggests that the canvas had its origins at the beginning of Nicholson's turn to geometric abstraction and that he returned to it, perhaps on various occasions throughout this period, completing it in 1938 and exhibiting it the following year at his one-man show at the Lefevre Gallery (fig. 50). Indeed, with the red rectangle removed, the composition has a close affinity with the austere *1935 (painting)* (fig. 42) and it arguably has more in common with this picture than with the multiplication of forms that occurs in the 1937 compositions and in his works of the subsequent few years (see, for example, cat. 19).

Interestingly, a second version of this canvas, also likely to have been started around 1935 and originally in the collection of Alexander Calder, replicates the composition.[2] But it is executed more freely, with the circle wonkily hand-drawn and the brushwork more clearly textured. Nicholson commonly scraped back his canvases with a razor blade and reworked them – particularly his still lifes during this period – and one wonders if the present painting underwent a similar process of refinement from coarser beginnings to the smooth surface and carefully ruled and compass-drawn forms of the final work. However, nothing of this is evident on the surface of the canvas itself and, in the absence of a full technical examination of the work, we have to presume that Nicholson developed the same composition in two different ways. Thus he expressed his parallel artistic concerns for the logic and clarity of geometrical precision on this canvas and for the idiosyncrasies of the hand-made object on the Calder work. Given Calder's own aesthetic, it is perhaps not surprising that he favoured the second version.

1 Lewison 1993, no. 71, p. 222.
2 *1938 (painting – version II)*, oil on canvas, dimensions and location unknown.

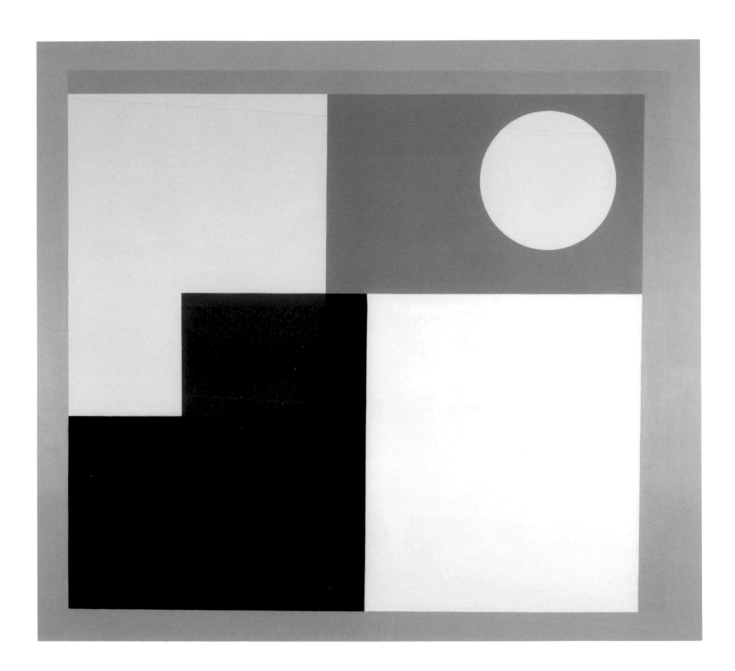

FIG. 50
A view of the exhibition,
'Ben Nicholson', Lefevre Gallery,
London, 1939, including *1936 (white relief)*, here cat. 9, and *1938 (painting – version I)*, here cat. 15, courtesy
Bowness

The drive towards greater complexity and visual dynamism is also a major feature of Mondrian's work of the 1930s and represents one of the most significant parallels with Nicholson's art. This painting pairs particularly well with Mondrian's *Composition B/(No. II), with Red*, 1935 (cat. 6), where the red plane is used to counterbalance the scaffolding of black lines and where the combination of red, black and white offers a similar visual intensity. However, Nicholson, typically catholic in his stated range of influences, did not cite the archly modernist Mondrian, but his proudly anti-modernist father, William Nicholson, as a source of inspiration for this work. Specifically, he stated that the painting had a close connection with a poster of 1895, *Girl Reading*, produced by his father and James Pryde, who worked together under the name 'J. & W. Beggarstaff' (fig. 50).[3] Their use of simplified forms in this poster, described in solid colour – indeed very similar colours to *1938 (version I)* – makes for a compelling and revealing comparison. The pairing draws attention to the modernity of the nineteenth-century print. More importantly, it demonstrates that even Nicholson's most uncompromisingly abstract paintings are part of a more complex narrative than their assertive modernist aesthetic at first suggests.
BW

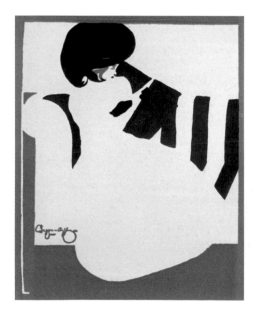

FIG. 51
'J. & W. Beggarstaff' (James Pryde and William Nicholson), *Girl Reading*, reproduced in *The Poster*, February 1899

3 Lewison 1993, no. 71, p. 222.

16

Piet Mondrian (1872–1944)
Composition No.I, with Red

1939
Oil on canvas, 105.2 × 102.3 cm
B292
The Peggy Guggenheim Collection, Venice
The Solomon R. Guggenheim Foundation, New York

Composition No. I, with Red is one of the very few paintings that Mondrian finished mostly to his satisfaction in London. Nicholson would have seen it on the trestle table on which Mondrian preferred to work in his room at 60 Parkhill Road or propped for viewing against the white painted wall on one of the white painted stools bought in Camden Town, though Mondrian may have made some adjustments to it in 1940, after Nicholson and Hepworth took their children to Cornwall, and perhaps later in New York.

In September 1938, as Mondrian prepared in a hurry for the cross-Channel journey to London, he wrote to Nicholson of his distress at having to stop work when he had "found the solution to two paintings of a metre square".[1] One of them was this. It was still apparently not quite finished to Mondrian's satisfaction when, in November 1939, to his great pleasure, the critic Herbert Read negotiated its purchase by Peggy Guggenheim for the Museum of Modern Art that she planned for London. The War prevented the fruition of that plan, but that November it was still on track, with Mondrian and Nicholson's friend and supporter Read the proposed director. Reporting the arrival of the agreed £50 from the American collector that month, thanking Hepworth for any help she may have given in securing the sale, he wrote to her that Read had made a visit to see that he was satisfied and he had promised to finish

the picture as soon as possible. "After all what I changed on it, I am now fairly satisfied with the picture."[2]

An annotated photograph sent by Mondrian at an earlier stage in the development of the picture to the Swiss artist Max Bill indicates that one change he made was the removal of grey from the small horizontal rectangle (now white) in the left top corner.[3] Angelica Zander Rudenstine, however, was told by Peggy Guggenheim that Mondrian "restored" the picture just before she opened her gallery 'Art of this Century' in New York in October 1942, and suggests that the removal of the grey might have happened then, along with the strengthening of the black lines.[4] The picture was, however, certainly close to completion by May 1939, because a reproduction of it that appeared in the issue of the *London Bulletin* shows as much.[5] There must have still been adjustments in colour relationships to be made and the blackness of the lines and opacity of the white may still not have satisfied him completely, or he would not have felt the picture still needed finishing when he received Peggy Guggenheim's payment. But all the major decisions concerning the positioning and relative weight of the lines had been made, as well as the decision to place the red on the bottom edge to the right. The picture we have now is still in its essentials the picture Nicholson knew in 1939.

1 *"Je suis tellement attristé que je dois interrompre ainsi, brutalement forcé par la nécessité, mon travail. J'avais just trouvé la solution de deux tableaux d'un mètre carré et trois autres"*: letter from Piet Mondrian to Ben Nicholson, 7 September 1938 (TGA 8717.1.2.3008).
2 Letter from Piet Mondrian to Barbara Hepworth, 12 November 1939 (TGA 965).
3 Rudenstine 1985, p. 563.
4 Rudenstine 1985, p. 563.
5 *London Bulletin*, The London Gallery, London, no. 14, May 1939.

As in both *Composition White and Red: B* (cat. 10) and *Composition with Red Blue and White: II* (cat. 13), colour, in its placing and its intensity, counters the strong insistent action of line. That small but forceful accent of red counters the pull leftwards and upwards of the horizontals that bridge the interval between the two most widely spaced verticals. At the same time the two horizontals that come together as a double line traversing this white gap quicken the rhythm to draw the eye away from the red, as the attention switches between fusing and splitting the two lines. Otherwise, the generous breadth of the intervals between the black lines, including those between the verticals on the right, slows things down. The grand architecture of the painting is certainly in tune with that of Nicholson's most resolved large-scale white reliefs.

In New York, Mondrian would speed things up again in both new and already started canvases by introducing notes of colour where the intervals between lines and the picture edge are squeezed. The other metre-square canvas on which Mondrian had to stop work when he left Paris for London in September 1938 was at that point very much the partner of *Composition No. I, with Red,* both in the generous breadth of its intervals and its introduction of a horizontal double line splitting the format. When he went back to work on this other picture in New York he added small accents of red in the narrow intervals between the black lines and the picture edge on two sides, setting up within those peripheral strips a completely new kind of colour-driven rhythm.[6] Nicholson would have known this picture in its earlier state as well as the Peggy Guggenheim picture in London; neither could have given him any idea of what would happen in Mondrian's painting when he crossed the Atlantic. CG

6 For the two stages of the work, 1939 and 1942, see Joosten 1998, B285 and B313, pp. 397 and 412.

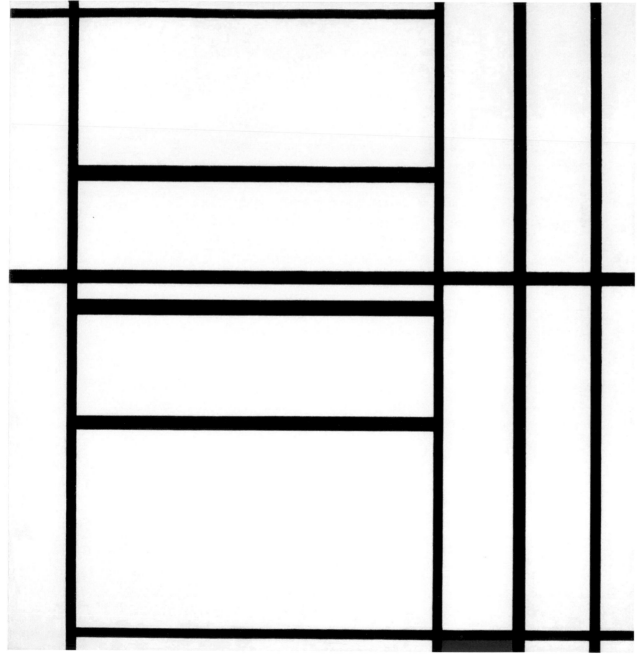

16

17

Ben Nicholson (1894–1982)
1938 (white relief)

1938
Oil and pencil on carved board, 106 × 110 cm
Kröller-Müller Museum, Otterlo

Nicholson completed this large white relief the year that Mondrian arrived in London. It is interesting to compare the work with Mondrian's contemporaneous, *Composition with Red* 1939 (cat. 16). This was one of the canvases the Dutchman had brought with him from Paris and worked on once he had settled into his studio next to Nicholson's in Parkhill Road, Hampstead. Mondrian's painting and Nicholson's relief are both of near-square formats and close in size. The two artists address very similar concerns in their two works. They explore the effects of multiplying horizontal and vertical lines across the picture plane, and the possibilities of varying their thicknesses and spacing to create different rhythms, whilst balancing the composition as a whole. It is tempting to imagine them producing these works at the same time in their neighbouring studios – each finding different solutions to a shared set of compositional challenges. Although the reality of this is uncertain, both works were undoubtedly well known to each of them from their regular studio visits. They represent Nicholson and Mondrian at their closest, both historically and aesthetically.

The present work is one of Nicholson's most complex and sophisticated white reliefs. He tightly groups the edges of three different carved planes at the bottom and left-hand side of the composition, forming a stepped effect. The intervals between them vary, and because each plane is carved to a different depth, the black shadow lines created are of different thicknesses. This all gives a staccato energy to these areas. On the opposite sides, the planes are cut flush with each other. Just two carved edges form the top and right-hand borders, so that this area appears to be smoothed and flattened in comparison to the multiple shadows and planes which form the opposing part of the composition. The effect dramatises the role of light and shadow. In Nicholson's earlier white reliefs our consciousness of the action of light on the works often serves to underscore their material presence as sculptural objects. But here the introduction of the pencil-drawn circle cues us to another set of concerns. Nicholson's interaction of different types of lines, using shadow, pencil and carved edges, creates a visual experience that offers us a play of illusionist effects, rather than an overriding sense of the relief's physical reality.

1938 (white relief) was included in Nicholson's Lefevre Gallery exhibition in March 1939 (fig. 53), and hung next to the largest of his coloured abstract canvases, *June 1937 (painting)* (fig. 12). The relief was also illustrated that month in the *London Bulletin*, which served as a catalogue for the exhibition, together with an essay by the artist's friend Herbert Read.[1] Read had played an important role in defending Nicholson's abstract work against its hostile reception in

1 Herbert Read, 'The Development of Ben Nicholson', *London Bulletin*, The London Gallery, London, no. 11, March 1939, pp. 8–10.

1935 (see cat. 8). His essay in the *London Bulletin* demonstrates that the argument for Nicholson's abstraction was not yet won. Read set out to counter what he claimed was the widespread belief that "abstract or constructivist art must lead to a kind of stalemate" and that Nicholson's art, in particular, was mechanical and impersonal. Against this, Read used a musical analogy to describe the experience of the coloured abstracts, suggesting that Nicholson's geometric precision was only "the counterpoint for a free melody of colour". He acknowledged that his abstract aesthetic was "at its severest, in the white reliefs" but maintained that even here "there is a sensitivity of line and a play of light and shade which are anything but geometrical or mechanical".[2]

The installation of Nicholson's coloured abstract paintings interspersed with white reliefs at the Lefevre prompted another of Nicholson's friends, John Summerson, to acknowledge that the reliefs continued to be the hardest works to appreciate. Summerson was explicit: "The all-white reliefs are less easy on the eye; the same complexity is there, the emotional assault of colour is not, and this produces a remoteness approaching inaccessibility for the ordinary observer". However, he was unapologetic and compared Nicholson's work to "advanced research in scientific thought, in so far as its results reach out a very long way from the common world of everyday affairs and everyday visual experiences". For Summerson, the power of Nicholson's abstract work lay in its uncompromising commitment to "the cultivation of that mysterious language of form which lies beneath the currency of name and appearance".[3]

If this white relief epitomises the severity and remoteness that Read and Summerson sought to counter or justify, then it would prove to be among the last of its kind in Nicholson's oeuvre. His complex interactions of line, form, light and shadow, and exploration of illusionistic devices, would never again be played out in such strictly geometric and monochromatic terms. BW

2 Read 1939, p. 9.
3 John Summerson, 'Abstract Painters', in *The Listener*, vol. xxi, no. 531, 16 March 1939, p. 574.

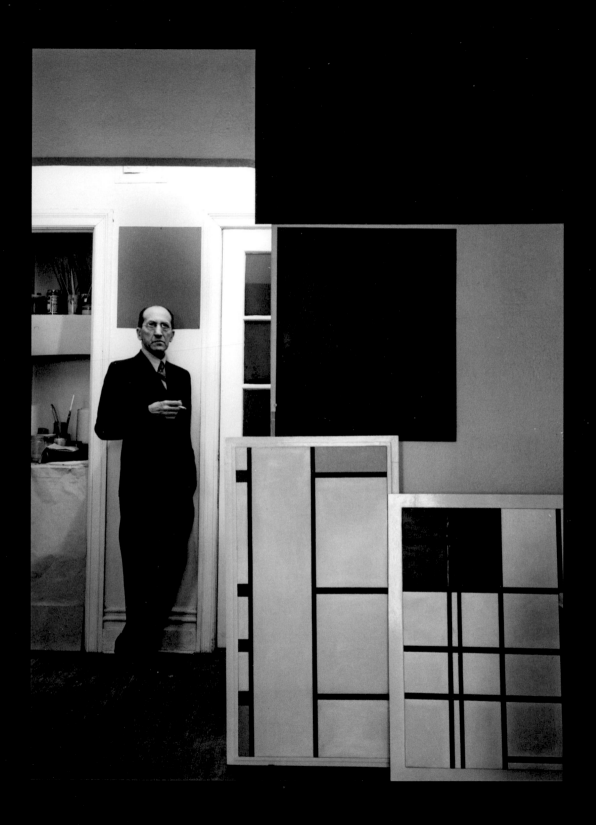

FIG. 53
Piet Mondrian in his New York studio,
1942, showing *Composition No.III
White-Yellow*, here cat. 18, in its
second state, and *Composition No. 7*,
1937–42, B312

Photographer: Arnold Newman
Getty Images
© 2012 Mondrian/Holtzman Trust
c/o HCR International Washington DC

18

Piet Mondrian (1872–1944)
Composition No. III White-Yellow

1935–42
Oil on canvas, 101 × 51 cm
B257/306
San Francisco Museum of Modern Art
(Purchase through a gift of Phyllis Wattis)

Alfred H. Barr Jr. illustrated two Neo-Plastic Mondrians in his hugely influential *Cubism and Abstract Art* published in 1936. He chose two with relatively unusual formats for Mondrian, a diamond and the present tall vertical canvas. When he reproduced it, the work was in crucial details different from its present state (fig. 54). The linear division of the picture surface lacked only the central horizontal on the right and the yellow plane upper right may have been there as it is now, but the blue and certainly one of the red elements that pulse along the white left edge of the canvas were not. In New York, Mondrian inscribed his signature with the date *35/42* in red on the black vertical lower left, indicating that these additions were made by 1942. *Composition No. III White-Yellow* is, in fact, a canvas that was "finished" twice, a clear demonstration that, as Yve-Alain Bois has put it, Mondrian's compositions were always on the point of being "undone", even when finished.[1] Moreover, first finished in Paris, this picture was with him at 60 Parkhill Road, when Nicholson was a frequent visitor there in 1938–39, before its second completion in New York. Nicholson, it is worth adding, relished unusual formats, as *1936 (white relief)* (cat. 11) demonstrates; they set their own distinctive challenges.

Despite Barr's expressed doubts about the future of "geometric" abstraction, he was fulsome about Mondrian's stature as an artist.

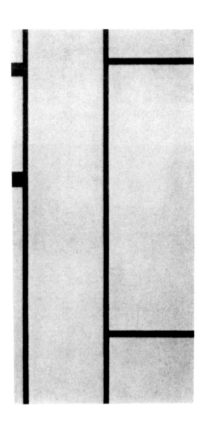

FIG. 54
Photograph of the first state of cat. 18 as reproduced in Alfred H. Barr Jr., *Cubism and Abstract Art*, The Museum of Modern Art, New York, 1936
© 2012 Mondrian/Holtzman Trust
c/o HCR International Washington DC

He placed him at the centre of De Stijl and the emergence of abstract art from Cubism, and called him one of "the finest artists of our time".[2] But he represented his arrival at abstraction in 1917–20 partly as the result of the stimulus provided by Bart van der Leck and especially Theo van Doesburg.[3] This riled Mondrian, who, writing to Nicholson from Paris in May 1936, dismissed the idea that geometric abstraction was in decline and claimed that Barr had misunderstood his

1 Yve-Alain Bois, 'The Iconoclast', in Bois, Joosten, Rudenstine and Janssen 1995, p. 339.
2 Barr 1936, p. 141.
3 Barr 1936, p. 142.

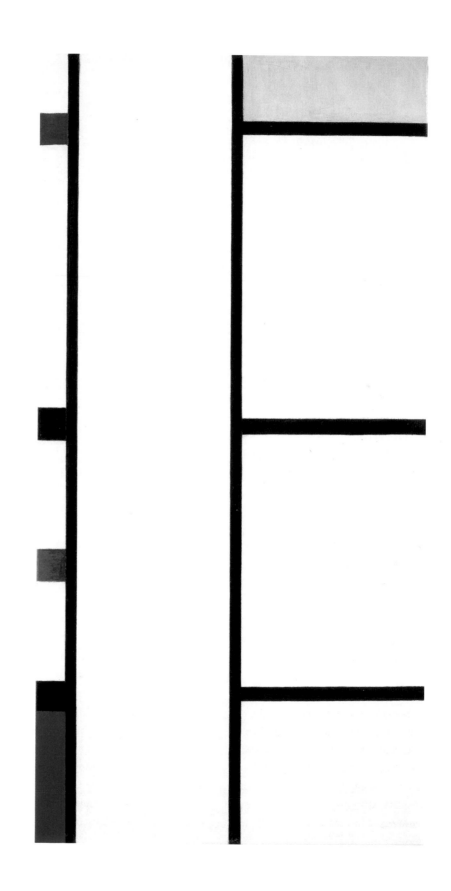

A view of Vera Moore's Sussex cottage showing
her Piet Mondrian, *Composition with Blue and Yellow*,
1937, B270, hanging above her piano, probably
autumn 1938, Tate Archive, London
(detail of fig. 21)
© 2012 Mondrian/Holtzman Trust
c/o HCR International Washington DC

Photographic Credits

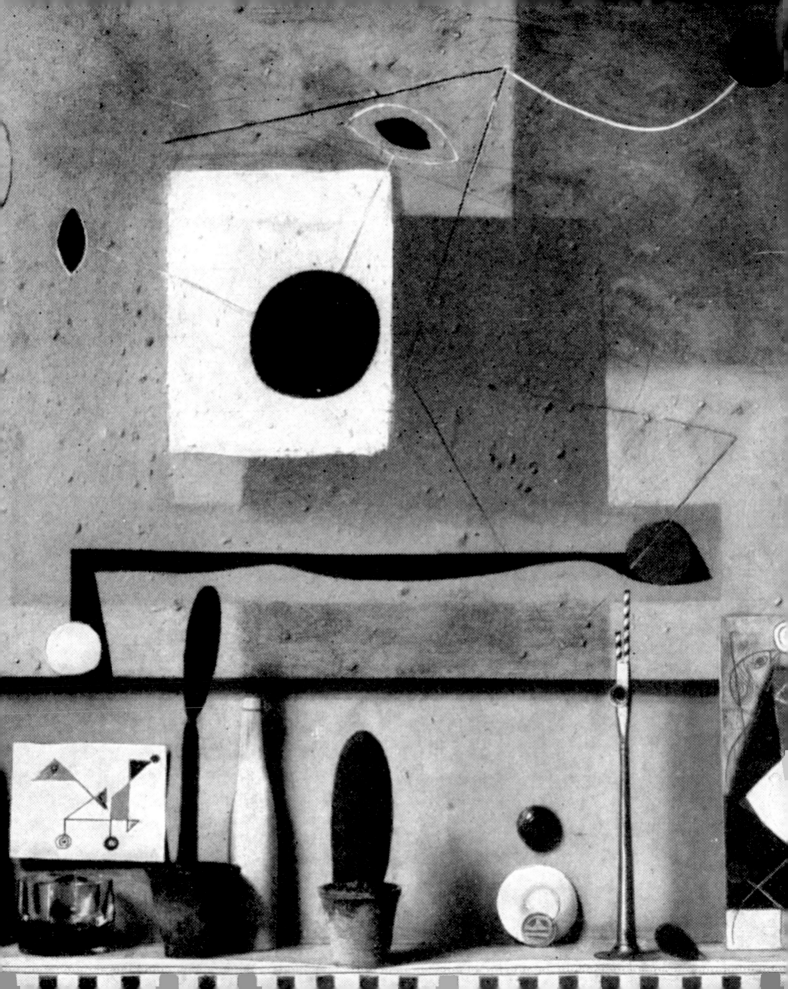